Getting Started in ZBrush

Getting Started in ZBrush

An Introduction to Digital Sculpting and Illustration

Greg Johnson

Focal Press
Taylor & Francis Group

NEW YORK AND LONDON

First published 2014
by Focal Press
70 Blanchard Road, Suite 402, Burlington, MA 01803

and by Focal Press
2 Park Square, Milton Park, Abingdon, Oxon OX14 4RN

Focal Press is an imprint of the Taylor & Francis Group, an informa business

Library of Congress Cataloging-in-Publication Data application submitted

ISBN: 978-0-415-70514-1 (pbk)
ISBN: 978-1-315-88996-2 (ebk)

Typeset in Myriad Pro
by Apex CoVantage, LLC

To my wife Penny — for her inexhaustible patience.

Contents

Contents

Contents

Acknowledgements

I would like to thank the various people who helped to get this project to publication: Professor Charles Shami for his editing and Professor Michael Betancourt for all of his advice. Thanks also go to Ms. Caitlin Murphy and the staff of Focal Press for their assistance.

About the Author

During the course of being a Professor of Game Development and Computer Art for over 17 years, I have had the privilege of teaching thousands of students a diverse array of courses, including digital sculpture, 3D modeling, texturing, game design and development, animation, rigging, visual effects, digital painting, and programming. This book is a compilation of material developed from my introduction to digital sculpting lectures and all of the good advice I have managed to cultivate over the years. I am a member of the Guild of Natural Science Illustrators and the Association of Science Fiction Illustrators, and have worked as a 3D Lead for Ascent Games while doing occasional freelance work. You can find my work online at <www.gregtheartist.com>.

Introduction

Overview

This book is an understandable and easy-to-use introduction to digital sculpting and painting with ZBrush. Everything you need to get started working in ZBrush is contained in this book. The book will guide you through the process of sculpting and illustrating your own fantastic digital creations. Topics covered include a thorough introduction to the program's user interface, professional workflow, illustration, sculpting techniques, and how to customize the tools and interface to suit your own personal work habits. Written with the digital beginner in mind, this book will teach you all of the necessary information to begin working in ZBrush to create magnificent works of digital artwork! Throughout this book ZBrush will empower you to be the digital artist you always wanted to be.

FIG 1.1 *Quick dragon head study*

ZBrush is a wondrously powerful program capable of doing things thought impossible just a few years ago. However, it is also, like other 3D programs, a very complex and deep program with thousands of buttons and options that can easily confuse and overwhelm someone new to it and to 3D in general. This book focuses on the workflows and techniques that will make you a productive artist with this program. It is not a guide to every button in the program; the official ZBrush documentation (http://docs.pixologic. com) already exists for that and it would be redundant to include all of this material here. Instead, this book will show you how to work with the program to produce the artwork you want to create and will serve as an entry point into the larger world of 3D. While you will not need any other resources aside from this book to become an effective artist with ZBrush, I would still suggest that you take advantage of the wealth of existing free material that can be found on Pixologic's main website (http://pixologic. com) and on the official ZBrush forum (www.zbrushcentral.com). You will quickly discover that the vast majority of artists working in 3D are a very friendly and helpful bunch provided that they are treated with respect.

Why ZBrush? ZBrush is an artist-orientated digital 3D sculpting and painting package. Since its inception over a decade ago, ZBrush has become a critical component of many industries such as film, video games, and illustration. The reason for this is that unlike any other 3D program on the market today, ZBrush is the only one capable of displaying millions of polygons on screen at the same time. This is due to the way in which ZBrush handles its camera since it treats everything as a 2.5D object as opposed to a true 3D object. While this imposes additional work when translating ZBrush objects into other 3D packages, it does allow for the creation of complex 3D objects within ZBrush that no other package can replicate. Because ZBrush has been integrated into so many movie and game production pipelines, it has become required knowledge for anyone wishing to become a 3D artist in these fields. ZBrush has also become a very influential player in the realm of illustration as many artists begin to adopt 3D into their workflow. What this all means is that if you want to become a professional 3D artist for games, movies, and increasingly illustration, you will need to know ZBrush. The program has been particularly useful for character artists for years, and it is now being used for all sorts of detail-oriented work, whether in character, environment, or object modeling. Simply visiting the gallery on www.zbrushcentral.com will show just how many projects ZBrush is currently being used for. Simply put, knowing ZBrush has become critical for many artists.

Let's begin learning with some basic universal advice and suggestions; then we will move on to the more technical material.

Professional practices

Here's a brief set of suggestions that should be helpful to anyone in the field of digital arts. If you intend to pursue a career in the visual arts, you should keep these suggestions in mind.

Sketchbook. The ability to draw is an essential part of working in this field and it is important to always practice this skill and improve it. You should purchase a small, easily portable sketchbook and keep it with you at all times. Any time you have a minute, when waiting for food, standing in line, or just hanging out, get out the sketchbook and draw whatever you see in front of you. It is important to draw what you see, not what is in your head (that goes into your idea book)! After a few months you will start to notice significant improvements in your skill level. After two years, you'll be pretty good.

Idea book. You need inspiration. Keep a small sketchbook with you and write down or sketch out any ideas that you have. Cut out anything interesting you

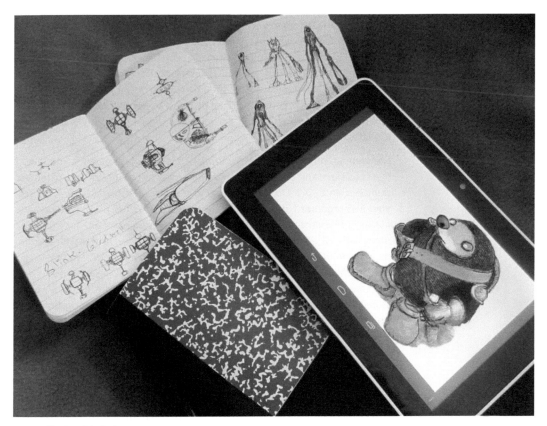

FIG 1.2 *Sketch and idea books*

find in magazines and paste it into the sketchbook. You can include photographs and photocopies as well. You can also keep a file folder on your computer which you should fill with whatever images you find intriguing. Then, whenever you need inspiration or are stuck for an idea, simply open up your idea book/file folder and browse through it. Soon you will be inspired again!

Technique library. Keep a file folder and populate it with any interesting tutorials or techniques you find. If you see an interesting image that has, let's say, a neat-looking approach to doing hair, save it and put it in your techniques folder. Later, when you need to do hair yourself, you can look at that approach and some other techniques you've found and use one of those techniques or combine them and come up with your own unique approach.

Job research. You must be aware of what you will need to have in your portfolio to get the job you want. To learn this, simply select five companies you'd like to work for one day. Go to their website and search through the job postings for the position(s) you want. Most companies provide a very detailed breakdown of the skill sets and requirements for each job. What you need to identify are the common elements between each of the same type of jobs from the different companies. If there is a skill set that every one of the jobs lists, then you must be absolutely sure that you have that skill demonstrated in your portfolio. Conversely, if there are skills that only one of the jobs talks about, then that is a skill that you should focus on only if you really want to work for that specific company (since no one else will care that you have that skill set). Just remember to compare jobs with the same (or almost the same) job titles.

File-naming conventions and organization. It is important to name your files in a consistent and organized fashion. I suggest using only lowercase letters, numbers, and _ or -. Do not use any unusual characters (!@#$%^&^&*). Keep your files organized into descriptively named file folders. When naming a file, include a version number and a current iteration number – for example, *mammoth_v2_205.ztl* (the 3D file), *mammoth_v2_20.psd* (the master texture file), *mammoth_v2_03_diffuse.jpg* (color texture file for the 3D scene), *mammoth_v1_02_normal.jpg* (normal map file for the 3D scene), and *mammoth_v1_06_spec.jpg* (specular level texture file for the 3D scene), all stored in the *mammoth* folder. This name breaks down into a description of the object (mammoth, a prehistoric elephant), the version number (_v2), and the iteration number (_205). Each time you save the file (3D, Photoshop, or otherwise), increment the iteration number by one: so, from *vulcan_v6_048.ztl* to *vulcan_v6_049.ztl* and so on. If you make a serious change you can increment the version number. This way if a problem develops in the file (it gets corrupted or you make a mistake) you can always go back and find an earlier file that isn't messed up. This will save you hours' and maybe even days' worth of work.

Backups. Don't forget to back up your work! External drives are cheap nowadays so there really isn't any excuse for failing to back up your work. Personally, I use around four different external terabyte drives and back my work up to a different one each week. I also have copies burned to DVD, a backup of current files at a different location, and a copy of my working files on my portable drive. There is a wide array of online backup services now available as well. Over the many years I have been a professor, I cannot even begin to count the number of times students have lost all of their work due to a hard drive crash – a simple enough thing to fix if they had bothered to back their work up to an external hard drive or a cloud storage service. Another common mistake is to keep saving work into the same file. When something happens to that one file, their whole project is ruined and they lose hours' if not weeks' or months' worth of work. Simply using a file-naming convention and iterating their file names would have saved them. I speak from personal experience. Several of my earliest animations are now lost. Even though I backed the files up, the storage device I used became inoperable and the files are now unrecoverable. There is nothing worse than having one's files become lost after spending hours, days, and weeks working on a project – especially when the solution is so easy and straightforward.

Anatomy. There is simply no substitute for knowing proper anatomy. It is the difference between getting a job as a character modeler or not. Ignore studying this material at your own risk! You will need to show competency in drawing, physical sculpture, musculature, and bone structure. The best approach is to take a class in constructive anatomy. This does not mean simply memorizing the muscle groups and bone names – this means doing a hands-on écorché sculpture. In this process you first create the bones of the model, then painstakingly apply each and every muscle to the model to build up the form until you eventually add the soft organs, fat, and skin to finish the model. It is a laborious and time-consuming approach, but it is the best way to truly learn proper anatomy.

Skills. There's a lot to digital art that you can teach yourself – and then there's some stuff that you probably can't. Almost all of the technical stuff can be self-taught. The technical side of things is well documented and easily accessible. A good book (like this one!) will get you started and then you can pick most of the remaining techniques up from quality websites (Zbrush Central, CGSociety, Polycount, etc.) and by reading the help files that come with every reputable software package. It is an excellent idea to take an entry-level programming class though, to get a good foundation for that sort of thing (unless you just have a real knack for it as some people do and can teach yourself programming). The problem is when you start talking about learning art. It is very difficult to teach yourself proper technique when it comes to drawing, anatomy, color, and design. While there are countless books on

each subject, nothing beats having a good instructor. I urge you to pay really close attention to the fundamental art courses: color theory, 2D design, and drawing. These are the classes that make you an artist. If you learn this material well, then you're an artist; otherwise you aren't and probably never will be (though there are tons of jobs for purely technical people in the entertainment industry too). I know that as I get older and more experienced technically, the techniques I keep going back to and working on are color, design, and my drawing skills.

Education. You don't have to go to college to get a job in the entertainment industry working on digital art. All these companies care about is the art that you can bring to the table. They don't care about your grades, just the quality of your portfolio. You also have to be capable of working well with others in a group. If you cannot do that, then you will be unemployable. Having said all of this, college is still a good idea. Why, you ask? Because it will open up opportunities that would be denied to someone who doesn't have that educational background. While the entertainment industry might not care about your educational background, a lot of other employers certainly will and that is a very important thing to consider. The entertainment industry is not for the faint of heart. The hours are long and the employment contracts are short – sometimes no more than a couple of months before you are looking for new work. Reputation is everything. If you have the reputation of someone who is easy to work with, takes direction well, and who has a lot of artistic capability, then you will find getting employed pretty straightforward. If you are at the point in life where you are thinking of marriage and kids, then you might want to look at other opportunities that will provide regular working hours and good benefits, and for that college is essential. One good approach is to work in the industry until the job market crumbles (which happens about once every ten years or so) and you can't get a job. Then go back to school for a few years and earn the next degree in the sequence. Get your Bachelor of Fine Arts degree if you don't have one or your Master of Fine Arts if you already do. By the time you finish the program, the job market will have heated back up and you will be employable again with a sparkling new set of qualifications. It doesn't hurt that advanced degrees like a Masters of Fine Arts (MFA) or a Doctorate (PhD) help in getting promotions either.

You don't need to spend a fortune to get a good education. A lot of very good colleges don't require an enormous amount of monetary investment; but you have to do your research. Look into who is teaching at the college and what they've accomplished – do they know their stuff? Go tour the campus and see if you are impressed after talking to them face to face. Be careful with the "rate my teacher" sites though; most often the people complaining are the ones who did the worst in class. Find students whose work you admire and ask them what their opinion is about a professor or class. It is best to ignore

the opinion of people who aren't putting in the effort to succeed. The single most important element in success is your determination. If you are willing to put in the hard work, you can succeed wherever you go to school or you can spend a jaw-dropping amount of money at the world's best art academy and still be unemployable if you don't put in the personal time and effort it takes. Play it smart. Take your English, math, and other core requirement classes at a cheaper college and transfer the credits in. You can usually take up to almost half your credits somewhere other than the place you graduate from; but it is best to check ahead of time and find out what will eventually transfer over and what will not – just so you don't waste any of your time or money. If you're going somewhere with a great reputation, it is a bit easier to get a good education; but just make sure that you will be able to pay off those student loans eventually. There's not much point in getting a $200,000 education in a field where the starting salary is $20,000 a year. The point is to do your research. Find out what it is going to cost, how best to work the system, and who to

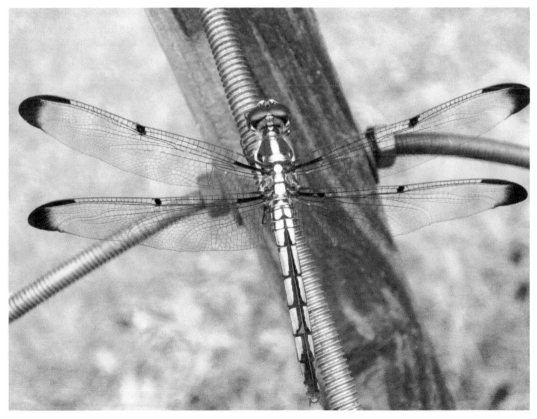

FIG 1.3 *Dragonfly*

take classes with to get the most out of your education. Make the system work for you!

Creativity

Creativity does not occur in a vacuum. You must continually feed your brain with fresh ideas and stimuli if you want to develop content that is original and unique. It isn't enough to simply play video games or watch movies. If you only do that, you will simply end up regurgitating the same sort of material that you've seen. There's plenty enough repetition in the industry as it is and there's no need to add another space marine, robot, or monster that looks like everything else already out there. So how does one break out of the rut? Find fresh material to serve as input, read, and be inspired by original work.

Go out and research as wide a variety of topics as possible. Almost anything can serve as an inspiration, but there are some areas of study which can be especially useful for a digital sculptor. One of the most beneficial areas of study is zoology and anatomy. Studying the shape and forms of the myriad creatures that make up our beautiful biosphere is greatly rewarding on several levels. It will help to teach you more about anatomy. Learning how muscles and bones work on other creatures will help to inform your decisions when it

FIG 1.4 *Spiders*

FIG 1.5 *Fungus*

comes to designing your own creatures and make the ones you create all the more believable, so much so that if you have the opportunity to study some animal anatomy or comparative anatomy classes, I'd suggest you take them. Knowing the visual elements that define a predator versus a prey creature will allow you to create creatures that possess the correct set of traits for their role. Let's take a few examples. A rabbit is a prey animal. As such, it has large ears that swivel about to enable it to detect the stealthy approach of a predator early on and to pinpoint the direction it is attacking from. The rabbit possesses powerful legs so it can flee from danger and a sensitive nose for additional detection abilities. One of the most telling attributes of a prey animal is how its eyes are set upon its head. Most prey animals like the rabbit have their eyes set far apart on the side of the head. This gives the creature a very wide field of vision in which it can easily detect the movement of a potential predator. Prey animals can also possess a wide range of defenses such as armor, camouflage, mimicry, poison, a bad smell, or even ink. Teeth are another vital clue to a creature's habits: blunt teeth for herbivores, a mixed set for omnivores, and lots of sharp pointy teeth for predators. Looking at predators, you can tell what kind of prey a creature eats from its teeth: lots of small sharp teeth for eating small slippery prey, big cutting teeth for ripping chunks out of their victim, or a pair of saber teeth for delivering a killing bite to the throat. Predators typically have their eyes set in the front so that they can have stereoscopic vision and good depth perception for judging how far it is to the prey animal for the final pounce. Combine this with additional senses such as a capable nose, sensitive ears, or something more exotic like a bat's radar or a dolphin's sonar for locating their prey. Add in some powerful claws for grabbing and holding onto their prey and you have an efficient predator. Predators usually fall into either pursuit or ambush types which can be used

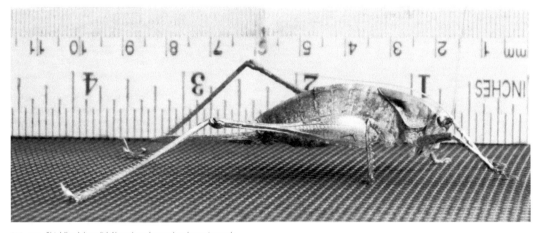

FIG 1.6 *Shieldback katydid: Note the ruler used to determine scale*

as a marker to give the creature either good camouflage and blinding reflexes (ambush types) or powerful legs and high endurance (pursuit types). Some of my personal favorites for inspiration include the strange creatures from the deep sea.

Searching a scientific term relating to oceanic studies such as "bathypelagic" or "abyssopelagic" will turn up lots of wonderful and exotic animals. Looking up a zoological term such as isopod, nauplius, or arthropod is a good start, as well as searching for paleontological phrases such as the "Cambrian explosion", "Arthrodires", or "terror birds". Studying zoology, biology, paleontology, and their related fields will provide invaluable insight into your own creature designs.

It is also worth reading the best of the science fiction and fantasy genres. Knowing the work of such luminaries as Arthur C. Clark, Isaac Asimov, and Robert Heinlein will not only provide endless amounts of inspiration, but will educate you as to where most of the current themes in science fiction come from. Authors such as Edgar Rice Burroughs, H. G. Wells, Larry Niven, and many others have defined the genre and are well worth reading. Fantasy authors such as J. R. R. Tolkien, Robert E. Howard, Michael Moorcock, Fritz Leiber, and Jack Vance are the origin point for most of the themes found in modern fantasy games and movies. In the same vein, Edgar Allan Poe and H. P. Lovecraft defined the horror genre. Reading the books written by these authors will help you to understand where most of the ideas in modern video games and entertainment come from and inspire you to create your own unique creative visions. You can find a lot of these works for free at Project Gutenberg (www.gutenberg.org).

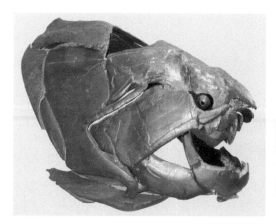

FIG 1.7 *Arthrodire fossil*

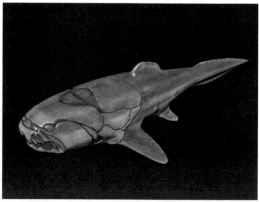

FIG 1.8 *Arthrodire model*

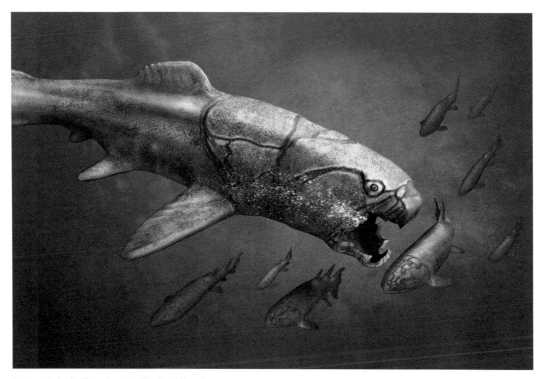

FIG 1.9 *Arthrodire illustration using ZBrush and Photoshop*

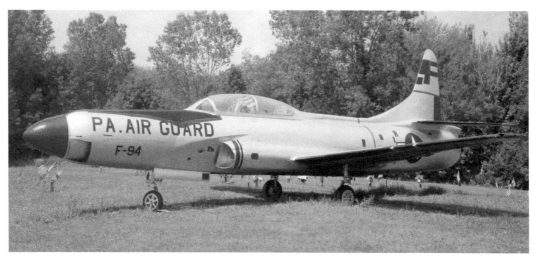

FIG 1.10 *F-94C Starfire fighter airplane*

History is replete with colorful examples from which to draw inspiration, from the ancient warriors of Assyria to the Polish Winged Hussars, or perhaps the F-94C Starfire fighter airplane, the SR-71 Blackbird spy plane, or the M-4 Sherman tank. Few things can be imagined that haven't cropped up somewhere in the history of humankind. A good starting point for discovering ancient cultures is *The Golden Bough* by Sir James George Frazer. A broad study of mythology and religion, it offers an interesting introduction to the very diverse subject of cultures and beliefs that humanity has at one time or another manifested. Best of all, it is freely available on Project Gutenberg (www.guten berg.org/ebooks/author/1241). Searching for the term "Arms and Armor" in Google books will also turn up a number of historical books on the subject of weapons and armor. It is well worth familiarizing yourself with how weapons and armor are really worn and used so that you can make your own creations believable. This brings us to the subject of proper reference materials.

Reference material

If there is one common failing I have noted in students over many years, it is a consistent lack of proper reference materials before they start a project. Every professional artist I know keeps a well-stocked library of reference images and objects that relate to their subject material. For example, an artist working on a dragon will do thorough studies of snakes, alligators, lizards, and such in an effort to make their creatures as realistic and believable as possible.

FIG 1.11 *Rattlesnake*

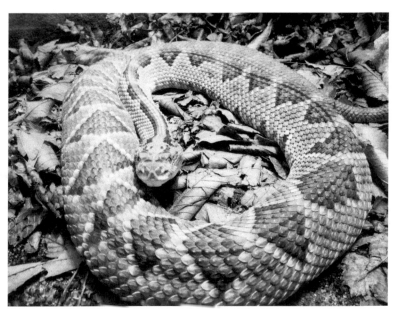

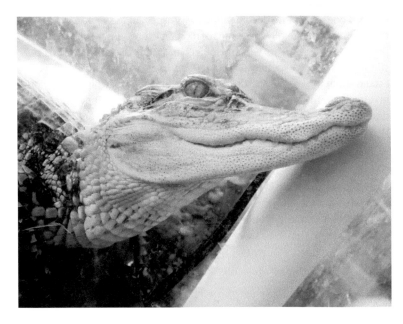

FIG 1.12 *Alligator*

A team working on a sports racing game will schedule visits to professional race car shops and will usually have a licensing agreement with specific teams to actually use the appropriate logos, insignia, drivers, and vehicles. A professional studio creating a modern military first-person shooter game will have real machine guns, clips, backpacks, and uniforms available to their artists so that they can actually have the item they are modeling on the desk in front of them as they do so. I guarantee you that a studio that focuses on a certain type of subject or upon a specific time period will know *everything* there is to know about the subject. If you were to submit a portfolio piece to them as part of a job interview, they will know immediately if you have not done your research and if you get any detail wrong. I have literally had clients look up the serial number on the airplanes I have made paintings of! If you are doing a medieval knight, then you better make sure that you get the armor and clothing right. Your warrior will need a long sleeved undershirt, a gambeson (quilted under armor padding), proper chainmail, and a surcoat to go on top, plus his sword belt, knight's spurs, cloak, and other accoutrement as befits his station, the type and look of which will vary depending upon exactly when and where the warrior is from and his rank. You will have to do proper research to get the details right – it is all about the details. Make a point of gathering as much reference material on your subject as possible before you start. It is the difference between making a good model and a great one that could get you a job. For example, if I wanted to model the historic M42 Duster anti-aircraft armored vehicle, I'd make a point of visiting every museum I could

that had one, and photo documenting every aspect of the vehicle from top to bottom, taking literally thousands of digital pictures. It is only through this process that you will learn what the object really looks like. There is no substitute for firsthand experience of something. I'd also read as many books as I could about the vehicle and do a very thorough job researching the various unit markings the tank used during its decades-long career. The result is a very thorough knowledge of the different variations of the vehicle and being able to create an extremely accurate 3D model.

The current standard for making a professional model isn't just making a perfect 3D version of the object. It is making a perfect object that has a personality and conveys a mood. It isn't just any object – it is a specific object, with a unique history, a distinctive look and emotional feel. It is not, for example, just modeling a tank; it is modeling a tank with the right unit markings; the dirt from where it has seen service; the long scrapes on the side armor skirts

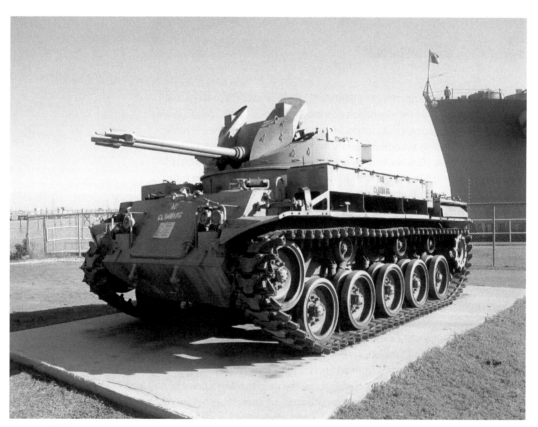

FIG 1.13 *M42 Duster armored vehicle. Note that vehicles put on display in museums usually do not look like they did when in service; wear and tear, bad paint jobs, and missing equipment are the norm in a lot of museums*

FIG 1.14 *M1A2 Abrams tank: Major Ellis Gales, U.S. Army, November 21, 2011 (111101-A-IQ400–502)*
Source: Retrieved from www.defenseimagery.mil/imagery.html#guid=ba8c0f09825a6c23bb6083619b449fd62f53f79b

where it has rubbed against buildings or obstacles; the shiny spot on the lip of the barrel where repeated firings of the gun have blasted the paint off; the boxes, crates, and gear that the crew has accumulated; the exhaust grime; the oil leaks; and so forth. You have to create a rich visual description full of detailed information that describes the history of the object. It is not enough to describe what the object is; you must also describe where it has been, who it has been with, and what it has been doing as well. This is true not just for objects but for any characters, monsters, environments, and architecture that you want to create. Everything should tell a story. Do that and you will be a successful modeler.

Copyright

There are a few things that everyone working in the digital arts field should know about copyright. The first is that you automatically have ownerships and copyright to the work that you create. It is a good idea to put the copyright symbol (©), the year of the first publication of the work, and the name of the

copyright holder somewhere on the work (e.g., © 2014 Greg Johnson) to make it obvious that the work being published is under copyright. The flip side of that equation is: don't infringe on anyone else's copyright. It simply isn't worth it. If a company even suspects that you have infringed upon their copyright, they will sue you into the ground – the operative idea being that they bankrupt you, whether the case against you has any merit or not. Most companies who engage in these types of lawsuits have far deeper pockets than the people they sue and can afford the money, time, and effort required, while you simply cannot. If a company that you work for thinks you have infringed upon someone else's copyright, they will not only fire you, they will spread the word of your infringement to the point where you will be unemployable in the entertainment industry. I have seen it happen. The entertainment industry is a fairly small one, where your reputation is priceless. Everyone knows everyone else or knows someone who does, and your reputation will precede you. It is critical to make sure that your reputation regarding copyright is spotless.

The easiest way to make sure your work isn't infringing upon anyone else's copyright is to always use your own original images whenever possible. Take a camera with you wherever you go. If you see something interesting – an old sewer cover, a rusty steel wall, an old brick wall, a section of sidewalk – simply take a snapshot of it for later use. There are a few general guidelines for taking images for reference or texture use. Usually it is best to take the images in diffuse light: light which has no obvious source. The best time of day for this is the hour immediately after sunrise or before sunset, often called the "golden hour" in photography. Otherwise any cloudy overcast day or taking the picture in the shade will suffice. The worst times are at noon or in strong light that creates dark shadows. It is more trouble than it is worth trying to paint out or fix bad lighting later on when you need the image for a texture or reference.

The rules are different for students, but don't cultivate bad habits. If you are a student, you have some limited usage rights to copyrighted work; but it is still a bad idea. While you are allowed to use copyrighted works for educational purposes, anything you create with someone else's images will be something that you can never enter into shows or even put into your portfolio. If you include the image in your portfolio and someone recognizes the other work, then that would raise questions about your integrity and probably end your job chances immediately. So even though it is technically allowed, it still isn't worth doing. It is far better to go ahead and just create and use your own images. Not only is it safer, but it gets you into using proper professional work habits, which you will need to develop anyway.

If you are desperate or simply cannot get the correct references you need, then you can buy reference images and textures from certain websites. Always check their terms of use to make sure that you are legal in the application

you are using them for. These are a few of the websites where you can obtain good imagery for money:

- www.3d.sk;
- http://dirtytexel.com;
- http://handpaintedtextures.com;
- http://gametextures.com.

There are a few places you can get legitimate texture references for free. One of the best is CGTextures (http://cgtextures.com). But again, always check the terms of usage on the website before you use the image. You can also use Google's advanced image search with the usage rights search restriction set to "free to use, share or modify, even commercially"; but I would be *extremely* careful about doing so and verify conclusively that the image you want to use is, indeed, free to use for that purpose. The penalties for being wrong are severe and this isn't something you want to take any chances with.

United States government work does not have any copyright restrictions on the reproduction, distribution, display of, or creation of derivative works from their images, and these make excellent reference or texture sources. You always need to thoroughly check and make sure, however, that there aren't any other copyright holders on the work before you use it. These are some of the best and safest places to get high-quality images from. Here are a few good sources for government images:

- NASA's image gallery (www.nasa.gov/multimedia/imagegallery/index. html);
- U.S. Department of Defense's image library (www.defenseimagery.mil/ index.jsp);
- National Oceanographic and Atmospheric Administration's photo library (www.photolib.noaa.gov/).

Publicizing your work

Once you get started making artwork, make a point of posting your work online in professional forums. Some of the best forums for posting ZBrush artwork are ZBrush Central (www.zbrushcentral.com), Polycount (www. polycount.com/forum), and Cghub (http://cghub.com). Once you post your work, make sure that you pay close attention to any constructive criticism that is offered and quickly fix any problems that people point out. This will help you to develop a reputation for working fast and taking critique well. These are two qualities that any company treasures in their employees, and if you can display those principles on these forums there is every chance that people will take notice. It may take a while and you will have to be persistent and

consistent in your work and online habits. Keep in mind that a lot of human resource people peruse these sites looking for talent, and having a good reputation on them will help you to get a job.

Make sure that you have a good portfolio website. Either purchase yourname. com or some variation thereof and host a simple gallery, or you can use a free hosting service such as Wix (www.wix.com/) to do so. Put only your best work on display. You will always be judged by the worst thing people see, so include only your strongest pieces. Include an Adobe PDF and/or Microsoft Word DOC of your current resumé and a valid email address where you can be contacted. Don't post your telephone number unless you really want everyone on the World Wide Web to have it! It also helps to have a business card. Even something as simple as your name, website gallery address, contact information, and job position or artistic title printed on a plain white card will suffice. A couple of good places to get your cards printed cheaply are VistaPrint (www. vistaprint.com) or Moo (http://us.moo.com). The website and business card don't have to be fancy – you're not trying to be a graphic designer or web designer. They just have to get people to your website where you can show your work off and let people know who you are and how to contact you.

The last thing to do is to get yourself out there. Go and talk to the companies and professionals in the entertainment industry. A good place to do this is at some of the various conferences that are held every year. Two I can wholeheartedly recommend are the Game Developer's Conference, or GDC (www. gdconf.com/), for video games and ACM SIGGRAPH (www.siggraph.org/) for everything else. Both are good conferences attended by thousands of people from the entertainment industry and are great places to meet people and make connections.

Resources

There are a lot of great ZBrush resources available for anyone interested in the program. The best place to start is Pixologic's own forum ZBrush Central (www.zbrushcentral.com). Before posting any questions, do a very thorough search through the forum's existing posts for the answer beforehand. Nothing irritates experienced posters like being asked a question for the hundredth time, so make sure that your question hasn't already been answered previously. Check out the tutorials section (www.zbrushcentral.com/forumdisplay. php?19-ZBrush-Tutorials-Forum); the ZBrush documentation website (http:// docs.pixologic.com) is also a great place to learn what each button in the program does. Another great Pixologic resource is the ZClassroom site (http:// pixologic.com/zclassroom/homeroom) for more learning resources. Once you have come to grips with the program by completing this book, these are the places to go to further your knowledge of ZBrush and to expand your

repertoire of techniques. For general 3D resources, the Polycount tutorial wiki is a good place to go (http://wiki.polycount.com/CategoryTutorials) and CGSociety has a lot of useful material as well (http://forums.cgsociety.org).

You should also make sure that you have a good book on human anatomy. There are plenty out there to choose from, so just browse around and find one that suits your taste. I've found *Dynamic Anatomy* by Hogarth to be invaluable, but there are a lot of good anatomy books out there. Pick up a book or two on animal anatomy as well for your creature designs. *The Human Figure in Motion* and *Animals in Motion* by Eadweard Muybridge are great resources for animation studies. Of particular use are the Citadel guides to painting miniatures, especially the older versions of the books, and a lot of plastic model and diorama magazines have great tips for texturing characters, objects, and environments. The techniques they include are easily adapted to the digital realm and will greatly improve your texturing skills.

Learning process

The learning process is a messy one. You will learn from your mistakes, so don't be afraid or upset when you make them. It happens. Simply reflect upon what you've done and figure out a better way of doing it the next time you try. This is how learning happens. If you find yourself getting frustrated or upset, take a break. Get up and walk around or do something else for a bit so that you can come back fresh and reinvigorated, ready to learn more. There is a lot to learn in this program. It is extremely complex and deep and it will take you a couple of weeks to become comfortable with it. I know that when I am working on a piece of artwork, it is usually very beneficial to reach a stopping point and walk away from it for a while so I can come back after a day or two and look at the piece with a fresh eye. Normally I can spot several flaws I had missed earlier and fix them. The same is true when learning new software. It is like the old trick of looking at your artwork in a mirror to get a new perspective on it. It forces you to re-evaluate your work afresh and to gain further insight. Don't let the mammoth amount of material to absorb make you miserable. Take it at your own pace and enjoy the process of learning. Making sure that you enjoy the process will ensure you learn more from it. Now, let's get started!

Interface

Buying and installing ZBrush

The first thing you will have to do is to buy a copy of ZBrush from Pixologic (www.pixologic.com) and install it on your computer. ZBrush works on either Windows or Macintosh machines and requires at least 2GB of RAM, 16GB of free space on the hard drive, and a minimum monitor resolution of 1280 × 1024 pixels. You can purchase ZBrush through Pixologic's online store (http://store.pixologic.com) or via one of their resellers. If you are currently enrolled as a student, you might qualify for a reduced price educational license, so make sure to check that out. The installation guide can be found in the ZBrush Documentation (http://docs.pixologic.com). Make sure you follow the instructions thoroughly and contact Pixologic Support (https://support.pixologic.com) if you have any problems that you cannot figure out.

It also helps to have a separate image editing software package such as Adobe Photoshop (www.adobe.com) or the GNU Image Manipulation Program (www.gimp.org), GIMP for short. A standard 3D modeling package such as Maya or 3dsMax (both available from www.autodesk.com) or even Blender (www.blender.org) would also help but isn't required.

Interface layout

Menus

The interface in ZBrush is very complex. There are literally hundreds of different buttons, sliders, options, and features for you to learn about. The good news is that most of these buttons really aren't critical to using the program. A lot of the buttons have very specific functions and are used only in rare circumstances, so you won't have to memorize a list of a thousand buttons to get the program to work. That said, ZBrush has a rather difficult and unusual

interface and it will take you around two weeks of solid practice before you get really comfortable with it. ZBrush is very sensitive to your workflow (the order in which commands occur), so make sure in upcoming chapters that you pay close attention to the process workflow of each chapter.

This is a rather dry and technical chapter. After all, we're just going through all of the various interface items and menus in the program! Feel free to jump ahead to the next chapter and try working with the program as you go through this chapter. You can refer back to this chapter whenever you get confused about any of the interface elements or features.

Every element in ZBrush is contained within the ZBrush window. While you cannot move things outside of this main window, you have a great deal of freedom moving the interface elements around within it. If you somehow mess up the interface and want to reset it back to default, go to the *Preferences* button on the top shelf, click it with the left mouse button (LMB); in the pull-down menu that opens, click the *Config* button, then click *Restore Standard UI*.

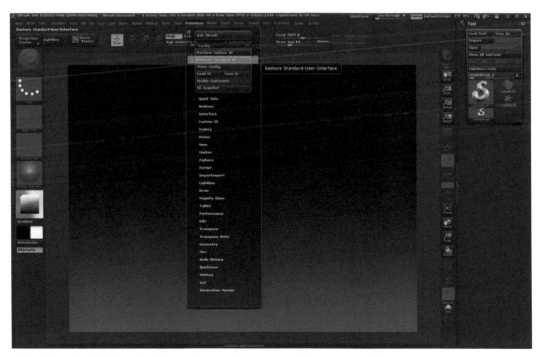

FIG 2.1 Restore Standard UI *button location*

Conventions and mouse buttons

In future, I will use an abbreviated format for this sort of instruction, as in: *Preferences > Config > Restore Standard UI* or *Preferences.Config.Restore Standard UI*, rather than go through the whole "click on this", then "this", then "this procedure". In a similar vein, when I say click, I mean specifically left mouse click (LMB for short). If you need to right (RMB) or middle mouse click (MMB) on something, I will specify that exactly using the abbreviations RMB or MMB. When I refer to a key on the keyboard you need to press, I will place it in italics like this: *T*. Similarly, any element that refers to a ZBrush function or command will be also be placed in *italics*.

Controls

The interface controls are composed of many different types of elements for adjusting ZBrush, but almost all of them fall into one of the following categories.

Buttons. Whether text or an icon, buttons comprise the vast majority of interface elements in ZBrush. Buttons often provide access to drop-down or expandable menus which open up menus with more buttons and controls. The buttons in the palette menu near the top of the screen, such as *Alpha* or *Document*, are examples of this sort of button.

Graphs and curves. Sometimes you will come across a box that gives you access to a graph or curve. To use these, click and drag a point to move it around, click on the curve to place a new point, and drag a point off the side of the graph to delete it. You won't see these very often and I will explain this again when you need it later, so don't worry about it very much for now.

FIG 2.2 *Mouse buttons and abbreviations*

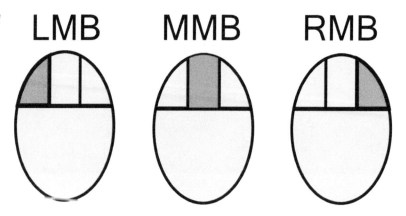

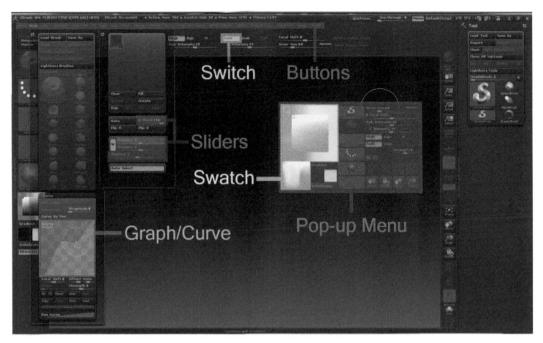

FIG 2.3 *ZBrush controls*

Pop-up menus. There are a few tools that will present you with a pop up menu or interface item. A simple example of this is the *spacebar* shortcut. Pressing and holding down the spacebar while in the painting area will bring up an interface centered on the current location of the mouse that includes the most useful tools and controls for painting and sculpting. You can then click on any of these buttons or swatches to access these items quickly.

Sliders. Sliders allow you to change a numeric value by clicking and dragging a bar along a line or by clicking on the slider and entering a number on the keyboard, then pressing *Enter*. If you change your mind while typing the new number, simply left mouse click (LMB) outside of the highlighted slider to ignore the new value.

Swatches. There are a few areas, such as the color menu, where ZBrush uses a swatch for the interface. To pick a color, simply click the outside ring to select the hue and then click in the inside box to set the saturation and value you want.

Switches. Some buttons don't bring up additional menus but serve as simple on/off buttons. These will highlight in orange when they are active and become a dark gray when turned off.

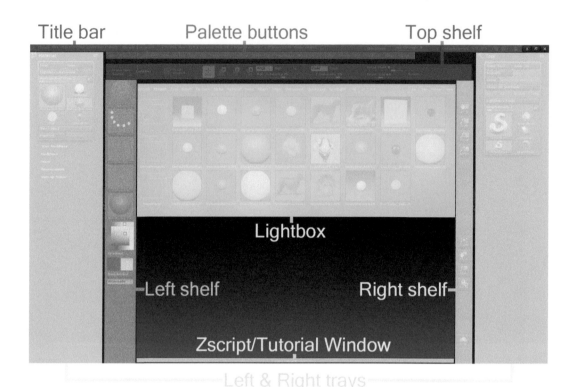

Title bar Palette buttons Top shelf

Lightbox

Left shelf Right shelf

Zscript/Tutorial Window

Left & Right trays

FIG 2.4 *ZBrush interface*

Interface

The interface is comprised of several different groups or areas, each with its own distinct functions.

Title bar

At the very topmost portion of the screen is a thin display and menu bar called the title bar. It contains information about ZBrush and your memory usage. On the right side of the title bar you can find a set of handy buttons for creating a "quicksave", adjusting the overall transparency of the ZBrush window, a "Menu" visibility menu, a button to run a default script, and a suite of buttons for quickly changing the look and layout of the interface.

Palette buttons

The palette buttons are at the top of the screen just underneath the title bar. This is where you can access the main menu items for ZBrush. Each palette item is listed as text In alphabetical order going across the screen from loft to

right. Simply left mouse click (LMB) a palette item to access that pull down-menu list.

Palettes are often divided into various sub-palettes in order to place similar features together and these, in turn, are sometimes divided into groups called "UI groups". Simply clicking on the name of the sub-palette or UI group will open it up. ZBrush normally only allows one sub-palette or UI group to be open at a time, but you can open another one by *SHIFT + clicking* the name of the other sub-palette/UI group or by changing the preference for how this feature works by toggling off the *Preferences > Interface > Palettes > Open One Subpalette* and *Preferences > Interface > UI Groups > AutoClose UI Groups* buttons. ZBrush won't remember any of your changes to preferences the next time unless you also save out the preference settings by clicking *Preferences > Config > Store Config* or pressing the shortcut for this command *SHIFT + CTRL + I*.

Top shelf

The top shelf holds some of the most commonly used and important buttons in the program. Buttons and sliders for moving, rotating, and scaling items, as well as your painting and sculpting controls, are located here, including a few important tools. You can press the *TAB* button to toggle the visibility of the shelves.

FIG 2.5 Open One Subpalette, AutoClose UI Groups, *and* Store Config *button locations*

Left shelf

This holds important menu items for controlling your paint brushes and colors.

Right shelf

The right shelf has the menu items for controlling your painting canvas. Tools for zooming in and moving about the canvas, as well as some uniquely 3D modes such as *Persp*, *Solo*, and *Floor*, are located here.

LightBox

The *LightBox* provides a simple interface for accessing your files, although it has the annoying habit of taking up a large section of the interface on startup. Simply click the *LightBox* button in the top left corner of the ZBrush interface or tap the *comma* key on the keyboard to toggle this menu on or off.

Canvas or document area

This is the area where you do your painting and sculpting; it occupies the majority of the center screen. You can adjust the color and gradient of the background. Click on the *Document* button in the Palette menu strip at the top of the page. Look through the pull-down menu until you see the *Back* swatch and the *Range*, *Center*, and *Rate* sliders. You can adjust the sliders to change the gradient and if you click and hold down the LMB while on the *Back* swatch, the cursor will change to a *Pick* function and let you move around the interface and choose a new background color by selecting it. If you ever mess something up in ZBrush and need to reset everything, just remember that you can always go to the *Preferences* pull-down menu and select the *Init ZBrush* button. It should reset everything back to ZBrush's startup set up.

Left and right trays

These two trays are holding places for the palette menu drop-down menus. By default, the right tray has the *Tool* palette open and the left tray is closed. The trays can be opened and closed by clicking on the divider icons for each tray.

ZScript/tutorial window

This tray is used for ZScripts (programming for ZBrush) and tutorial purposes only.

You can scroll up and down within the tray by clicking and dragging any blank space in the tray. To place a palette menu into a tray, first open the palette menu you want. Once the palette is open, find the circular palette icon (it should be the icon in the upper left corner of the menu), click on it, and drag it to the tray you want the menu to be in or simply click the icon once to automatically move it into a tray. Clicking the palette icon for a palette that is inside one of the trays will send it back to the palette menu bar and remove it from that tray.

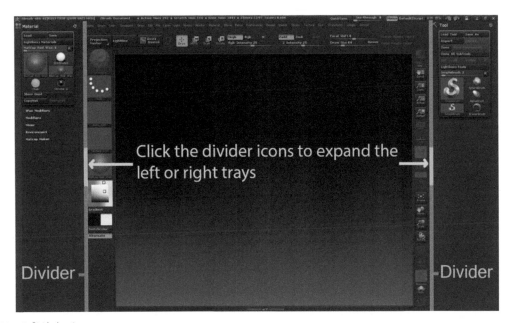

FIG 2.6 *Divider locations*

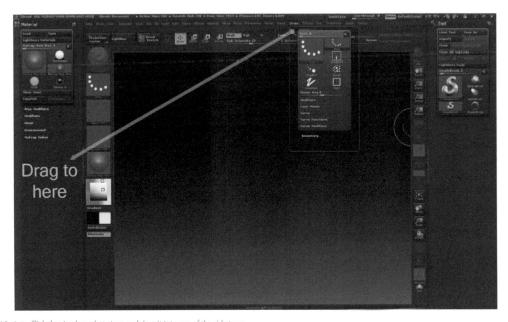

FIG 2.7 *Click the circular palette icon and drag it into one of the side trays*

Help and shortcuts

Getting help in ZBrush is very easy. Simply place your mouse cursor on top of a button without clicking it. A dialogue box will pop up with the full name of that button and the shortcut for quickly accessing it. If you also press and hold down the *CTRL* key while doing this, ZBrush will give you a full description of what that button does. This should work on every button in ZBrush and is a fast way of figuring out what everything is.

ZBrush has a shortcut available for many of the most commonly used tools. A few examples are the *spacebar* shortcut to bring up the painting and sculpting tools and the *comma* button to toggle the LightBox on and off.

Concepts

There are a handful of critical concepts that you must familiarize yourself with before starting to use ZBrush productively.

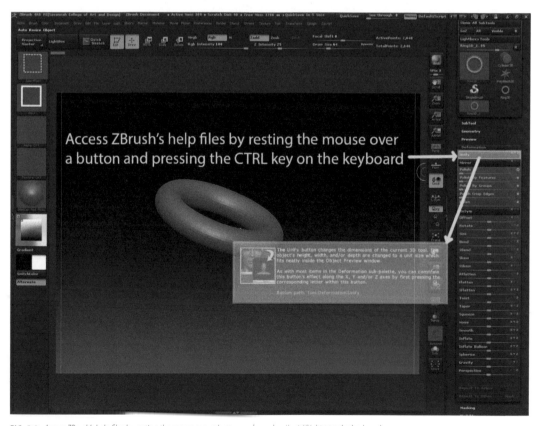

FIG 2.8 *Access ZBrush's help files by resting the mouse over a button and pressing the CTRL key on the keyboard*

2D, 3D, and 2.5D, as well as bit depth

ZBrush is quite an odd duck in the software world since it is one of the few programs capable of working in 2D and 3D at the same time. A 2D image is a flat image composed of just the width (X) and height (Y) dimensions. A 3D image adds the dimension of depth (Z) to the mix.

Pixel

A regular 2D program works around a basal unit called the pixel. A pixel is simply one of the square dots that make up a digital image on your screen. You can see them individually if you zoom in enough to a digital image or if you look hard enough at your monitor (especially along diagonal edges). A computer image's resolution is measured in the amount of pixels wide and tall that it has. Digital images are also called raster images. Another element in a digital image's resolution is the "bit depth" of a picture. This is a value measured in binary bits that tells you how many colors a pixel in the image can represent (but remember that one pixel can only be one color at any given time). For example a 2-bit image consists of strictly black and white. In an 8-bit image, each pixel can be one of up to 256 levels of gray from a value of 0, or black, up to 255, or white. A 24-bit image is what is normally called a true color image. In a true color image the 24 bits are divided into three 8-bit channels – one channel each for red, green, and blue. Each channel holds 256 levels of that specific color ranging from 0 to 255, which when combined together gives a possible color range of some 16.7 million possible colors. Most digital images are of this type though you will occasionally see reference to RGBA (red, green, blue, alpha), which adds a separate alpha (A) or mask to the standard RGB. There are a lot of other variations as well, from 48-bit deep color images with billions of colors to various combinations of additional alpha channels, to even different color spaces such as CMYK (cyan, magenta, yellow, and black) for printing. But these fall into the realm of image editing software and are largely outside the scope of this book.

Pixol

The trick to ZBrush is that it adds the elements of depth, material, and orientation to the standard pixel. ZBrush calls this a pixol. This feature enables the use of lighting, materials, and a host of other elements not found in most image editing software packages. This is what Pixologic means by the 2.5D image. Pixols are a unique feature of the ZBrush canvas and are stored only in special ZBrush files called ZBR files. To save your ZBrush canvas with its pixol information go to *Document > Save* and save out a ZBR file of the document you are working on. You can use *Document > Save As* to save the ZBR file with a new name. Note that this *does not* save any 3D models you

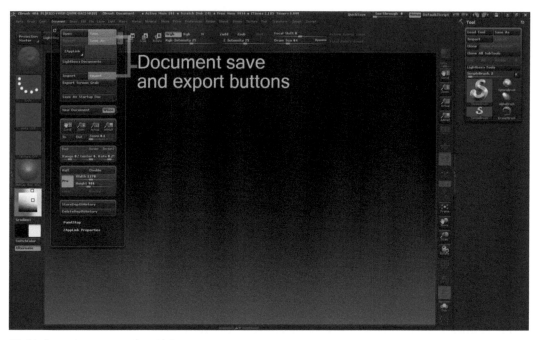

FIG 2.9 *Document save, save as, and export buttons*

have been working on! It just saves the image document on the canvas with its pixol information intact. You can save out just the pixel information using *Document > Export* to create lossless Photoshop PSD-, BMP-, or TIF-type files or compressed JPG and PNG files. I suggest using uncompressed file types for your artwork. Using an image compression algorithm on your artwork can lead to data loss and the images derezzing or losing quality.

Working with the canvas and documents

Now that you've got a few of the basic ideas down, let's dive right in and draw something. On the right side of the screen you should see the *Tool* menu. If not, then you can open up the *Tool* menu under the *Palette bar* at the top and drag it using the *Palette icon* to the *Right Tray*, or you could just re-initialize ZBrush by going to *Preferences > Init ZBrush*.

Under the tool menu you will see a golden S-shaped icon for the *SimpleBrush*. If you click on that it will open up a pop-up menu that will let you select from a variety of brushes. I'm going to choose the *Ring* under the *3D Meshes* section.

ZBrush will remember the most commonly chosen brushes and keep them in the *Quick Pick* section of the brushes menu as you continue to work.

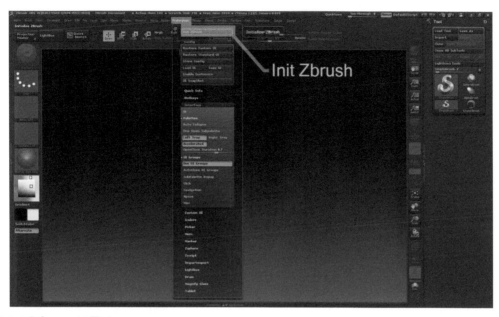

FIG 2.10 *Preferences > Init ZBrush*

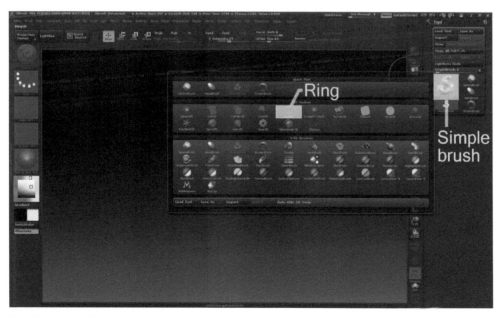

FIG 2.11 *Simple brush and ring*

Quick pick

FIG 2.12 *Quick pick brushes*

Now click and drag on the canvas. That should create a nice reddish-colored ring. Go around the canvas and create as many more rings as you like. Fun, but clicking and dragging all the time gets tedious fast. In the left tray, find the hollow white square icon labeled *DragRect*. This is the current stroke for the ring brush. Click on it and choose one of the other strokes – I'm choosing *Color Spray*. Now try drawing on the canvas. You get a completely different result!

Try out a few of the other strokes and see what happens. Now look in the left tray and find the red sphere icon labeled *MatCap Red Wax*. Click on this and choose a different material, like *SketchShaded* under the *MatCap* section. Try painting some more.

Now look underneath the Material chooser and find the *Current Color* swatch. Use it to pick a new color; you can even select a color from the canvas by clicking and holding the LMB down on the color swatch and dragging to select a new color from anywhere on the screen. This trick also works for selecting materials from the canvas if you click instead on the materials icon!

Save your document under *Document > Save*. Make sure you remember where on your computer system you are saving your files to!

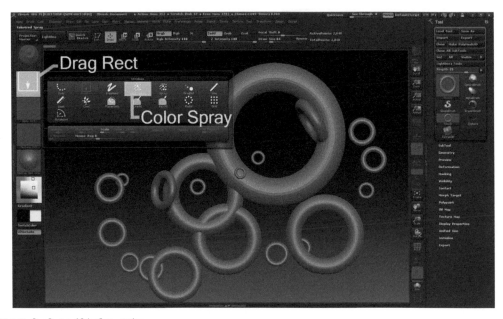

FIG 2.13 DragRect *and* Color Spray *strokes*

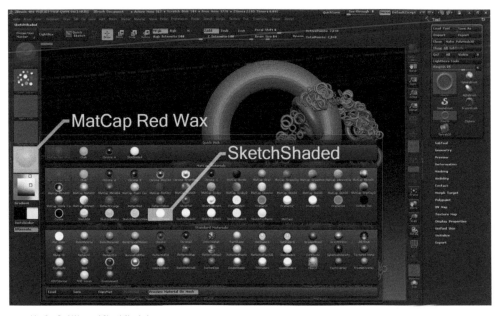

FIG 2.14 *MatCap Red Wax and SketchShaded*

FIG 2.15 *Current color swatch*

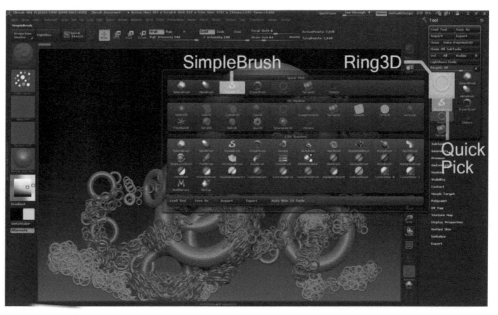

FIG 2.16 *Ring3D, SimpleBrush, and QuickPick*

Let's switch our brush back to the *SimpleBrush* by clicking on the *Ring3D* icon under the *Tool* menu in the right tray and selecting *SimpleBrush* from the *Brush* pop-up menu, or you can just click on the *SimpleBrush* icon in the *Quick Pick* area.

Now choose a stroke from the left hand tray (I'm using *FreeHand*), a new material, and color.

Under the stroke selector you will find the *Alpha* pop-up menu. This is a way to control the shape of the brush, so click on it and choose an alpha (I chose Alpha 10, the star-shaped one). Try painting with it. You should get a completely new result as the brush affects the previous work you did on the canvas, replacing the color, material, and sculpting the surface.

Now try selecting a texture from the texture selector, which is just above the material selector. Click on the blank gray square that says *Texture Off* and choose a new texture from the pop-up menu (I'm using *Texture 25*). When you use it, notice how the texture over rides your color selection. You can set texture back to *Texture Off* by selecting that option in the texture menu.

Under the color swatch you will find two separate square color patches. These are the main color and alternate color swatches. You can set each one by clicking the color square; then choose a color in the main color selector. If you tap

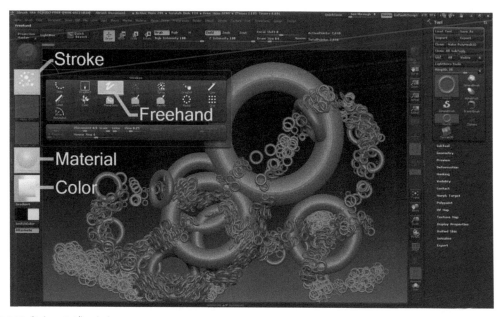

FIG 2.17 *Stroke, material, and color*

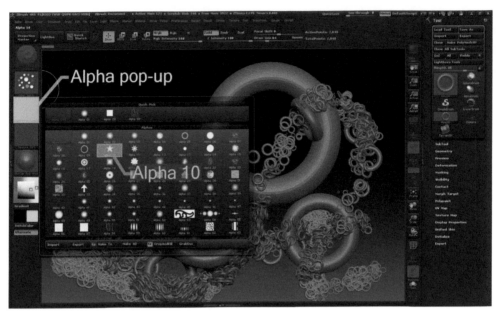

FIG 2.18 *Alpha*

the *V* key on the keyboard or press the *SwitchColor* button under the color swatches, you can switch back and forth between the two color swatches.

There a few other controls for painting you need to know about. If you look at the top shelf you can find the *Draw Size* slider. Use this to control the size of your paint brush. You can also use the *[* and *]* keyboard shortcuts to decrease or increase the size of you brush quickly while you work. On top of the *Draw Size* slider you can find the *Focal Shift* control. This controls the amount of falloff the brush tip has. Try it out while you paint to get a full understanding of what it is doing with the different 2D paint brushes. To the left of these controls you can find the *Rgb Intensity* slider, which controls the amount of color being deposited by the brush. Above the *Rgb Intensity* slider are buttons for selecting the mode to paint in. Select either *Mrgb* to paint in material and color, *Rgb* for painting with color only, or *M* for changing just the material of the canvas. Be aware that *M* does *not have any* falloff between materials. It is an all or nothing affair when it comes to materials; they simply don't blend together. If you press the *spacebar* key you will bring up a pop-up menu for accessing these and other essential controls quickly while you are working.

The last essential piece of information you need to work in 2D within ZBrush is how to use the *Move*, *Scale*, and *Rotate* transform tools to affect your brush strokes.

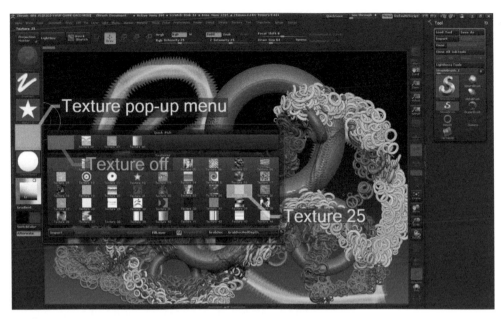

FIG 2.19 *Textures*

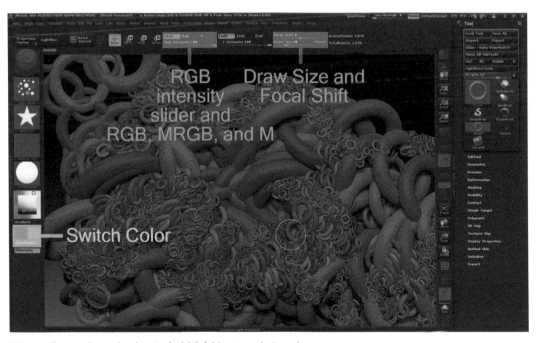

FIG 2.20 *Alternate color swatches, draw size, focal shift, Rgb Intensity, and paint modes*

Simply draw a stroke on the canvas. I'm going to use the *Ring3D* brush and the *DragRect* stroke that we used in our earlier example. In the top shelf, locate and press the *Move* button or press the *W* shortcut key to automatically switch to move mode. A colorful icon consisting of three intersecting circles will appear over your last brush stroke. Clicking the different parts of the move tool will move your stroke around the canvas in various ways. The different colors on the tool indicate which axis clicking and dragging on that spot will move the stroke: red for the X plane, green for Y, and blue for the Z plane. Clicking and dragging on the yellow intersection of the green and red circle will move the last brush stroke in the Z axis, the cyan intersection moves along the X axis, and the magenta section along the Y. If you click and drag using the empty center space, you will move the stroke along the surface defined by your painting. Once you get used to using the move tool, try out the scale (*E* shortcut) and rotate (*R* shortcut) tools as well. They use the same tool interface as move but have dramatically different effects. You can quickly switch back to the standard painting mode by either clicking the *Draw* icon in the top shelf or pressing the *Q* key.

If you mess up while you are working, you can easily fix things by going to *Edit > Undo* in the palette bar or simply use the keyboard shortcut of *CTRL + Z*. You will also find the "Redo" button immediately next to the undo button. The redo shortcut is *CTRL + SHIFT + Z*.

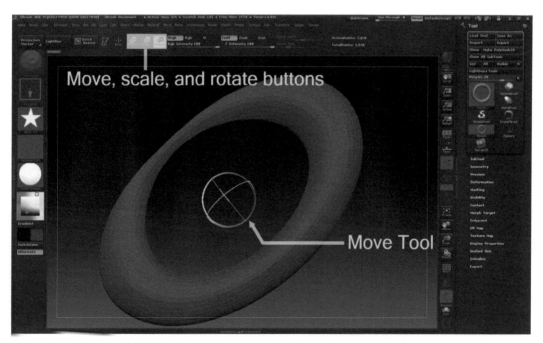

Move, scale, and rotate buttons

Move Tool

FIG 2.21 *Move, scale, and rotate buttons and tool*

Saving your work

Now is a good time to save your work again, *Document > Save*; just be aware that ZBrush is the only program capable of opening up the resulting ZBR file. If you want to edit this image further using a different software package, you will have to export it as an image file using *Document > Export* to save out a standard raster file type such as BMP (BitMap). If you'd rather not save this particular image, then simply go to *Document > New Document*.

Organizing files and paths

One last little note to add. Make sure that you have a specific place that you are saving your files into. You probably don't want the files you create cluttering up your ZBrush install folder! Being a bit organized will help you immensely further on down the line, so create a folder to save things into. You can call it "ZBrush_Files" or something else that clearly labels it as a holder for your ZBrush files. When you create the folder you will need to be able to find it later on, so it is important to have an understanding of how paths work on computer systems. A path is simply a guide to a specific location on a computer. There are two flavors of paths used: global and local paths.

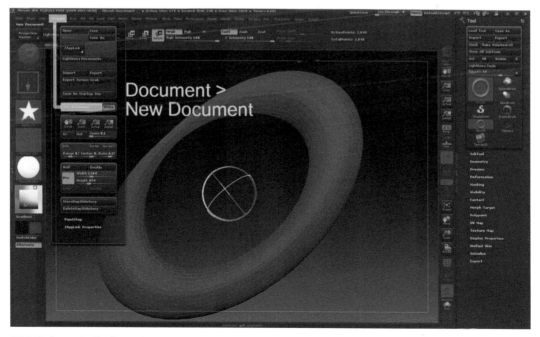

FIG 2.22 *Document > New Document*

A global path starts from one of the lettered drives on your computer like the *C:* drive. After that you have the names of the folders found on the C drive and the sub-folders found inside them each separated by a backslash. So a typical example might look something like *C:\ZBrush_Files\Tools*; this means the Tools folder located inside the ZBrush_Files folder on the C: drive of your computer. Another way to get around on a computer is to use a local path which tells the computer the path from one place to another without using the drive name, just the relative locations of the different folders.

Additional help

It is always useful to have more resources available. Make sure you look through the official ZBrush documentation (http://docs.pixologic.com) and read through the *ZBrush Getting Started Guide* (www.pixologic.com/docs/index.php/Main_Page). There is a tremendous amount of support available online through the ZBrush forum (www.zbrushcentral.com), and the tutorial section there is extremely useful (www.zbrushcentral.com/forumdisplay.php?19), although you should always make sure the tutorial you are reading isn't for a previous version of the software. Pixologic also hosts a ZBrush classroom site (www.pixologic.com/zclassroom) to provide additional instruction. Make sure you avail yourself of these additional resources, but don't let the amount of information overwhelm you. Everything you need is in this book – but it is nice to have more resources available.

The Basics

Working with 3D ZTools

Up to now we've been using ZBrush as more of a painting package. Now it's time to switch gears and start working with 3D. First we need to reinitialize ZBrush so we can start fresh. Click *Preferences > Init Zbrush* from the top menu bar, or if you are just now starting ZBrush press the *comma* key on the

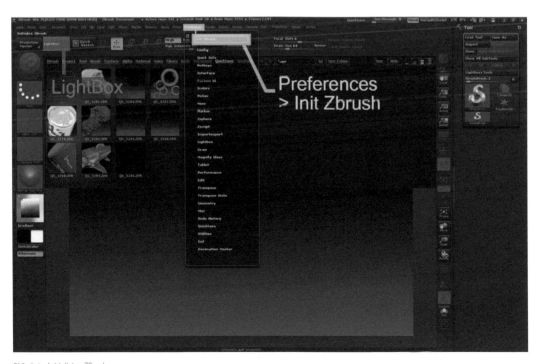

FIG 3.1 *Initializing ZBrush*

keyboard or the *LightBox* button in the upper left hand corner of the interface to turn off the large LightBox interface that pops up on start up.

In the right tray under the *Tool* menu, click the *SimpleBrush* icon, the largest icon in the top left corner of the icon list, and pick *Cube3D* from the pop-up menu.

Click and drag on the center of the canvas to create a large cube. The very next thing you must do is press the *T* key or click the *Edit* button on the top shelf.

This activates ZBrush's 3D mode with the cube as the current 3D object. Now, if you right mouse button (RMB) click and drag on the canvas area, you will rotate the cube around! If instead you get a new cube drawn on the canvas, it's because you didn't press the *T* key or *Edit* button immediately after drawing the cube. That's OK. Just reinitialize ZBrush by clicking *Preferences > Init Zbrush* from the top menu bar and try again. When you rotate the cube around, if you also press the *SHIFT* key it will lock the rotation to 90-degree angles. If you want to move the object within the canvas, press the *ALT* button and right mouse (RMB) click and drag the mouse on the canvas (*ALT + drag*). If you instead press the *CTRL* button and RMB click and drag, you will scale the object. If you need to delete an object from the canvas, click on the *Layer* button on the top menu bar and then the *Clear* button in the resulting pull-down

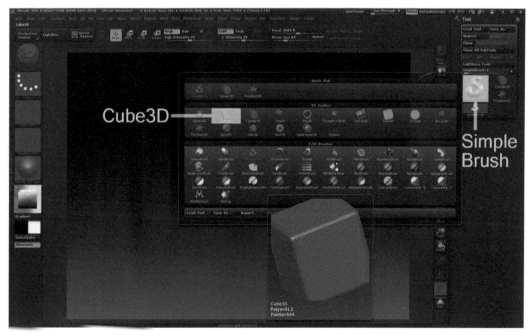

FIG 3.2 *Cube3D brush*

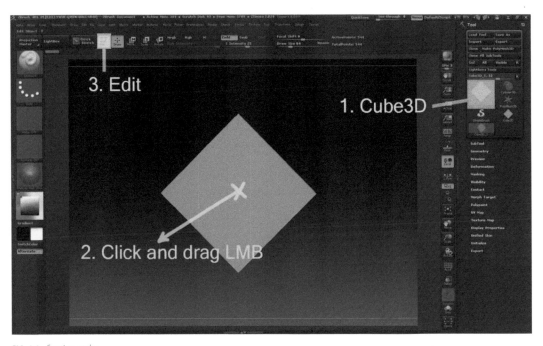

FIG 3.3 *Creating a cube*

menu to get rid of whatever objects are currently drawn on the canvas. Deleting an object from the canvas does *not* remove that object from the Tool menu or erase it from the program. You can always draw the same object onto the canvas again if you desire. It merely wipes the canvas clean.

An alternate way of doing the same transformations is to use the LMB (left mouse button) and click and drag on any blank area of canvas to rotate around as well. If you want to move the object within the canvas, you can also press the *ALT* button and left mouse click and drag the pointer on the canvas (*ALT + drag*). You can also press ALT+RMB, then release ALT (continuing to hold RMB) to drag and scale the object.

Of course, the mouse shortcuts aren't the only way to access these transformations. You can also rotate the object by clicking and dragging on the *Rotate* icon located on the bottom half of the right shelf. You will find buttons for *Scale* and *Move* immediately above the *Rotate* button which work the same way. You can also simply press the *F* key to frame and center the object on your canvas or press the *Frame* button on the right shelf, which is right above where the move button is located. As you can see, ZBrush usually provides

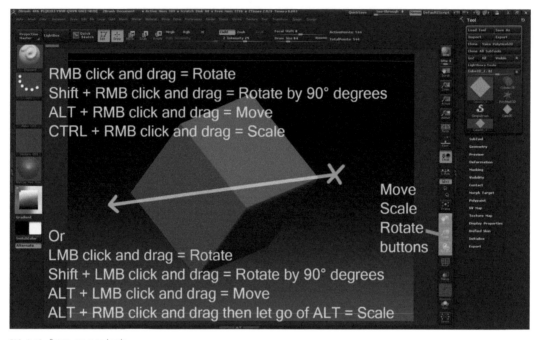

FIG 3.4A *Rotate, move, and scale*

several ways to do anything you might want. It is all about finding a workflow that is comfortable for you.

Let's take a moment and finish going up the right shelf button list while we are there. Above the frame button you can find the icons for locking the object's rotation to a specific axis or allowing it to rotate freely around all three axes. The *L.Sym* or *Local Symmetry* button is useful once you have multiple objects in the scene to preserve each object's unique symmetry when sculpting (we'll talk about this more later). Having the *Local* button active means that transformations (move, scale, and rotate) are centered on the last point clicked on the object rather than the object's actual center. To try it out, just click on the cube, then rotate it with this button on. Now turn the button off and rotate the object. See the difference! If ZBrush pops up a warning about enabling sculpting, just ignore it; we will get to sculpting soon. The *Floor* button (*SHIFT + P* shortcut) activates a transparent plane that lets you see that the XZ plane exists within ZBrush. The Y axis is perpendicular to this plane and defines the up direction within ZBrush. It is a very good idea to make sure that your object always has its up direction aligned to the Y axis and its front aligned along the Z axis. This is so that if you ever take the model into another program it won't be facing the wrong direction and is a good work habit to get into.

ZBrush, like every other 3D program, uses a Cartesian coordinate system to define 3D space. If you've ever taken a geometry class and worked with a grid system, then you have seen this system before and might recognize it. The basic idea is that the X axis defines the right and left directions, Y up and down, and Z backwards and forwards. With the *Floor* button turned on you can faintly see the lines showing the X axis in red, Y in green, and Z in blue at the origin or center point. This is really important information if you are working with another 3D package such as Maya, 3dsMax, or Blender; but if you are strictly staying inside of ZBrush then it probably won't matter much to you. In almost all modern 3D programs these axes are color-coded for easy identification: the X axis in red, the Y axis in green, and the Z axis in blue. To see a visual representation of these axes in ZBrush, you can turn the *Floor* button on. Click on the X, Y, and Z characters inside the *Floor* button to display the coordinate grids. These characters are only visible when the *Floor* button is turned off. The colored grid is perpendicular to the axis it represents – in other words, the axis goes straight up and out from the grid. If you turn all three characters on (X, Y, and Z), you will have all three coordinate grids displayed as in the example image below.

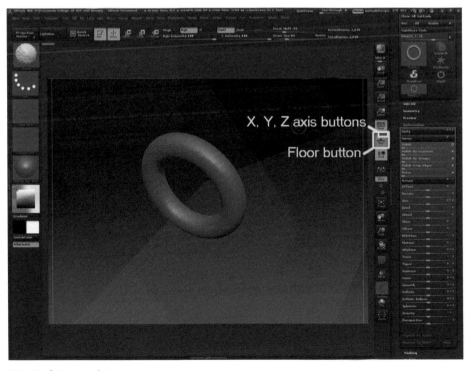

FIG 3.4B *Cartesian coordinate system*

Just above the *Floor* button is the *Persp* button, which actives perspective camera mode in ZBrush (*P* shortcut). By default, ZBrush uses an orthographic camera, which is why when you turned on the floor the grid lines didn't converge. If you look at the floor grid with the *Persp* button on you will notice the grid lines converging towards the horizon line. While it is better to work in orthographic mode, you will most likely want to turn on perspective when it is time to render images of your final product. The *AAHalf* button shrinks the canvas view to half size while the *Actual* button restores it to full size. The *AAHalf* button is there so an artist can check the image at something more like print size without having to go through the imprecise process of zooming. The *Zoom button* does exactly that but it doesn't affect the size of the object; it is zooming into the canvas instead. Zoom in enough and you will see the individual pixels that make up the image document.

Inside the *Document* menu found in the top shelf you will find the *Width* and *Height* sliders, which control the dimensions of the image document you are working on. If you are working on an image that will eventually get printed, for example, then you will have to work on a much bigger document size than if you are going to video. It is always important to know where your artwork will end up. If you are going to print, then you need an image resolution of somewhere between 150 and 300 dpi (dots per inch), so if you want an 8 × 10 inch picture, you will need an image resolution of 2400 × 3000 pixels.

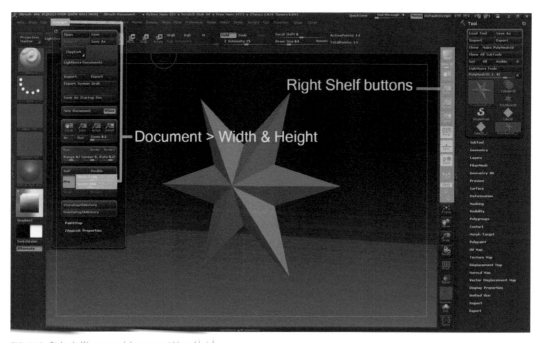

FIG 3.5A *Right shelf buttons and document width and height*

Video, on the other hand, has a much lower resolution of 1920 × 1080 pixels for high-definition television (HDTV).

The *Scroll* button moves the canvas around. The *SPix* slider lets you adjust the quality of the anti-aliasing for your images. Just be aware that higher values mean that it will take longer to render your high-quality images. Set the *Spix* value to 0 to turn off anti-aliasing. Anti-aliasing in digital images is the process of adding a slight blurring effect to diagonal lines to make them appear smoother and less jagged.

Press the *BPR* button to create a *Best Preview Render* of what you are working on. It is a quick and simple of way of creating a nice render. Once the render is done, if you want to save it just go to *Document > Export* and save out an image file. *Document > Export* will bring up an export image window to let you choose where to save the file and pick what file format you'd like to use. Make sure you save your files where you can find them again on your computer! Use the *Save as type* pull-down menu to choose your file format. The default Photoshop PSD format is a good choice if you have an image editor on your system; BMP and TIF are good choices for archival images or images you want to work on later since they're widely supported formats, whereas JPG and PNG are web formats that will compress your image and I don't suggest using them unless you want to post the image directly to the internet.

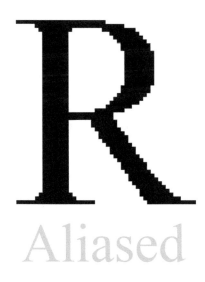

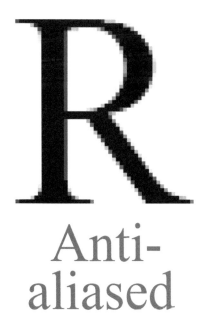

FIG 3.5B *Aliased and anti-aliased letters*

47

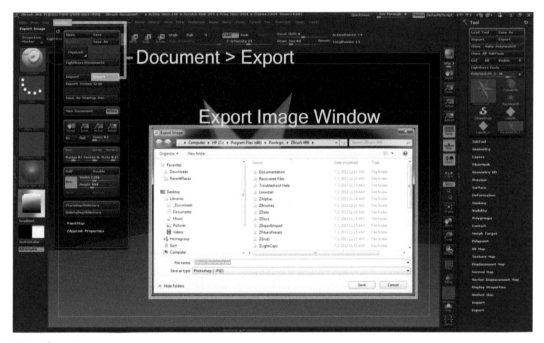

FIG 3.6 *Document export*

At the bottom of the right shelf you will find a set of buttons which control object transparency and isolation for working with multiple objects. We will save talking about these for later when we actually start working with multiple objects.

Let's start a new document: *Document > New Document*. Go to the *Tool* menu, click the top left tool icon, and select Cylinder3D from the pop-up menu. Now draw the cylinder upon the canvas, then press *T* on the keyboard to enter into edit mode. Look down the *Tool* menu until you find the *Initialize* menu and click on it. In this menu you adjust the shape of the cylinder. Play with the slider values and watch what happens to the cylinder on screen. I'm leaving the X, Y, and Z sizes at 100 and giving mine an *Inner Radius* of 50, *HDivide* of 10, *VDivide* of 4, and set the *Taper* to 50. To sculpt this object we need to convert it to an editable 3D object by pressing the *Make PolyMesh 3D* button in the *Tool* menu. If you have trouble using the sliders to set specific numbers, remember that you can click on the numbers themselves and set them using the keyboard. You can even use the *TAB* key on the keyboard to cycle between the numeric slider values.

Once that's done we can learn how to sculpt the object and transform it using the transpose tool. In the top shelf, click on the *Move* icon (*W* shortcut). You should see a small complicated icon appear over your object. The icon

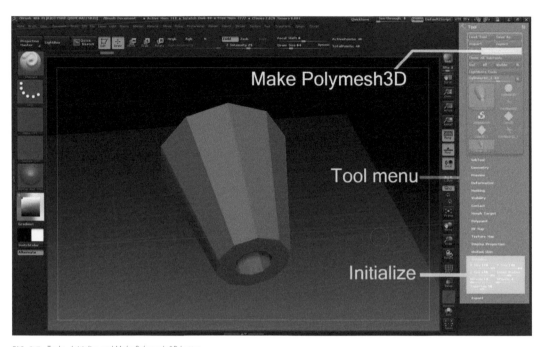

FIG 3.7 *Tool > Initialize and Make Polymesh 3D button*

consists of a series of three orange circles connected by a straight line with a small white circle at the tip and an array of red, green, and blue lines tipped with tiny circles radiating from the origin point. The small red, green, and blue lines represent the coordinate axes: red for the X axis, green for the Y axis, and blue for the Z axis. If you click inside any of the tiny red or green circles, the orange circles will align themselves with the corresponding axis. If you click inside the tiny white circle at the tip of the transpose line you can rotate around your view of the object. You can adjust the position of the transpose tool by clicking and dragging *on* the rings of the different orange circles. Clicking and dragging on the orange rings at either end of the transpose line will change the shape of the transpose line. Clicking on the middle circle or on the orange line connecting the orange circles will move the transpose tool around. If you click inside the orange circles you affect the object in different ways depending upon which of the orange circles you click and drag.

Clicking and dragging inside the orange circle that does not have the red and green axis lines around it will distort the object around a center defined by the other end of the transpose tool. Doing the same to the middle circle will move the whole object around, while clicking and dragging the inside of the

49

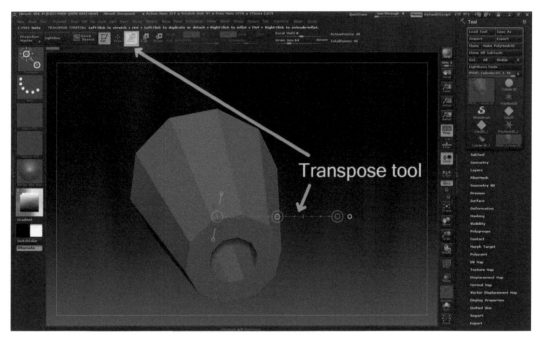

Transpose tool

FIG 3.8 *Transpose tool*

circle with the red and green lines surrounding it will cause the object to collapse down along the transpose line as you drag it. Play around with this tool until you are comfortable with it. It is a very strange interface and is difficult to master. The trick is remembering that clicking on the transpose line itself or its orange rings will adjust the transpose line, whereas clicking inside the orange rings will affect the object you are working on.

The scale tool (*E* shortcut) works similarly to the move tool, but clicking inside either of the end circles scales the whole object proportionately centered on the other end of the tool. Clicking inside the middle circle scales the object along an axis perpendicular to the transpose line.

The rotate tool (*R* shortcut) makes more sense. It acts as a lever and pivots around whichever end isn't being clicked on. In other words, when using the rotate tool, clicking and dragging either end circle will rotate the object around a pivot point defined by the other end of the transpose tool. Using the middle circle will rotate the object around the axis defined by the transpose tool.

All of the transpose tools are some of the most unusual 3D transformation tools to be found in any software package. They are rather difficult and take a lot of getting used to, so don't be upset if you find them cumbersome to use.

As an alternative to using the transpose tools you can always resort to the *Offset*, *Rotate*, and *Size* sliders found in the *Tool.Deformation* menu. These sliders are a lot more understandable and easier to use, though the *Rotate* slider always revolves around the global origin, the center of the ZBrush Cartesian coordinate system, and can thus be a bit tricky to predict.

Saving your 3D work

Now let's save the 3D object we've been playing with. In ZBrush, 3D objects are considered tools and the *Tool* interface has almost all of the commands related to them. When you are working on a 3D object, what you are doing is affecting an instance or copy of the actual tool which lives in the tool menu. What this means is that if you accidentally drop the 3D object to the canvas, turning off *Edit* mode, you haven't actually lost your 3D object. In fact, you can place as many copies of your object on your canvas as you want – it doesn't affect the tool itself at all until you go into edit mode and make changes to the object itself. One *extremely* important aspect of this is that when you save out a document or export an image you *are not* saving the 3D object you've been working on! To save your 3D object for later you need to go to the *Tool*

FIG 3.9 *Tool > Save As*

FIG 3.10 *File > Save As*

menu and click on *Save As* (*Tool > Save As*) and save out a ZTL file. This is a ZTool file format that contains your 3D object.

If you want to save everything – all of your loaded tools, the canvas, animation, and everything else about your current ZBrush session – then go to *File > Save As* or press *CTRL + S* on the keyboard and save out a ZBrush project file (ZPR). Because you are saving everything these files are much larger than either the ZBR canvas files or ZTL tool files. Be aware that when you load a project file using *File > Open* it will replace everything that was previously loaded in ZBrush, so be careful with it!

Take some time and play around with all of the buttons you've learned so far. Become familiar with where things are located and how the interface is laid out because things are going to start getting more complicated from now on.

Modeling a Head

You should now be ready to dive into ZBrush's 3D sculpting features. Make sure you have read and understood the section on "Working with 3D ZTools" in Chapter 3 so you know how to move around 3D in ZBrush before starting this section. Launch ZBrush, or if ZBrush is already running then click on *Preferences > Init ZBrush*. This resets the program and changes any

FIG 4.1 *Initialize ZBrush*

previous models, customizations, settings, and so forth back to their default values.

On the right side of the monitor under the *Tool* menu find the large golden S-shaped icon for the *SimpleBrush*. Click on it to open up a pop-up menu and select the *Sphere3D* tool.

Draw a sphere on the canvas by holding down the left mouse button and dragging on the canvas. After drawing the sphere, release the mouse button and immediately press the *T* key or turn the *Edit* button on in the top shelf. On the right shelf find and turn on the *PolyF* (polyframe) button so that you can see the polygon edges of the sphere.

All 3D objects in ZBrush are made of geometric polygons. A polygon is a plane whose boundaries are defined by edges which connect the polygon's corner vertices. Each vertex is a point in a three-dimensional Cartesian coordinate system with X, Y, and Z coordinates. ZBrush uses only four-sided polygons called quads and three-sided polygons called tris, or triangles, in its geometry and it has a great preference for quads due to how they create more surface resolution, using what are called subdivision surfaces. In the subdivision process it divides every polygon in a surface into smaller polygons. The *PolyF* polyframe button displays the edges that comprise the borders

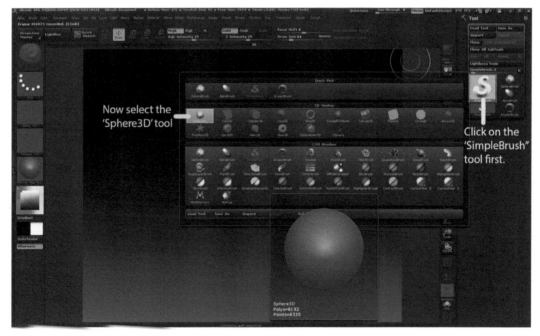

Now select the 'Sphere3D' tool

Click on the 'SimpleBrush' tool first.

FIG 4.2 *Select the Sphere3D tool*

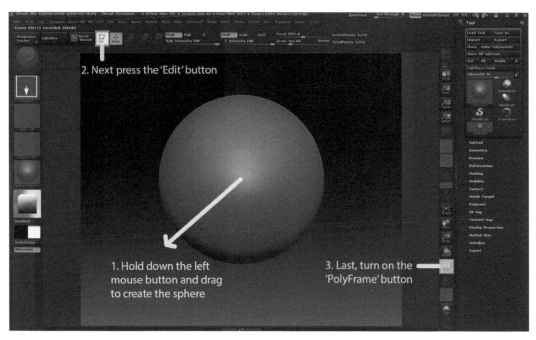

2. Next press the 'Edit' button

1. Hold down the left
mouse button and drag
to create the sphere

3. Last, turn on the
'PolyFrame' button

FIG 4.3 *Draw a Sphere3D on the canvas*

of the polygons of whatever objects are on screen. Try not to turn the *PolyF* polyframe button on when you have a lot of highly subdivided topology or objects on screen. ZBrush could crash trying to display the edges on millions of polygons and there will be so many polygons that it will just turn the object dark without being very informative. *PolyFrame* is much more useful on relatively low-resolution 3D meshes where it can display your geometry clearly.

Now press and hold down the *Shift* button while you click and drag the empty space around the sphere to rotate it so the sphere's pole locks into place facing you. The poles are at the top and bottom of the sphere where all of the edges meet. If you lose sight of your sphere, click the *Frame* button on the right shelf to center the sphere on the canvas or simply press the *F* key to accomplish the same task.

To start sculpting, we will have to change this sphere into a PolyMesh3D object. In the *Tool* palette, click the *Make PolyMesh3D* button. If you click and drag the mouse on the sphere's surface you will sculpt it using your current brush settings. If you look at the top shelf, just under the menu bar dead center in top of the screen, you should see a button labeled *Zadd* highlighted in bright orange. This is the default deformation setting for your current brush which pulls the surface out towards you when

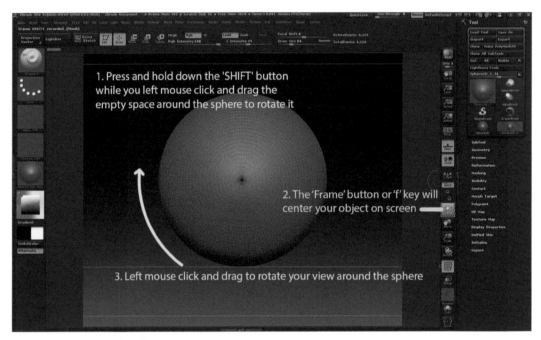

1. Press and hold down the 'SHIFT' button while you left mouse click and drag the empty space around the sphere to rotate it

2. The 'Frame' button or 'f' key will center your object on screen

3. Left mouse click and drag to rotate your view around the sphere

FIG 4.4 *Viewing the pole and "Frame" button*

you sculpt the surface with your mouse. If you click on the *Zsub* button and highlight it instead, your brush will now push the surface of the sphere away from you when you click and drag on it. You can quickly swap between the two sculpting methods by holding down the *ALT* button while sculpting. This is similar to the functionality of using the *ALT* button in Photoshop to switch between adding a selection and subtracting from one. Underneath these two buttons you will see the *Z Intensity* slider. This numeric slider represents the amount of push or pull the brush has each time you use it. Click and drag the orange slider dot to increase or decrease the amount of effect the brush has. The higher the number the stronger the brush's effect will be. If you click on the number to the immediate left of the *Z Intensity* slider it should highlight in red. Now you can input a specific amount using your keyboard, then press *Enter* to set the number. You can also press U to have shortcut access to this slider while you are working on the canvas. Pressing the *spacebar* or RMB while the pointer is over the canvas workspace will also bring up a shortcut menu of the most commonly accessed settings. Next to these buttons you can find the *Focal Shift* slider, which controls the amount of falloff the brush has, and the *Draw Size* slider, which controls the brush size. The [and] shortcuts allows you to quickly decrease and increase the brush size while you work. Nestled in

the *Draw Size* slider is a tiny button labeled *Dynamic*. When *Dynamic* is on, the brush size is tied to the object instead of the canvas and the brush size won't change when you zoom in and out from the object, although visually it will look different. When *Dynamic* is off the brush size is tied to the canvas and zooming in and out from the object will change the effective size of the brush, though it won't change visually.

If, while you are working, your model vanishes; don't worry. This is just a glitch caused by the video drivers. A simple click on the canvas should make it reappear. If it doesn't reappear then press the *F* key to frame the model on the center of the canvas. If it still doesn't reappear then go to *Document > New Document*, then select your item from the *Tool* menu and redraw it on the canvas. Because ZBrush works on a virtual copy of your object, called an instance, even if you somehow lose your object you can always just draw it again on screen. Don't forget to save frequently using the *Tool > Save As* button though!

Always keep in mind that when working in 3D it is astonishingly easy for errors to occur. A complex sculpture can easily have any of a hundred different little errors that can change or prevent other commands from working later on. There were several things that happened, for instance, just in the process of creating this book. The trick to working in 3D is being able to problem solve

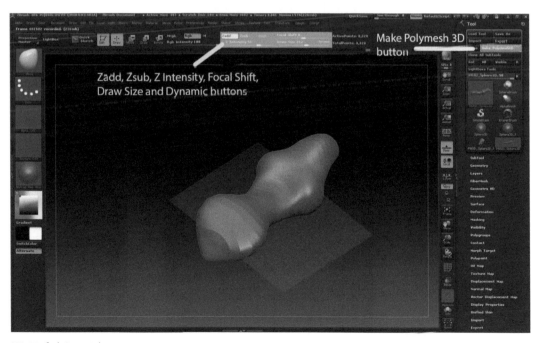

FIG 4.5 *Sculpting controls*

FIG **4.6** *The* Tool.Save As *command*

these issues when they occur or being able to work around them. One easy way to prevent a lot of issues is to save your work iteratively. In other words, name your file like this: "*descriptive_name_version_number_file_number*", so you might end up with "*blue_dragon_v1_01*" for a file name. The next time I save the file instead of overwriting the existing file I'd save out "*blue_dragon_v1_02*". This way if there turns out to be a problem with my file I can backtrack to an earlier version before the problem began. If I make a big change to the model, I increment the version number. Otherwise just keep adding to the file number at the end of the name each time you save. Data storage is cheap – you can afford the space it takes up, and it is a very safe way to work.

Symmetry

It is frequently useful to have your brush strokes mirrored across the center of the object in order to make a symmetrical form when you sculpt. To turn on symmetry, go to the top shelf and find the *Transform.Activate Symmetry* button and turn it on. You can set which axis the symmetry button uses by clicking on the *X, Y*, or *Z* buttons located underneath the *Activate Symmetry* button. Later you can try out the *Radial* button and *RadialCount* slider, which uses the specified axis to draw a number of strokes in a circle around the object. For

now make sure you have the *X* button and *Active Symmetry* turned on. Now when you place your cursor over the sphere you should see a red circle, which represents the outside edge of your brush, and a smaller red circle within it, which shows you where the brush's falloff effect begins. Directly across the center of the sphere you should see a red dot that displays where the symmetrical stroke will occur. If you can't see the red dot then rotate the sphere around until you find it or you can change the axis you are using for symmetry to either *Y* or *Z*.

Try out some different brushes by clicking the Standard brush icon on the top of the left tray. A pop-up window containing all of the different 3D brushes will appear. A short list of the most useful brushes found here includes the *Standard*, *Move*, *Inflate*, *Pinch*, *Polish*, and *Clay* brushes. While I encourage you to try every brush in the brush pop-up menu, quite a few of them are very specific to certain features and will not be useful when sculpting a normal object, so if any of the ones you try out don't seem to work, then just understand that it is a specialized brush. ZBrush keeps a list of your recently used brushes at the top of the brush pop-up menu for easy access. You can press the *B* shortcut key to bring up the brush pop-up menu. Pressing a keyboard letter while in the brush pop-up menu will isolate any brush that begins with that letter and also display in orange a keyboard shortcut for selecting

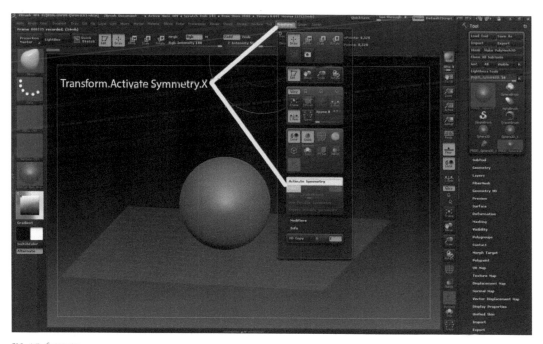

FIG 4.7 *Symmetry*

FIG 4.8 *Brush pop-up menu*

a specific brush. To select the *Move* brush you can press *B*, then *M*, then *V* on your keyboard.

Use the *Move* brush to pull and push your object into shape. Make sure you have *Symmetry* turned on so your shape is consistent across its major axis and try to achieve a strong silhouette.

To smooth out any features that are becoming too pronounced, simply hold down the *Shift* keyboard button to activate the *Smooth* brush while sculpting the surface. This will immediately start blending away the details that you have added to the sphere. You can make changes to the brush settings while pressing the *Shift* key in *Smooth* mode and ZBrush will remember them the next time you go back into the *Smooth* brush again. When you press *Shift* you will see the brush icon switch from *Standard* to *Smooth* on the top of the left tray. You can actually set shift to trigger any brush. To do so, press *Shift* and click on the *Smooth* brush icon and select a different brush. Now the shift button will activate the new brush instead of smooth. Don't forget to set it back to the *Smooth* brush after trying this out!

By now if your sphere is looking rather ragged you might want to start over. If so, you'll want to save the object you have been working on. Make sure it is

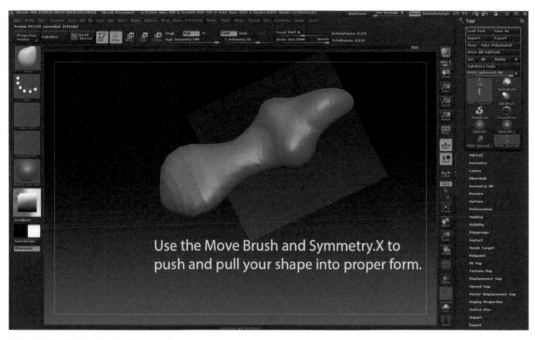

FIG 4.9 *Using the* Move *brush and* Symmetry.X

the selected object in the *Tool* palette (it should be highlighted in light gray) and click the *Save As* button in the *Tool* palette (*Tool.Save As*). This will bring up a file window where you should give your file a name such as "*play_sphere_1.ztl*" inside the *File name* input area. Leave the *Save as type* setting alone (you can't change it anyway) and press the *Save* button to finish saving your object.

Starting over is easy – just swap the object you are currently working with to a different model. On the right hand side of your screen under the *Tool* palette click on the *Sphere3D* icon. Clicking on the *Sphere3D* icon while you have a different object in *Edit* mode will immediately swap your old mangled sphere for a new pristine one. All you have to do now is to click on the *Make Polymesh3D* button in the *Tool* palette to begin working again. Notice that your earlier sphere isn't deleted – the icon for it still exists over in the top of the Tool palette and you can switch back to it anytime you like. Once you've created an object in ZBrush the object doesn't go away just because you swap objects or even delete the current image you are working on. Each object lives in the *Tool* palette while you have ZBrush open and you access an instance, a working version of the object, when you select that tool. The *Tool* menu where your objects live and the document or canvas you are drawing on are two completely different things in ZBrush.

FIG 4.10 *Starting over*

To start working on your new sculpture, press the *B*, then *M*, then *V* keys. This switches the selected brush to the *Move* brush. Press and hold the *J* key on the keyboard to make the brush very large. Tap the *X* key on the keyboard to turn on symmetry. Now pull and push the sphere into a rough head shape. Shrink the brush using the *[* key and press the *B*, *S*, then *T* keys to switch to the standard brush and add features. Rough out the nose, chin, and add some cheek bones. Hold down the *Alt* key to switch from *Zadd* to *Zsub* and sculpt the hollows for the eyes. Remember that you don't have to be precise or even work towards a set shape. At this point we are just exploring possibilities and playing around as we try to achieve an aesthetically interesting shape. While working, remember to frequently rotate your view of the object around so you can see your shape from different viewpoints and get a better understanding of the shape you are sculpting.

DynaMesh

As you sculpt you will start to notice that areas you work on a lot become stretched out as you put more and more effort into them. The polygons in

these areas become larger and as they do, so the amount of detail you can put there diminishes.

To fix this, ZBrush has an awesome tool for resurfacing the object called *DynaMesh*. Go to the *Tool* menu and open the *Geometry* sub-menu; now open the *DynaMesh* menu and click on the big *DynaMesh* button (*Tool.Geometry. DynaMesh.DynaMesh*). This drops a new grid surface onto the model we've sculpted. If you still have polyframe (*PolyF* button) turned on you will see the geometry radically change into more of a grid form. The resolution of this new grid-based shape is determined by the *Resolution* slider. It is a good idea to start with this number set pretty low at 32 or 64 and increase it as you work. Geometry takes up a lot of computer memory (RAM), so you want to keep your object resolutions fairly low to preserve your interactivity with ZBrush. If the object resolution gets too high, ZBrush can easily choke up or crash and you can lose whatever you are working on. For now a value of 64 is fine for our resolution.

Now you can turn off *PolyF* and keep working. One thing to be aware of is that a lot of brushes like the *Smooth* brush have different amounts of effect depending upon the resolution of the surface. The results of using the *Smooth*

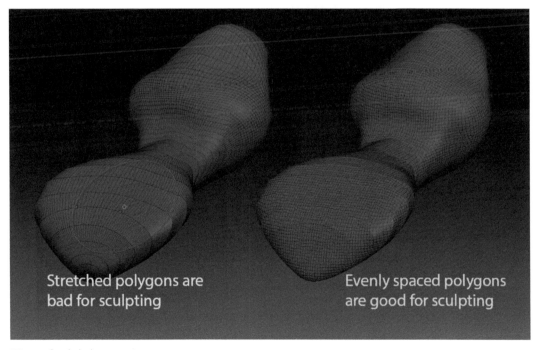

Stretched polygons are bad for sculpting

Evenly spaced polygons are good for sculpting

FIG 4.11 *Stretched polygons*

FIG 4.12 *DynaMesh*

brush are much more dramatic on a low-resolution surface than on a high-resolution one.

When you input numbers in ZBrush you will frequently notice a pattern of 8, 16, 32, 64, 128, 256, 512, 1024, 2048, 4096 in the sizes and values of things. This is because these numbers are all powers of two and since computers think in binary, this helps to maximize the amount of memory used for an operation without having any wastage. In other words, if the computer is going to allocate 128 bits of memory to your process anyway, don't use a value of 100 and waste the extra 28 bits it gives you.

As you continue to work you might need to resurface your object again. Make sure that *DynaMesh* is still active. Try lowering the *Resolution* slider to 64. In a blank part of the canvas, hold down the *Ctrl* button and click and drag the

mouse to form a little square. Make sure that you don't cross over any part of the model when you do it since this will create a mask on the object. This is a shortcut that will activate *DynaMesh* and resurface the object again. If you find the shortcut too confusing, then you can just deactivate *DynaMesh* and turn it back on to achieve the same effect.

Keep working until you are happy with your result. Remember that we are just practicing so don't let yourself get frustrated. If you find you're getting upset at the program, take a break and get up and walk around for a bit. Just like drawing, learning sculpting in ZBrush takes a lot of effort to master. It is excellent practice just to sit and create these little sculpts whenever you have the time. It is the same thing as doodling on a sketchpad! Remember that you can follow along with my example using the videos on the companion website www.focalpress.com/cw/Johnson. Don't forget to save your tool (*Tool* > *Save As*) as a ZTL file so you don't lose your work. Practice making several variations of different heads until you achieve one you really like.

For the practice dragon head that I am sculpting, I turned on *Transform. ActivateSymmetry.X*, then used the *Move* brush to pull the sphere into a basic shape. Once I was happy with the silhouette I used the *Standard* brush to

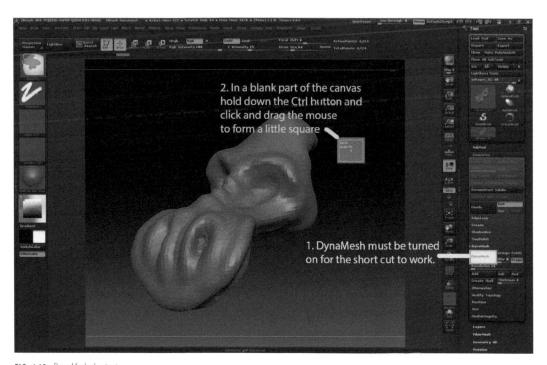

FIG 4.13 *DynaMesh shortcut*

FIG 4.14 *Using brushes to sculpt in features*

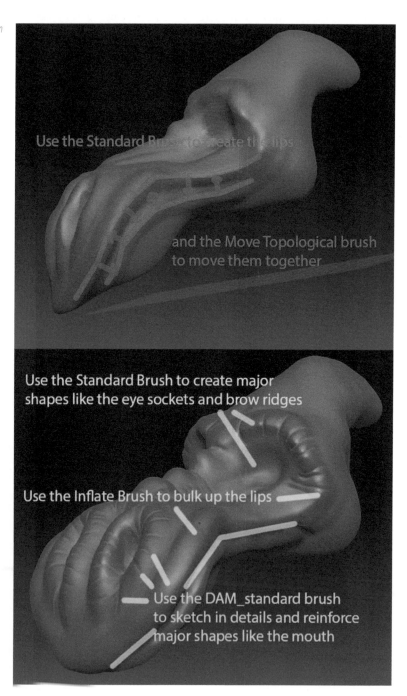

sculpt the eye sockets, lips, and cheeks. I then switched to the *Move Topological* brush to move the lips closer together and tweak the placement of the other features. The *Move Topological* brush is a quite useful brush. It analyzes your object and only moves points that are close to one another on the surface. It is a great brush for moving specific parts of your model around without affecting the other parts. Next I selected the *Inflate* brush from the brush pop-up menu, or just pressed the *B-I-N* keys to use the shortcut, and played with the model a bit. The *Inflate* brush is similar to the standard brush but expands the surface outward like a balloon from the center of the brush stroke. I used the *Inflate* brush to puff up the lips a bit. Switch back and forth between the *Inflate* and *Standard* brushes and try them out until you get a feel for them. Use the move, standard, and inflate brushes to define the basic form of your model. Once I had the major form worked out I began adding details. A very useful brush for starting to refine the model is the *DAM_standard* brush (*B-D-S* key shortcut). It is a great brush for drawing initial details which can later be expanded upon. I used it to incise in the major creases and wrinkles of my model. It is also very good for defining the edges of major muscle groups, which can then be bulked up in the middle for shape. Holding down the *Shift* key to switch to the *Smooth* brush I then go back over these initial lines and soften them up. Any lines I don't like I just smooth out of existence.

Subdivision

Now that you have a head sculpture you're satisfied with we can take the time to refine it even further. To add more detail you need more resolution. You could simply increase the value of the *DynaMesh* command and keep resurfacing the object, but this isn't a good workflow as it quickly approaches the memory limits of what *DynaMesh* can achieve and you risk losing some of the finer details when you resurface the object. What we will do instead is subdivide the object.

Subdividing a 3D object means taking every polygon in the object and dividing it into four equally sized pieces. Subdivision can be repetitively applied until you run out of computer memory. This is how artists are able to achieve the magnificently detailed models seen on ZBrush Central's gallery page! The subdivision process is not at all like the *DynaMesh* process. With *DynaMesh* you are actually replacing the current model with a new one based off of a grid system. When you subdivide you are taking the existing model and cutting each polygon into four. While both techniques can be used to add more resolution to the model, the subdivision process is less destructive and preserves information that might be imbedded in the model such as ultraviolet (UV) information (which we will talk about later on). Basically put, use *DynaMesh* to rough out your object's silhouette and basic shape, then switch to subdivide to add the details. Remember to only subdivide a model as

much as you need to. While ZBrush is capable of displaying many millions of polygons at the same time, it has a "sweet" spot at around 1 million polygons where it is still easy to work with before the program starts getting bogged down by memory concerns.

To use subdivision, first make sure that you have turned off *DynaMesh* in the *Tool.Geometry.DynaMesh* menu. Next, slightly above the *DynaMesh* command you will see the *Divide* button (*Tool.Geometry.Divide*). Click the *Divide* button to subdivide the model one level or use the *Ctrl + D* shortcut to do so. Immediately as you do so, several new buttons and sliders will come to life above the *Divide* button. The most important item is the subdivision, or *SDiv* slider. This is the interface for controlling what subdivision level your model is currently on. With *SDiv* set to *1* you are working on your lowest subdivision level. Moving the slider to the right and upping the *SDiv* number increases the subdivision level you are working on and the level of detail you can achieve with the model. High subdivision levels are better for creating fine details on a model; but don't create more subdivision levels than you need to or your interactivity within ZBrush will suffer.

FIG 4.15 *Subdivision*

ZBrush will keep you informed of how many 3D points your model currently has. If you look up on the right side of the top shelf you will see two readouts. *ActivePoints* lets you know how many points are in your currently active 3D model. *TotalPoints* tells you the total number of 3D points in the current tool, including all of the subtools for that model (more on subtools later). You can also discover the number of polygons in a model by just resting your mouse over its ZBrush tool icon.

This will tell you the number of polygons, points, and the number of any hidden polygons or points in that model. ZBrush can usually handle somewhere between 200,000 to 1 million polygons in an active object before it starts having problems. The important thing to remember is to only have the level of detail you need for a model. In other words, don't subdivide your model to 1 million when less would work just as well. One of the most common things I see in beginning-level work is an excess of unnecessary detail. If no one will ever see the work, then don't do it! That's why a lot of buildings in game worlds or movies don't have reverse sides, vehicles don't have interiors, and so forth. You only make what is required by the production. Of course, if you are just practicing or making a portfolio piece it might not hurt to go all out just

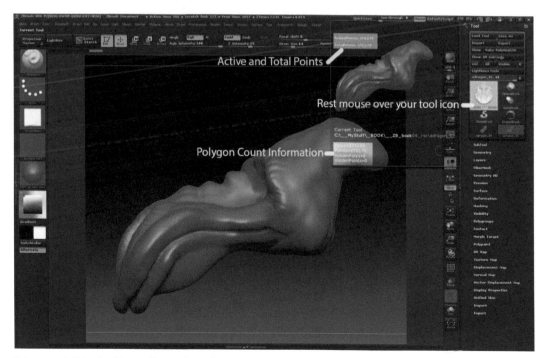

FIG 4.16 ActivePoints, TotalPoints, *and* Polygon Count *information*

to show off; but that doesn't fly in a production environment since making things that won't be seen is a waste of time and money.

To lower the current subdivision level, simply slide the *Tool.Geometry.SDiv* slider to the left or input a lower number. Lower subdivision levels are useful when you want to make large changes to the entire object. ZBrush keeps track of each subdivision level separately to a certain degree and changes to one subdivision level have a ripple effect on the other levels. What this means is that you can make substantial changes to the form at a low subdivision level and still preserve the fine detail you've already created at a higher level. This effect is most noticeable with smoothing. If you create a set of fine details at a high subdivision level and then go to a lower level and smooth them out, what you will get when you return to the higher subdivision level is a more subtle effect. The details will still be there – they just won't be quite as strong. To completely smooth something out – that is, to erase it – you'll have to go through subdivision level by subdivision level and smooth out the effect. This is actually a feature since it allows you to get some very nice subtle effects; but it can feel like a flaw until you get used to working with it. The different brushes can have vastly different effects depending upon what subdivision level you are on. For instance, the smoothing brush is most dramatic at lower subdivision levels and very subtle at higher ones. To quickly go up and down your subdivision levels, you can use the *D* shortcut to go up a level and *SHIFT + D* to go down. It is a good idea to work from large shapes and features progressively down to smaller, finer details. Not only is this efficient computer memory use; it mirrors traditional art and sculpture practices. Start with a fairly low resolution mesh and sculpt out your silhouette, then increase you resolution a level or two and add in the defining features on the model. Once you are happy with your overall progress you can add an additional level or two of subdivision and proceed to add the fine details and surface texture which we will cover thoroughly in the next chapter.

Don't forget to save your work!

Working with files

It is important to name your files in a consistent and organized fashion. I suggest using only lowercase letters, numbers, and _ or -. Do not use any unusual characters (!@#$%^&^&*). Keep your files organized into descriptively named file folders. When naming a file, include a version number and a current iteration number. – for example, *spaceship_v2_205.ztl* (the 3D ZBrush tool file), *spaceship_v2_20.psd* (the master texture file), *spaceship_v2_03_alpha.jpg* (alpha texture file for the 3D scene), *spaceship_v1_02_render.jpg* (JPG export file of the canvas), and *spaceship_v1_02_render.zbr* (ZBrush canvas document), all stored in a folder labeled *spaceship*.

Each time you save a file, increment the iteration number by one – so, from *spaceship_v6_048.ztl* to *spaceship_v6_049.ztl* and so on. If you make a serious change you can increment the version number. This way if a problem develops in the file (it gets corrupted or you make a mistake) you can always go back and find an earlier file that isn't messed up. This will save you hours' and maybe even days' worth of work.

Don't forget to back up your work! Data is ephemeral and can vanish utterly due to any number of computer failures. External drives are cheap nowadays so there really isn't any excuse for not backing up your work. Personally, I use four different external terabyte drives and back my work up to a different one each week. I also have copies burned to DVD, a backup of current files in internet cloud storage, and a copy of my working files on my portable drive.

Brushes, Materials, and Painting

Brushes

Now is a good time to explore some more of the various brushes and their associated options. Initialize ZBrush and load the model we created in Chapter 4 using the *Tool.Load Tool* button. At this stage you are really just looking for a strong silhouette that communicates the idea of your object well. All the technology in the world won't help you if your fundamental art skills aren't well developed! I'm happy with the rather goofy looking dragon's head I roughed out for Chapter 4 so I will just keep working on it.

If you want one of your brush strokes to be stronger you can easily strengthen them by pressing the *1* (numeral one) keyboard button or go to *Stroke.Modifiers.Replay Last*, which will repeat the last brush stroke.

It is better to work with a low *Z Intensity* setting and gradually build up your surface. You will get a lot more subtlety in your surface and it will read much better. Don't forget that you can invert the brush's effect by holding down the *ALT* key while you paint to pull the surface out instead of carving it in. If the polygons start to look a bit stretched, make sure you have *DynaMesh* activated (*Tool.Geometry.DynaMesh*) and hold down *CTRL* and click and drag out a tiny box in an empty area of the canvas. This will cause *DynaMesh* to resurface the object. When doing this on a 3D sculpture that already has some detail, make sure that you have the *Project* button turned on in the *DynaMesh* menu.

This tells ZBrush to project the details from the old mesh onto the new *DynaMesh*. Provided that you have enough polygon resolution in your new *DynaMesh*, it will do a very nice job of saving any details that you have already created. A value of 128 or 256 for *DynaMesh's* resolution should work for

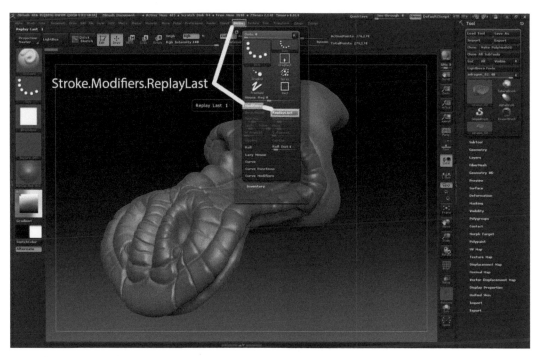

Stroke.Modifiers.ReplayLast

FIG 5.1 Replay Last *command*

now. Be careful, though; setting the resolution value too high will crash your machine as ZBrush tries to create millions of new polygons!

If you make a mistake and select part of the object and some of the model turns dark, don't worry. You have simply accidentally bumped the *CTRL* button. Using the *CTRL* button activates ZBrush's masking features and that is exactly what has happened. Simply go to *Tool.Masking.Clear* to get rid of it.

Don't forget to save your work occasionally using the *Tool.Save As* command.

The *Move Elastic (B-M-E)* brush lets me now make some big changes to the head's silhouette without destroying the flow of my polygons. The effect is a subtle one compared to the normal move brush, so try them both out and see if you can tell the difference. Now is a good time to turn *DynaMesh* off (*Tool. Geometry.DynaMesh*) and subdivide our model (*CTRL + D* or *Tool.Geometry. Divide*) one level so we can have a bit more resolution to play with. A quick check on the number of active points in my scene with the *Active Points* readout on my top shelf lets me know that I am well under my computer's memory limits at around 100,000 points.

FIG 5.2 DynaMesh > *Project option*

I've used the *Inflate* brush to puff up the areas between the creases I've cut in with the *DAM_standard* brush. Now I can flatten these out a bit by using the *Polish* brush (*B-P-O*) to make these areas a bit less bulbous. For areas that need to be sharpened, I use the *Pinch* brush (*B-P-I*) to sharpen it up a bit. You may have noticed that to access any given brush, you tap the *B* key for brush, then the first letter of the brush's name –in this case, *P* for brushes that begin with the letter "P". Last, select the final shortcut letter to tap from the reduced selection of brushes you now have – *I* in this case for the pinch brush. There is a huge selection of brushes available by default in ZBrush, plus more you can load up off the disk and even more you can download for free from ZBrush central or other websites. To access the brushes stored on the hard disk, click on the brush icon, then the *Load Brush* button

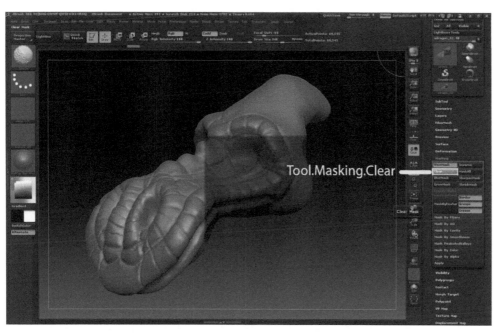

FIG 5.3 Tool.Masking.Clear *to get rid of a mask*

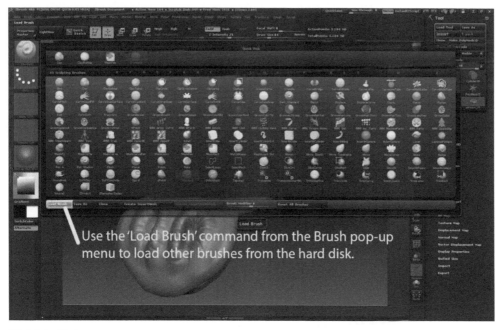

Use the 'Load Brush' command from the Brush pop-up menu to load other brushes from the hard disk.

FIG 5.4 *Load Brush*

Now just find and select the brush you'd like to try out. If you performed a default install of ZBrush on a Windows computer, the brush location will be "C:\Program Files (x86)\Pixologic\ZBrush 4R6\ZBrushes\". Try out the different *Polish*, *Flatten*, *Layer*, and *Planar* brushes to familiarize yourself with what they do. There are dozens of brushes to explore! Most artists eventually settle on just a handful of brushes that they use for almost everything, only breaking out the others when they need something really specific. For instance, I created most of the detailing on the dragon model's face using just the *DAM_Standard* brush to carve in the lines.

While there are a lot of brushes in ZBrush, you will find that you keep going back to just a few that become your favorites. For example, I like to use the *Move* brush to rough out my initial shape since it is good for just pushing shapes around. The *DAM Standard* brush is extremely useful for carving in initial features which are then repetitively smoothed out and redrawn to increase the intensity of the feature as needed. The clean, sharp line it draws is perfect for defining the edges of muscle groups and creating the boundaries of major features. The *Clay* brushes are excellent at bulking up a surface and fixing up problem areas, while I use the *Standard* brush for adding textures and fine details. The *Layer* brush is useful for adding a uniform layer of surface to the model and helps when you are trying to keep things as smooth and as even as possible. Sometimes it is certain combinations of brushes that are particularly useful. A neat trick is to use the *Standard* brush with the *ALT* key held down to switch to subtract mode to sculpt in a pit on the object. Next switch to the *Planar* brush and begin sculpting with it from the deepest point of the pit to create a smooth face at that level across the model. If I decide to alter the overall shape of my model after I have added some of the details, I usually go for the *Move Topological* brush. This brush pays attention to the actual flow of the surface of the model and only affects the parts of the surface that are adjacent to each other. This is very useful for tweaking one part of the model without affecting the surrounding areas. Again, there is no substitute for simply trying out all of the different brushes to get a feel for what they do. Refer to ZBrush's documentation (http://docs.pixologic.com) for specific information on all of the dozens of brushes since there are far more brushes than can reasonably be explored in just one book.

Different strokes

So far we've just been using the brushes with the default settings. There is a world of variation, though, that can be unlocked if we start changing the various elements that control brush behavior. The easiest controls to access are the alpha and stroke pop-up menus in the left tray.

Brush alpha

The third icon from the top in the left tray is the brush *Alpha* menu. This menu sets the shape of the brush tip for the current brush. By default, this is set to *Alpha Off* and is a blank gray square. Click this blank icon and access the pop-up menu. Pick one of the alpha icons from the menu such as *Alpha 60* to try out. Now when you sculpt your surface you will get a very different result as ZBrush uses the brush alpha as a mask through which the stroke is applied. Brush alphas are a great way to add a fine level of texture and visual interest to your models. Try out several of the different alphas now. To turn off the brush alpha, simply choose the blank *Alpha Off* icon in the pop-up alpha menu.

FIG 5.5 *Brush Alpha and Brush Stroke*

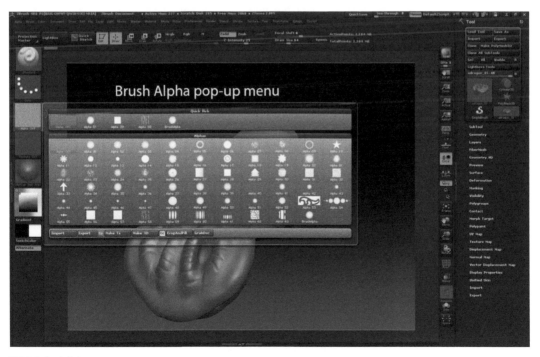

FIG 5.6 *Brush Alpha pop-up menu*

77

Brush stroke

The *Stroke* menu setting changes how the brush is applied to the surface. This is the left tray icon second from the top, just underneath the brush icon. The default setting for the standard brush is the *Dots* setting, which repeats the brush's alpha along a given brush stroke line. Click on the *Strokes* pop-up menu to see the other available options.

For a much smoother stroke, use the *Freehand* setting. When ZBrush draws a stroke upon the surface it is repeating the brush alpha along the line of the stroke. The freehand stroke provides a much more tightly spaced interval of your brush alpha, creating a more continuous line. Pick a brush alpha and change the stroke to *Freehand* to try it out. At the bottom of the *Stroke* pop-up menu there are a number of sliders and buttons for modifying the behavior of each stroke. The *Mouse Avg* slider adjusts the smoothness of the brush stroke by averaging out the mouse's position slightly before applying each stroke with higher values, providing a smoother movement.

The other stroke options include *DragRect*, *Spray*, *ColorSpray*, and *DragDot*. *DragRect* lets you control the size and orientation of each individual brush alpha you place on the model. Simply select it and click and drag the shape out on your object. As you move the mouse around while you drag out the shape you will notice how you can control its orientation.

DragDot is a quicker way of placing the same brush alpha individually. *DragDot* let you interactively place one copy of your brush alpha at a time. It is very similar to *DragRect* but sacrifices some control for speed of placement.

FIG 6.7 Brush Stroke pop-up menu

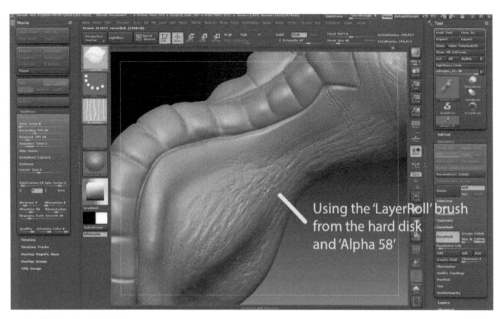

FIG 5.8 LayerRoll *brush and* Alpha 58

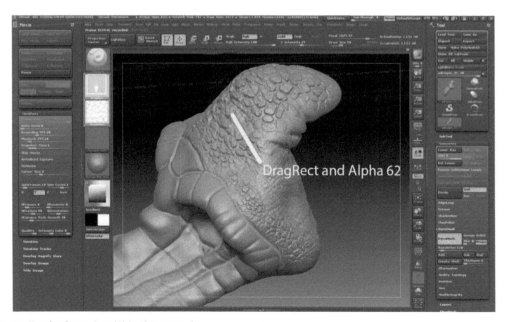

FIG 5.9 *Using* DragRect *stroke and* Alpha 62 *to create scales*

By this point you should have a fun little sculpt that you've made and you are happy with. If not, then take some time to go back through the tutorial and create a small cartoon head sculpt to practice with. Make sure before you proceed that you have turned *DynaMesh* off (*Tool.Geometry.DynaMesh*) and you will also want to subdivide your model once or twice (*Tool.Geometry.Divide* or *CTRL + D*) to get enough surface resolution to work with, say around 0.5 million active points. Click on the *Alpha* icon and choose *Alpha 62* from the pop-up menu. Now go to the *Stroke* menu and choose *DragRect*. Click and drag your mouse on your model to apply one instance of the brush alpha. You can control the size and orientation of the alpha on the surface by dragging the mouse around while still pressing the left mouse button (LMB). The edges of the alpha are a bit strong, so let's fix that. Undo (*CTRL + Z*) and set your brush's *Focal Shift* on the top shelf to around 50. Now try it. The edges of the alpha fade out near the rim. Another way to accomplish this is to go into the *Alpha* menu at the top left of ZBrush's menu bar and set the *Rf*, or radial fade, value to around 50. Very frequently there are multiple ways of doing the same thing in ZBrush. It boils down to a matter of personal preference and the subtle differences in effect as to which one you prefer to use. You can now go in and apply a very interesting scale pattern to your creation! Leave some blank spaces, though – we've got some more tricks to use.

A quick and dirty way of applying a lot of texture fast is to use the *ColorSpray* or *Spray* strokes. *Spray* and *ColorSpray* shower the model with a blast of multiple brush alphas at the same time in a chaotic spread pattern. *ColorSpray* varies the hue of the currently selected color, while *Spray* varies its value. Both are quite good for achieving a broken-up natural look to your brush strokes. Using the same alpha as before, change the stroke to *ColorSpray*. Set the *Z Intensity* to around *10* or so. The texture will build up very quickly, so we want to start with a lower setting than the default one. Now you can very quickly go and fill in the blank areas. Even though you are using the same alpha as before, you will notice that you achieve a very different look to the texture you create.

If you find that your cursor is jumping around too much and is difficult to control there is one option you can turn on to fix this. Go to the *Stroke* menu and turn on the *LazyMouse* button. This averages the mouse position as you draw to produce a much smoother stroke. You can strengthen the effect by increasing the *LazySmooth* setting underneath the *LazyMouse* button. You should see a thin red line trailing your cursor now which can help you to visualize what the *LazyMouse* button is doing. With *LazyMouse* on, small jumps and twinges in your strokes will be minimized. The other use for *LazyMouse* is to draw a straight line!

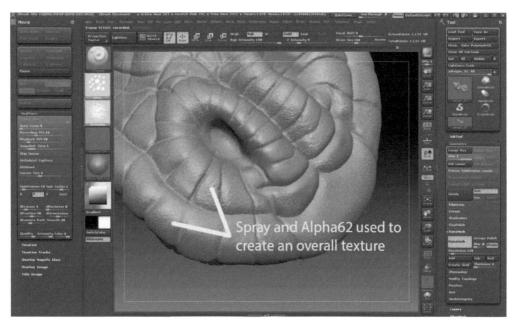

FIG 5.10 *Using* Spray *stroke and* Alpha 62 *to create fine texture detail*

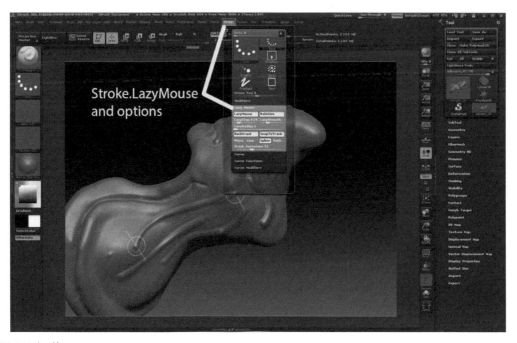

FIG 5.11 *LazyMouse*

ZBrush has a very odd approach to drawing a straight line. First go into the *Stroke.LazyMouse.LazyMouse* menu and turn on the *BackTrack* button as well as the *Spline* and *SnapToTrack* buttons. When you click and drag your mouse on the model you get a red line capped by orange circles on either end. Now play your mouse back and forth over the red line to sculpt your line. The *Snap-ToTrack* button locks the stroke to the line you draw while *Spline* controls the type of line you can draw out. Play with the different combinations of *Plane*, *Line*, *Spline*, and *Path* to explore how they work together with the *SnapToTrack* button and *Track Curvature* slider. This is a very unintuitive tool and can take a bit of getting used to before you find it natural to use; but when combined with the variety of brushes and alphas available it is quite powerful – just strange.

Don't be afraid to go back in and make drastic changes. Simply save where you are at and then go crazy and try out a few things. Don't let your object become so "precious" that you are afraid to experiment. After all, the beauty of working digitally is that you can save a version of a file and then play with it as much as you like. You can always go back to the earlier version if you mess things up.

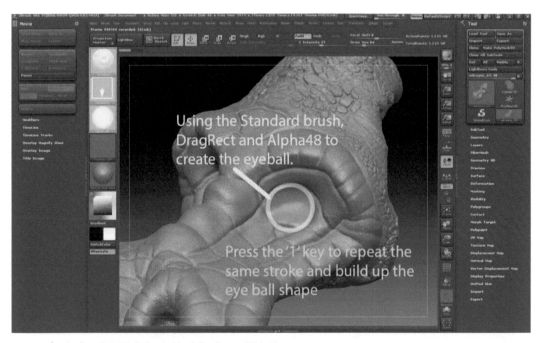

FIG 5.12 *Creating the eyeball with the Standard brush, DragRect, and Alpha48*

We can use the *DragRect* stroke to create eyes for our first model. Set the stroke to *DragRect* and choose *Alpha 48* for your brush alpha. Put your *Z Intensity* to a value of 25. Now click and drag out a rough eye shape in the socket for the eye. Press *1* or go to *Stroke.Modifiers.ReplayLast* to repeat the stroke and shape out the eyeball to the level desired. You can use the *Smooth* brush (press and hold *SHIFT* to access the smooth brush) to get rid of any rough spots. Now you can change brushes to *DAM_Standard* and carve in the wrinkles and creases around the eye. Use the *Standard* and *Inflate* brushes to refine the eyelids and add more detail. Don't forget to add some texture to the eyelids using your spray stroke as well.

For the pupil I chose the *ClayTubes* brush and gave it a round alpha with a soft edge like *BrushAlpha*, then set the stroke to *Freehand*. Now just hold down *ALT* and carve the iris into the middle of the eye. Press *SHIFT* to smooth away any irregularities. You don't want to have a lumpy eyeball after all! Save your file using *Tool.Save As*. The *ClayTubes* brush is a good choice anytime you need to bulk up a feature on a model. Notice how the *ClayTubes* brush acts differently than the *Standard* brush we were previously using.

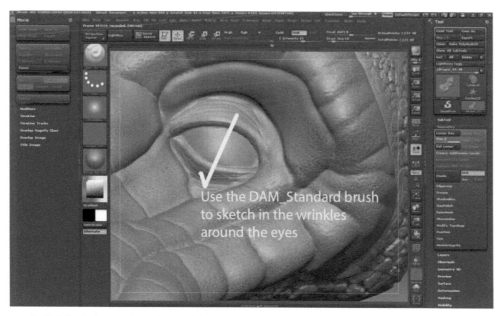

FIG 5.13 *Use DAM_Standard to create the wrinkles around the eyes*

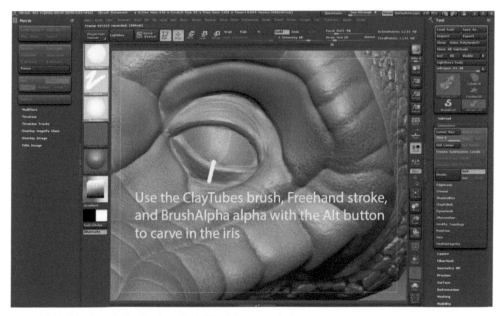

Use the ClayTubes brush, Freehand stroke, and BrushAlpha alpha with the Alt button to carve in the iris

FIG 5.14 *Use the* ClayTubes *brush,* Freehand *stroke, and* BrushAlpha *alpha to create the iris*

Problems and fixes

When sculpting you want to avoid pulling a surface through itself. This is where one part of a model starts to push through the opposite side of the model, inverting it. This can become very difficult to work with and should be avoided. If you see your model turning itself inside out, simply undo or load an earlier version of the model. Another issue that frequently pops up is that of working on very thin surfaces. Each brush is actually a sphere shape, not just the flat circle indicated by the brush cursor. When you sculpt a thin surface the brush will, by default, affect the back side of the surface as much as the front! To avoid this you can turn on *Brush.Auto Masking.BackfaceMask*. Backface masking will automatically turn off the brush's effect on the side of the surface facing away from you.

Well, that's a solid introduction to the major features of sculpting in ZBrush. We will be returning to some of these points later on and expanding upon them; but for now we should be able to move on to the next phase of applying materials to and painting our model. Don't forget to save your model now.

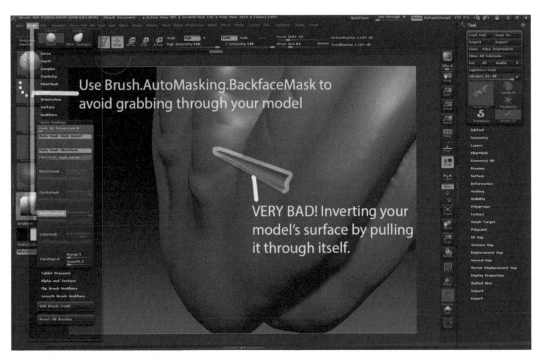

FIG 5.15 *A common error and* Backface Masking

The Dragon's Head

It's a lot of fun sculpting the dragon's head, but what if we wanted to turn that quick model into something more functional? The answer is that it can be done, of course! It will take some effort and a whole bunch of new techniques. Use the "adragon_05.ZTL" model from the supplemental materials if you want to follow along exactly.

Helpful tidbits

A couple of helpful tidbits to know. You can use *SHIFT + ALT +/−* to create an underscore symbol when you use the *Tool.SubTool.Rename* button to rename a subtool layer. For some reason you cannot get an underscore any other way in ZBrush. If you are familiar with other 3D programs, the *BackfaceMask* feature is analogous to backface culling − a switch to ignore any polygons that face away from the view screen or camera.

You can download a printable PDF of all of the various shortcuts in ZBrush from Pixologic's website (http://docs.pixologic.com/user-guide/keyboard-shortcuts).

Making a mouth

One of the biggest challenges will be to give our dragon a proper mouth. What we are going to do is cut the bottom jaw off of the current model and create a proper mouth from the pieces. To start, turn on the *PolyF* (PolyFrame) button so that you can see our polygon edges and colors.

Next we need to make sure our dragon head doesn't have any subdivision levels. Go to the *Tool.Geometry* palette and drag the *SDiv* slider to the right as

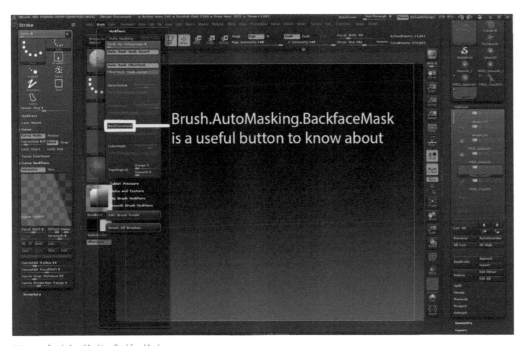

FIG 6.1 *Brush.AutoMasking.BackfaceMask*

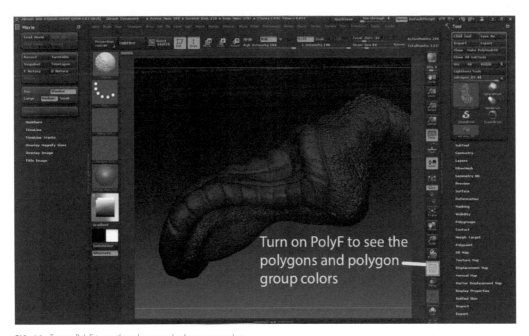

FIG 6.2 *Turn on PolyF to see the polygons and polygon group colors*

far as it will go. Now press the *Del Lower* button to delete the lower subdivision levels from our model. If you don't have any subdivision levels on your model, that is fine too. We just can't have any on the model if we are going to be slicing it apart.

Hold down the *CTRL + SHIFT* keys, click on the *SelectRect* brush icon, and select the *SliceCurve* brush from the *Brush* pop-up palette.

Now when you hold down *SHIFT + CTRL* you can access the SliceCurve brush. So press *SHIFT + CTRL* and use the *SliceCurve* brush to draw an outline around the lower jaw. When you are drawing the curve, if you press the *ALT* button you add a point on the curve which will let you bend the curve. If you press *ALT* twice at the same point you will add a corner point which will give you a sharp corner.

This has the effect of placing the part of the jaw we outlined into a separate *PolyGroup*. A *PolyGroup* is just a selection set of polygons, but it does let us use a whole assortment of specialized functions.

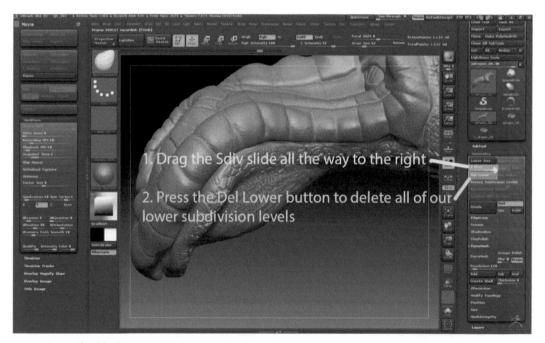

FIG 6.3 *Drag the SDiv slider all the way to the right, then press Tool.Geometry.Del Lower button*

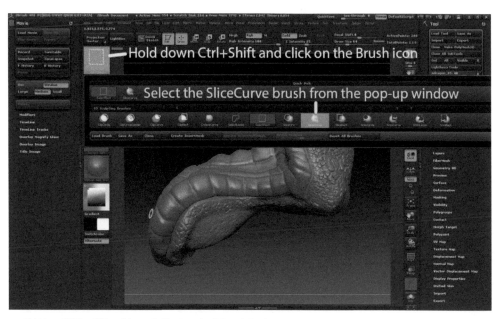

FIG 6.4 *Hold down* SHIFT + CTRL *and choose the* SliceCurve *brush from the* Brush *pop-up menu*

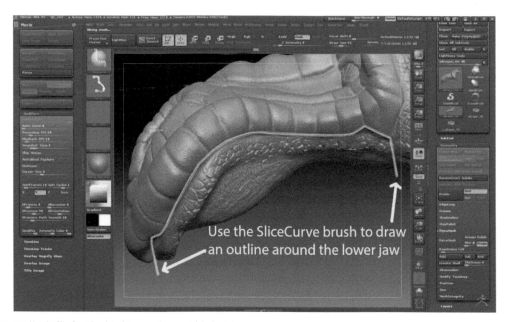

FIG 6.5 *Use the SliceCurve brush to draw an outline around the lower jaw*

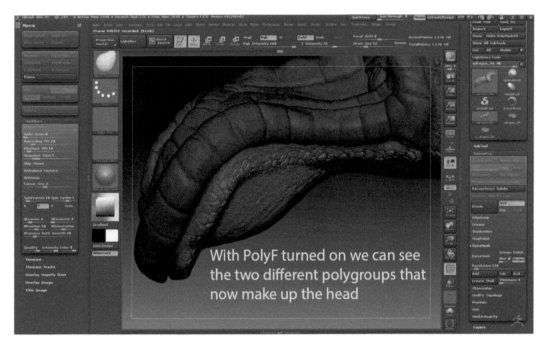

With PolyF turned on we can see
the two different polygroups that
now make up the head

FIG 6.6 *With PolyF turned on we can see the two different polygroups that now make up the head*

Hold down *CTRL + SHIFT and click* on the head. The jaw will disappear, having been hidden by the *CTRL + SHIFT + click* function. If you *CTRL + SHIFT + click* on the visible head it will swap places with the hidden object, whereas if you *CTRL + SHIFT + click* the background canvas both objects will reappear.

Now *CTRL + SHIFT + click* the jaw and hide the head. Go to the *Tool.SubTool. Split* palette and click on the *SplitHidden* button. This splits the head into two separate subtools which are both listed as different layers in the *SubTool* palette within the *Tool* menu. Both objects are still considered the same model or *Tool*; they're just placed in different layers now. Utilizing subtools is a fantastic way to organize your model. Not only are they easy to work with, each subtool can have up to 1 million or more polygons and you can have dozens of subtools on screen at once. Where a normal program would crash if you tried having 30 million polygons on screen at once, ZBrush can handle it, provided that the scene is made up of different subtools and that each subtool has no more than roughly 1 million polygons in it. The trick is that ZBrush uses a sort of mental shorthand to store subtools that are not being edited at the moment, so there's never more than 1 million or so editable polygons on screen at any one time even though there might be dozens of subtools each with 2 million polygons being displayed.

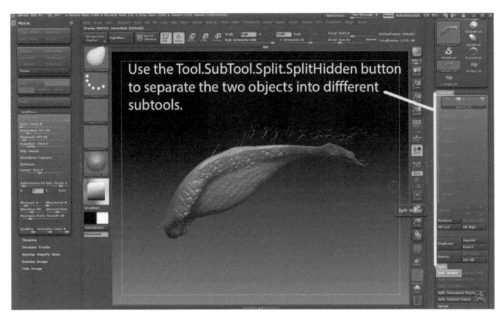

FIG 6.7 *Use the* Tool.SubTool.Split.SplitHidden *button to separate the two objects into different subtools*

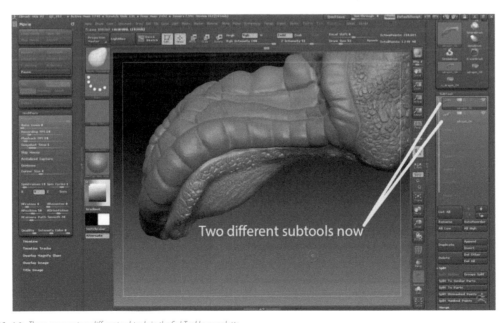

FIG 6.8 *There are now two different subtools in the SubTool layer palette*

If we now open up the *SubTool* palette within the Tool menu we can see that there are two different subtool layers within the menu: one for the top of the head and one for the jaw we just separated out.

In the *SubTool* palette, select the head layer. Click on the "eye" icon on the far right side of the layer listing to hide everything other than this layer. Go to *Tool.Geometry.DynaMesh* and set the *Resolution = 256*. Now activate *DynaMesh*. This will seal up the hole left by carving out the jaw. Hold down *SHIFT* and go over any leftover seams with the *Smooth* brush.

Using the *MoveTopological* and *Standard* brushes, carve in a shape to the roof of the mouth we just created. Don't forget to add some gums so we can add teeth later on.

Click the eye icon on the head subtool layer to unhide all of the layers. Select the jaw layer and click its eye icon to hide everything else. Now use *DynaMesh* (*Tool.Geometry.DynaMesh.DynaMesh*) to close the hole in the lower jaw. The jaw has a lot of little edges sticking out left over from when we cut it off the rest of the head. These could cause us problems modeling in the future, so we need to get rid of them. To do so, first we're going to switch our selection tool. Hold down *SHIFT* and *CTRL* and click on the *SliceCurve* icon to access the brush

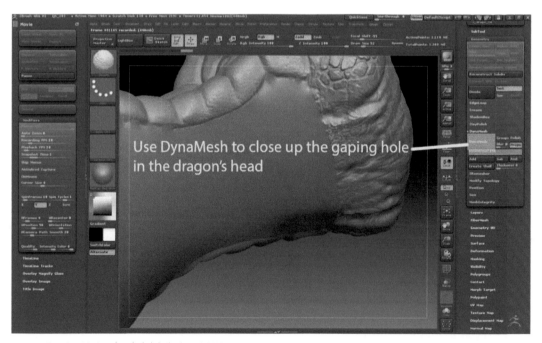

FIG 6.9 *Using DynaMesh to close the hole in the dragon's head*

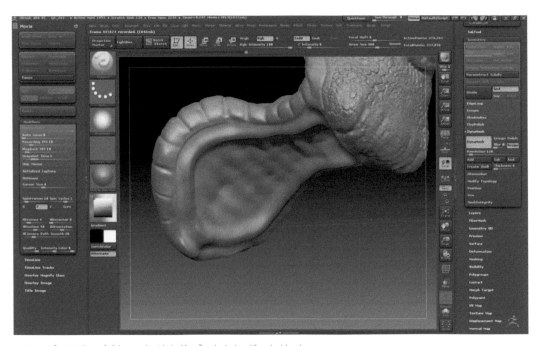

FIG 6.10 *Creating the roof of the mouth with the* MoveTopological *and* Standard *brushes*

pop-up palette where you should choose the *SelectLasso* brush. Holding down *SHIFT* + *CTRL* now brings up the *SelectLasso* brush. If you just use this, it draws out a green selection area that hides everything not within it. I prefer to press *SHIFT* + *CTRL* + *ALT* and use the red *SelectLasso*, which hides anything covered by the selection area. Now go around the edges of the lower jaw and use *SHIFT* + *CTRL* + *ALT* and the *SelectLasso* brush to hide any of the jagged edges left around the jawline.

Once you are finished hiding all of the nasty jagged edges you can use the *Tool.SubTool.Split.SplitHidden* command to cut off all those jagged edges. Select the subtool containing the nasty edges and delete them using the *Tool. SubTool.Delete* command.

DynaMesh the lower jaw once again to close up any new holes. Use the *SHIFT* key to access the *Smooth* brush and smooth away any rough spots. You can also use the *ClayBuildup*, *ClayTubes*, or *Inflate* brushes to bulk up and fill in any remaining holes in the jaws. The various clay brushes are great for building over seams and filling in small gaps, while *Inflate* is great for swelling things shut.

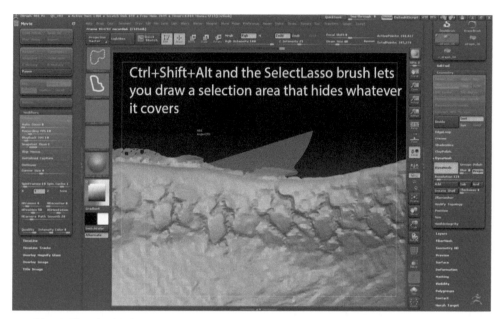

FIG 6.11 CTRL + SHIFT + ALT *and the* SelectLasso *brush lets you draw a selection area that hides whatever it covers*

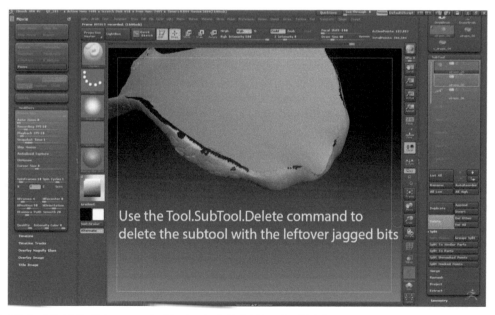

FIG 6.12 *Use the* Tool.SubTool.Delete *command to delete the subtool with the leftover jagged bits in it*

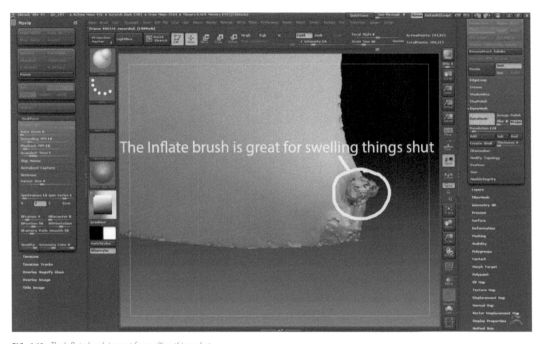

The Inflate brush is great for swelling things shut

FIG 6.13 *The* Inflate *brush is great for swelling things shut*

Once you use one of these brushes to patch things up you still need to go in and *DynaMesh* your model again to permanently fix the problem, otherwise the holes might show up again at an inopportune time when you are smoothing or otherwise working on the object. After you *DynaMesh* the object, use the *Smooth* brush to get rid of any unpleasant irregularities. Now you can use your regular brushes to sculpt in a lower part of the mouth. Don't worry about the tongue though. We will add that in later.

Once you are done sculpting the lower jaw, go back to the *SubTool* menu and click on the active layer's eye icon again to show all of your subtools. With the subtool for the lower jaw still selected, activate the *Transpose Rotate* brush by clicking on the *Rotate* icon at the top of the screen or just press the *R* key on your keyboard. Click on the base of the lower jaw where it meets the rest of the skull and drag out a transpose action line along the lower jaw that ends at the tip of the lower jaw. Use the transpose action line like a lever and click inside the rung at the outer tip of the jaw and rotate around to open the jaw.

Swap back and forth between the head and jaw subtools and use the *Inflate* and *Standard* brushes to bulk up the gums and continue sculpting the interior of the mouth.

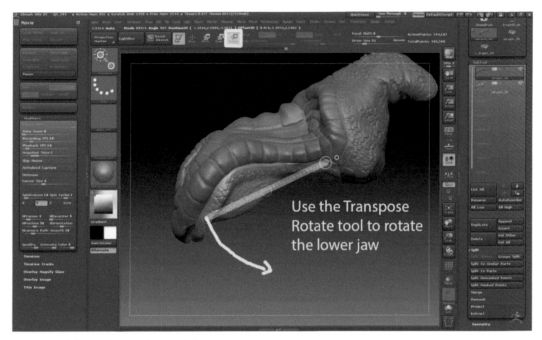

Use the Transpose
Rotate tool to rotate
the lower jaw

FIG 6.14 *Use the* Tranpose Rotate *brush to rotate the lower jaw*

Creating eyes

While the eyes carved into the head look OK, we should really try for some-thing more expressive if we are converting this concept sculpt into more of a production-quality model. Just select the *Standard* brush and hold down the *ALT* key to activate the *Zsub* sculpt mode and push the eyes in to form eye sockets.

Once we have the eye sockets sculpted we need to add the eyes. Since eye-balls are spheres, adding them is a very simple process. Go to the *Tool.SubTool* palette and click on the *Append* button. This will open up the *Tool* icon inter-face from which you can pick a *Sphere3D* tool. A *Sphere3D* will now be added as a new subtool layer to your model.

Turn on the *Transp* button to make your other subtools transparent so it is easier to find the new *Sphere3D* subtool you've just added. Open the *Tool. SubTool* palette and find the subtool layer your sphere is on and click on that layer to activate it. The sphere will highlight and become the active tool. Press the *W* key on the keyboard to activate the *Transpose Move* brush.

Now click on the sphere and drag out a new transpose action line. Click inside the middle rung on the action line and drag to move the sphere into place over the eye socket.

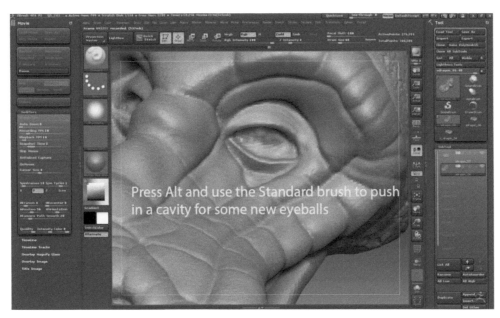

FIG 6.15 *Hold down* ALT *and use the* Standard *brush to push in a cavity for some new eyeballs*

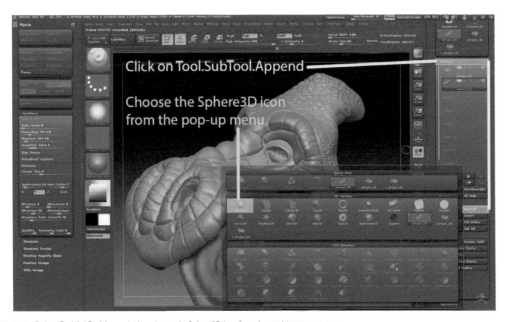

FIG 6.16 *Click on* Tool.SubTool.Append, *then choose the* Sphere3D *icon from the resulting pop-up menu*

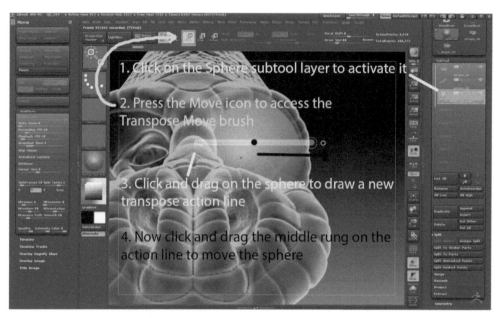

FIG 6.17 *Accessing the* Transpose Move *brush for your* Sphere *subtool*

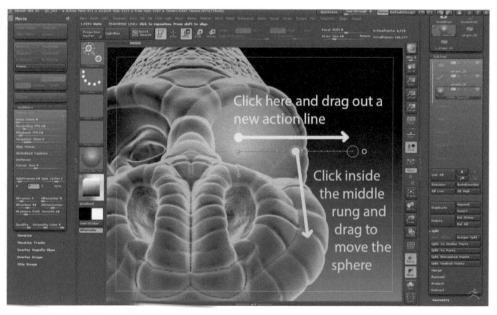

FIG 6.18 *Using the* Transpose Move *brush*

Now select the *Transpose Scale* brush by clicking on its icon or pressing the *E* keyboard shortcut. Click and drag on the inside of the rung farthest from the sphere to scale the sphere to fit inside the eye. Switch back and forth between the *Scale* and *Move* functions to position the eyeball inside the socket.

Once you have the eyeball positioned where you want it, go to the *SubTool* palette and select the layer that contains the dragon head model. Now you can use the *Move Topological* and *Inflate* brushes to create eyelids for the eye.

Use the *DAM_Standard* brush to carve in the wrinkles around the eyes. A highly effective approach is to carve in a line, then soften it using the *Smooth* brush, and then repeat the process so that you gradually build up an effect. As a general rule, you want to sculpt with fairly low *Z Intensity* settings so that you gradually build up your form. Using this approach will result in a more sophisticated surface that contains more visual interest.

Now activate the lower jaw layer in the *SubTool* palette and use the *Standard* brush to add some more detail to the mouth. Then switch to the upper part of the head and add more definition to the roof of the mouth as well.

To create the pupil of the eye, select the sphere subtool layer and turn on *PolyF* so we can see polygons that make the sphere.

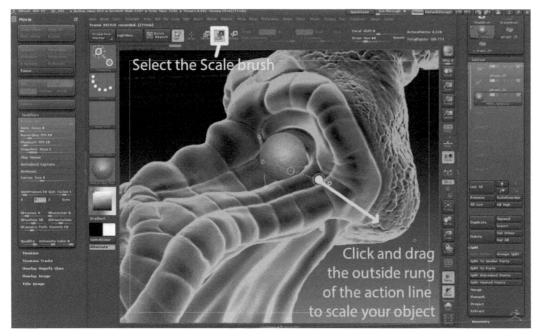

FIG 6.19 *The Transpose Scale brush*

FIG 6.20 *Use the* Move Topological *and* Inflate *brushes to create the eyelids*

FIG 6.21 *Use the* DAM_Standard *brush to create the wrinkles around the eyes*

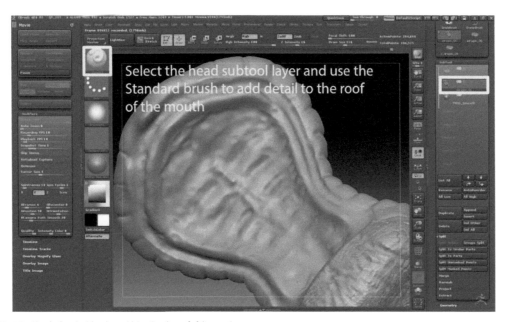

FIG 6.22 *Use the* Standard *brush to add detail to the roof of the mouth*

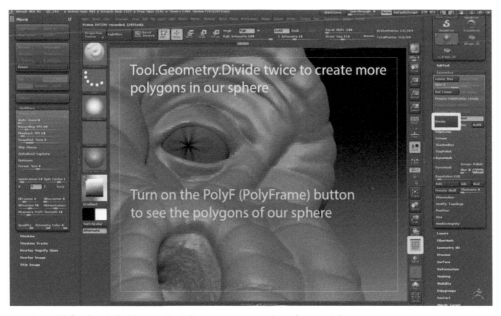

FIG 6.23 *Turn on* PolyF *and use the* Tool.Geometry.Divide *button to create more polygons for our eyeball*

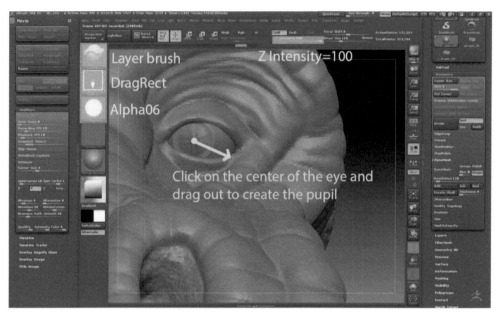

FIG 6.24 *Use the* Layer *brush,* DragRect *stroke, and* Alpha 06 *to create the pupil*

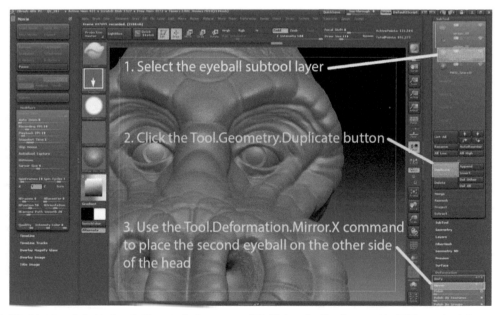

FIG 6.25 *Select the eyeball subtool layer, Tool.Geometry.Duplicate; now use the* Tool.Deformation.Mirror.X *command to place the second eyeball*

Click the *Tool.Geometry.Divide* button twice to subdivide the sphere and give more resolution to sculpt with. You cannot sculpt any detail on a surface that doesn't have enough resolution to support it.

Change your brush to the *Layer* brush, set *Z Intensity* to 100, and change your *Stroke* to *DragRect*. Change your *BrushAlpha* to *Alpha 06*, a circle with a slightly blurred edge. Hold down the *ALT* key and click on the pole of the sphere, the dark part where all of the polygon edges meet, and drag out the circle to form an indentation for the pupil.

To create the other eyeball, go to the *SubTool* palette and select the eyeball layer. Use the *Tool.Geometry.Duplicate* command to create a copy of the eyeball. Then use the *Tool.Deformation.Mirror.X* button to place the second eyeball in the correct location.

Teeth

What kind of dragon would he be if he didn't have teeth? Obviously we need to create some teeth. Luckily it is a fairly easy process. First append a *Cone3D* to our dragon head model by going to the *SubTool* palette and clicking on the *Append* button and selecting the *Cone3D* icon from the *Tool*

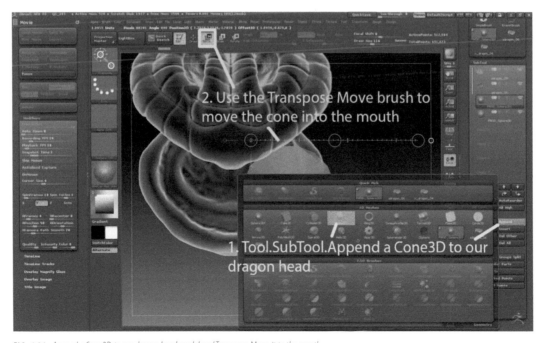

FIG 6.26 *Append a* Cone3D *to our dragon head model and* Transpose Move *it to the mouth*

pop-up window that opens. Then use the *Transpose Move* brush to move the cone into the mouth.

Use the *Transpose Scale* and *Move* brushes to fit the tooth into the mouth. Activate *Tool.Geometry.DynaMesh.DynaMesh* to resurface the tooth and use the *Move Topological* brush to sculpt the cone into more of a tooth shape.

Click on the *Tool.SubTool.Duplicate* button to create a copy of the tooth. Use the *Transpose Move* brush to move it to a new place in the mouth. Then use the *Transpose Rotate* and *Scale* brushes along with the *MoveTopological* brush to adjust it.

Repeat these steps, duplicating the tooth, then moving, scaling, and sculpting it into position to create all of the teeth on one side of the lower jar. Once you have half a jaw of teeth done we can merge all of the teeth using the *Tool.SubTool.MergeDown* command. Since the *MergeDown* command does exactly that (it merges the selected subtool with the one below it), you can use the *MoveUp* and *MoveDown* arrow keys (the up and over icons) to rearrange the order of the layers in the *SubTool* palette and control which subtools get merged that way. Always keep in mind the size of your mode. Look at the number of *ActivePoints* in the upper right-hand side of the interface. This tells

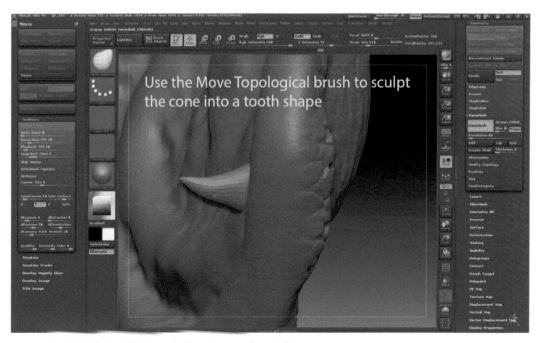

FIG 6.27 *Use the* Move Topological *brush to sculpt the cone into more of a tooth shape*

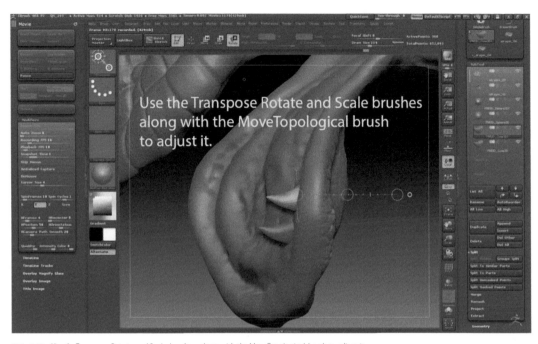

Use the Transpose Rotate and Scale brushes
along with the MoveTopological brush
to adjust it.

FIG 6.28 *Use the* Transpose Rotate *and* Scale *brushes, along with the* MoveTopological *brush to adjust it*

you the number of active points in your subtool. Make sure that the total number of active points in your subtools won't combine to make an amount of geometry that ZBrush can't handle. In other words, save frequently when merging subtools!

You can also use the *Tool.SubTool.Merge.MergeVisible* command to combine all of your currently visible subtools. This leaves the original model unaffected and creates a new tool combining all of the subtools in the *Tool* pop-up menu. There are no visual cues for this and it doesn't automatically switch to the new model, so make sure you check the Tool pop-up menu before continuing or assuming that the command did not work.

Next, with your newly merged teeth subtool selected click on the *Tool.SubTool. Duplicate* button, then use *Tool.Deformation.Mirror.X* to copy the teeth to the other side of the jaw just like we did for the eyeballs. Now you can merge the mirrored copy with the original, then duplicate this subtool. Use *Tool.Deformation.Mirror.Y* to create the teeth for the upper jaw. Use the *Transpose Rotate* brush to orient the teeth with the jaw.

Because each tooth is a separate object, you can use *CTRL + SHIFT + ALT and click* on a tooth to isolate it and hide the other teeth. If you have *Transform.*

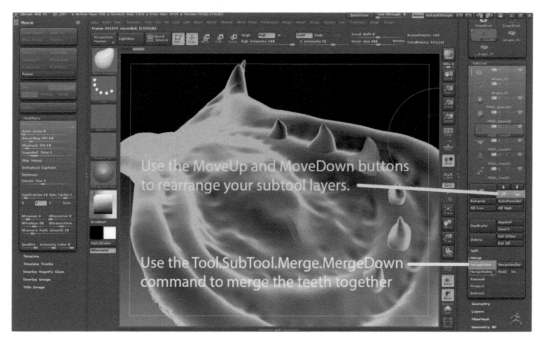

FIG 6.29 *The* Tool.SubTool.MergeDown *command will merge the different teeth subtools together; use the* MoveUp *and* MoveDown *buttons to rearrange your subtool layers*

Symmetry.X on at the time it will keep the teeth on both sides of the jaw. A variation on this approach is to hold down *CTRL + SHIFT* and pick the *Select-Lasso* brush. This brush will now activate every time you press *CTRL + SHIFT*. So if you press *CTRL + SHIFT* you can draw a green selection lasso around any object you want to keep visible. Any part of that subtool not covered by the green selection lasso will get hidden. If you press *CTRL + SHIFT + ALT* the selection lasso will be red and it will hide anything it covers. Once you start to draw the *SelectionLasso* you can let go of the keyboard buttons; it won't change the brush. With only a specific set of teeth showing you can *Move, Rotate,* and sculpt just these two teeth without affecting the ones that are hidden. To unhide all of the teeth, just *CTRL + SHIFT + click* the background.

Now just carefully work through all of the teeth making sure each pair is positioned properly. A neat trick is using the *MoveTopological* brush for this. The topological part of the name means that it pays attention to the surface of the object it is moving. In other words, it will move one tooth without affecting the others. Make the brush size quite large and turn the *Focal Shift* way down so there isn't any falloff and you can quickly move teeth around. A very useful thing to know!

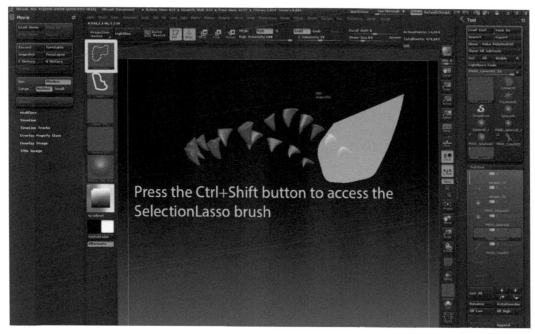

Press the Ctrl+Shift button to access the
SelectionLasso brush

FIG 6.30 *Using the* SelectionLasso *to hide objects*

Tongue

To make the tongue, I'd like to introduce the *CurveTube* brush. This brush is a
very quick way of drawing curved tubes. Simply click on your current brush
and select the *CurveTube* brush from the brush pop-up menu. Now just draw a
forked tongue or rather an inverted T shape on screen.

While the brush icon is blue, it is in edit curve mode. You can use it now to
move the curve around and edit it. Use the *S* key to make the brush bigger or
smaller to edit more or fewer points at the same time on the existing curve.
If you move the brush away from the curve, it changes color to red. If you
change the size of the brush while it is red, then click on the curve, it updates
the size of the tube placed along the curve.

Click on the little red line at the tip of the curve to draw an extension onto it.

Open the Stroke menu on the top menu shelf and click the circular icon and
drag it into the left tray. The *Stroke* menu contains all of the controls and
settings for the curve brushes. For example, the *Stroke.CurveModifiers.Snap-
Distance* slider controls the length of the little red line at the tips of the
curve, which allow you to keep extending your curve once it is drawn.
Having *Stroke.Curve.Bend* on will allow you to edit and bend the curve.

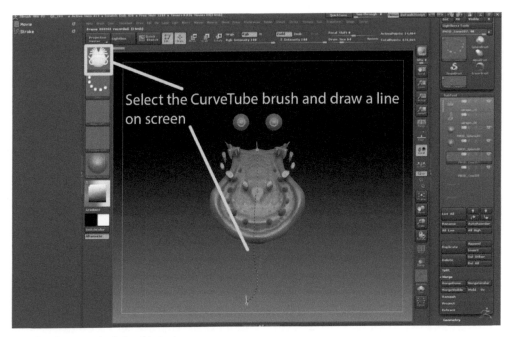

FIG 6.31 *Draw the tongue using the* CurveTube *brush*

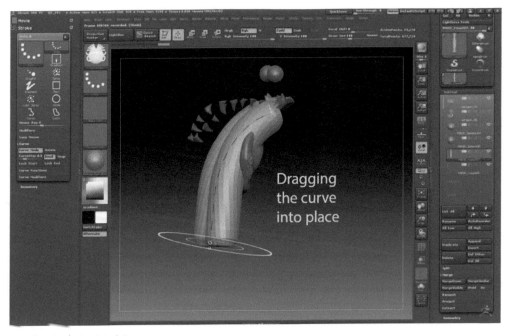

FIG 6.32 *Dragging the curve into place*

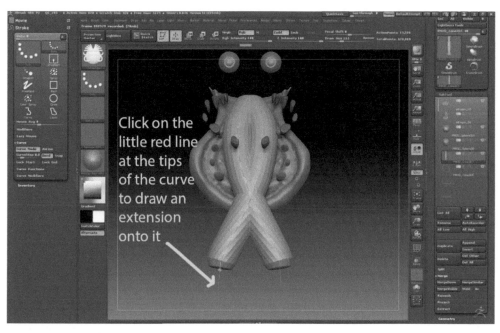

FIG 6.33 *Extending the curve further*

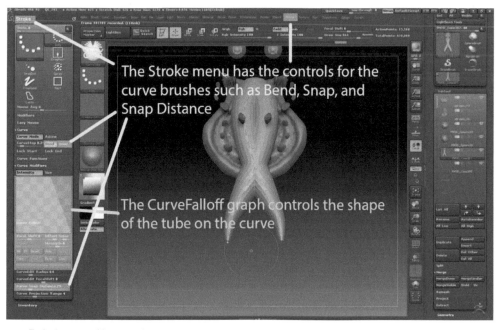

FIG 6.34 *The Stroke menu and Curve controls*

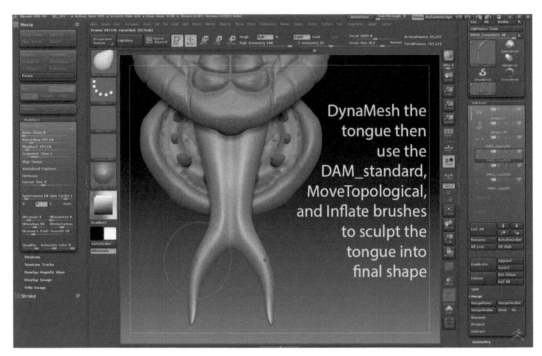

Within the image: DynaMesh the tongue then use the DAM_standard, MoveTopological, and Inflate brushes to sculpt the tongue into final shape

FIG 6.35 *Finishing the tongue*

The *Stroke.Curve.Snap* button toggles whether the curve will snap to the underlying surface. Make sure that *Curve Mode* is on or you won't be able to access the curve controls.

Click on *Curve Falloff* in the *Stroke.CurveModifiers* palette. This opens up a graph which controls the shape of the tube on the curve. You can adjust the end points to change the shape of the tube and even add extra control points on the graph curve just by clicking on it. If you click and grab a control point on the graph and drag it off the side of the graph and then back onto it you will change the control point from a curve to a sharp corner point. If you just drag a control point off the side of the graph and release it there you will delete that control point – but you can't delete the original two on the graph, just the ones you have added. If you mess up horribly you can press the *Reset* button under the graph while you can use the *Save* and *Load* buttons there to save a graph out for future use or load an existing one off of the hard drive. Shape your graph like the one in the picture to get the same tongue shape. Hint: try adding an extra control point in the middle and turning it into a corner point, then dragging it and the first point all the way to the top.

To finish the tongue simply *DynaMesh* it and smooth it out. Use the *DAM_standard* brush to carve in a few details and use the *MoveTopological* and Inflate brushes to tweak its shape.

Creating the Wings Using Shadowbox and ZSketch

Shadowbox

It is a good idea to start new projects by clicking on the *Preferences.Initialize* button to re-initialize ZBrush back to its default settings and clear out any previously loaded tools. Now we can get to work making bat wings for our little dragon.

To begin making the wings, click on the golden "S" brush icon and select the *Plane3D* tool from the *Tool* icon pop-up list. Then click the *Tool.MakePolymesh3D* button to convert the plane into an object we can sculpt.

Choose a different material, something white like *SkinShade4* for our plane. Now draw the plane on screen while holding the *Shift* button so it locks into place, then immediately press *T* to go into *Edit* mode.

Press the *F* key to frame your object on screen. Open the *Tool.Geometry.Shadow Box* palette, set *Res = 256*, then press the large *ShadowBox* button.

Turn on the *Floor* button so you can see the reference grids for each axis. Now hold down the *SHIFT* key and rotate your view so that you are looking down the X axis at the red-tinted grid.

Press the *Tool.Masking.Clear* button to get rid of any existing masks. Now hold down the *CTRL* key and choose the *MaskLasso* brush from the Brush palette. Try out the *ShadowBox* by drawing a mask on it. Drawing on the back plane creates the shape. You can press *CTRL + ALT + MaskLasso* to subtract from the existing mask.

Rotate your view to the side. Drawing a mask on the side plane controls the depth of the resulting shadowbox object. Press the *Tool.Masking.Clear* button

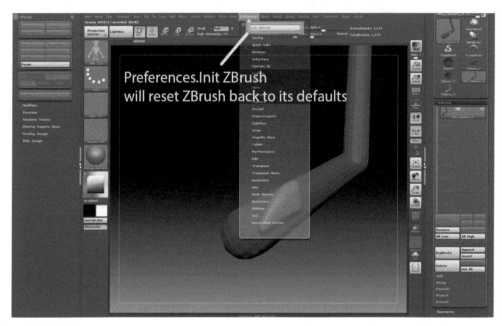

Preferences.Init ZBrush
will reset ZBrush back to its defaults

FIG 7.1 *Initialize ZBrush*

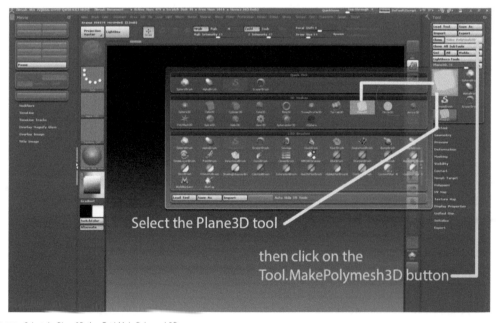

Select the Plane3D tool

then click on the
Tool.MakePolymesh3D button

FIG 7.2 *Select the* Plane3D *then* Tool.MakePolymesh3D

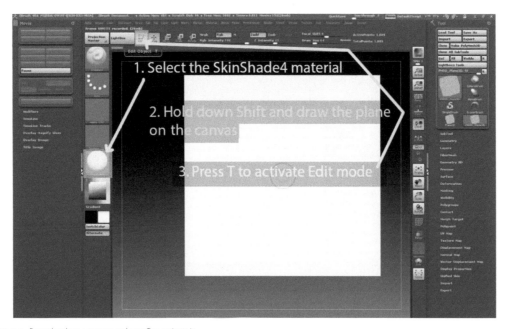

FIG 7.3 *Draw the plane on screen and press* T *to activate it*

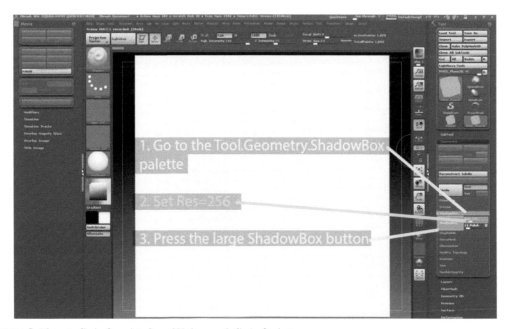

FIG 7.4 Tool.Geometry.ShadowBox *palette,* Res = *256, then press the* ShadowBox *button*

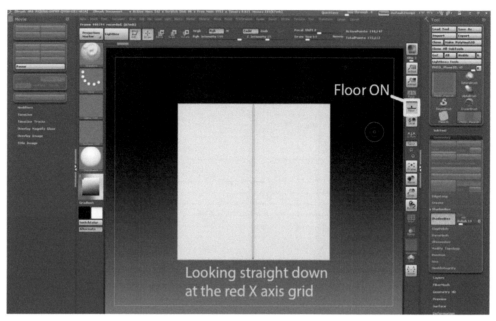

FIG 7.5 *Turn on* Floor *and rotate your view so you are looking down the X axis*

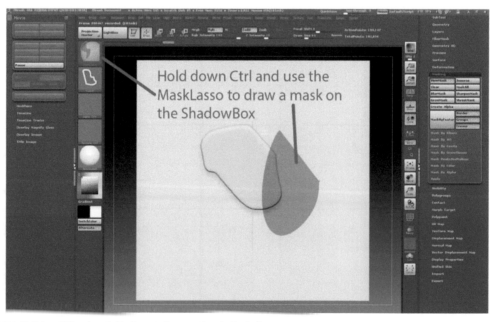

FIG 7.6 *Hold down* CTRL *and use the* MaskLasso *to draw a mask on the ShadowBox*

to get rid of any existing masks and empty the *ShadowBox*. Make sure that the *Perspective* button is off and *Rgb* mode is on before proceeding to the next step. Line your view back up with the X axis so that you are again staring down at the reddish floor grid. Go to the *Document* menu and click on the *ZAppLink* button.

If you get a query to "*Enable Polygon Colorize?*", answer yes.

If this is the very first time you have ever used *ZAppLink*, you will have to set the target app for it. Click on the *Set Target App* button on the *ZAppLink Projection Dialogue* menu box. Point it towards the install location of either Photoshop or GIMP depending upon which one you have installed.

After you have set the application for it to work with, *ZAppLink* will present an option window. Turn *Double Sided = ON, Fade = ON*, and *Enable Perspective = OFF*, then click the *DROP NOW* button.

A copy of your ZBrush canvas will open in Photoshop. Open the "dragon_ wing_mask.jpg" image on the companion website, use *CTRL + A* to select the image, then use *CTRL + X* to cut the image of the wing into memory. Select the ZAppLink image window in Photoshop and paste the dragon wing silhouette into the picture using the *CTRL + V* shortcut.

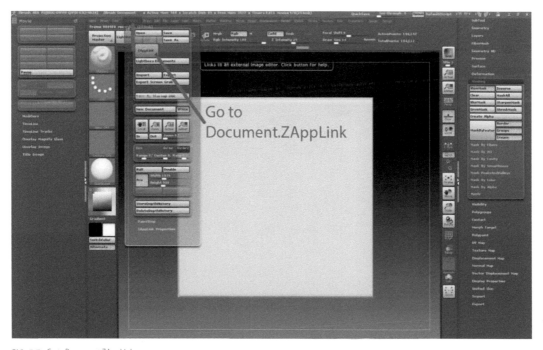

FIG 7.7 *Go to* Document.ZAppLink

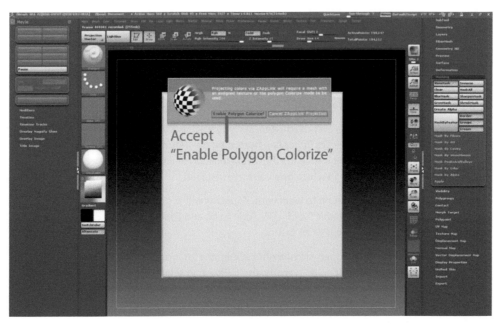

FIG 7.8 *Accept the* "Enable Polygon Colorize?" *query*

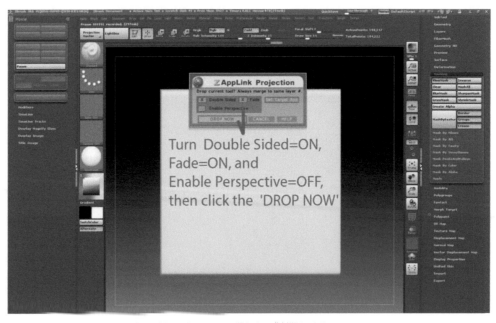

FIG 7.9 *Turn* Double Sided = ON, Fade = ON, *and* Enable Perspective = OFF, *then click* DROP NOW

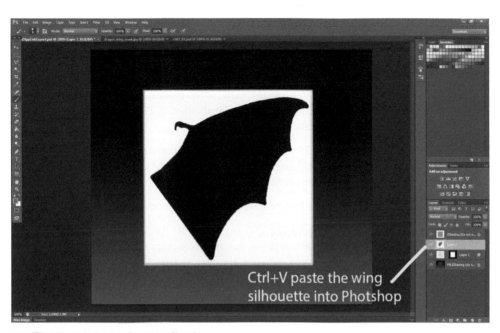

FIG 7.10 *CTRL + V to paste the wing silhouette into Photoshop*

FIG 7.11 *Preserve the Layer Mask when you CTRL + E to merge the silhouette into "Layer 1"*

Merge the dragon wing image layer down into *"Layer 1"* using the *CTRL + E* shortcut and opt to *"Preserve the mask"* when asked. Now save your Photoshop image using the *CTRL + S* shortcut.

Any modifications that you make in Photoshop to the ZAppLink image must be merged into *"Layer 1"* in the *Layers* palette. Do not change the name of *"Layer 1"*, do not modify the ZShading or *Fill ZShading* layers, and do not lose the layer mask!

Go back to ZBrush and in the option window on screen choose *Re-enter ZBrush*, and *Pickup Now*. This will transfer the image from Photoshop onto our object in ZBrush. Magic!

Click on the *Tool.Masking.MaskByColor.MaskByIntensity* button.

Now hold down the *CTRL* key to activate the *MaskLasso* brush and mask off an empty section to get ShadowBox to update. You will see the dragon wing model pop into existence. Now you can use *CTRL + ALT MaskLasso* and get rid of the little speck you created when you forced ZBrush to update with the previous *MaskLasso*.

Hold down the *CTRL* key again and change the brush to *MaskRect*. Now rotate your view to the side while holding down the *SHIFT* key so that you get a

FIG 7.12 *Choose to* Re-enter ZBrush

FIG 7.13 *Then select* Pickup Now

FIG 7.14 *Tool.Masking.MaskByColor.MaskByIntensity*

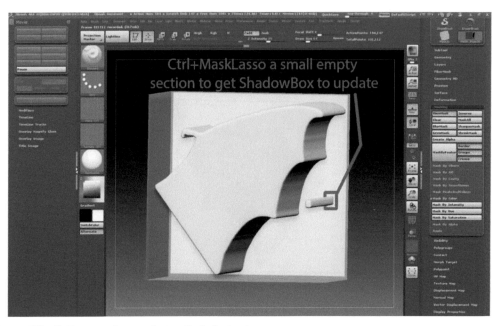

FIG 7.15 CTRL + MaskLasso *a small empty section to get ShadowBox to update*

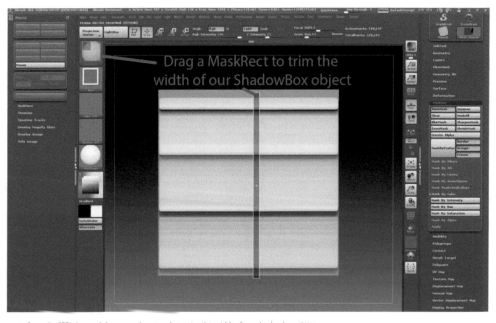

FIG 7.16 *Press the CTRL key and drag a mask rectangle to trim the width of our shadowbox object*

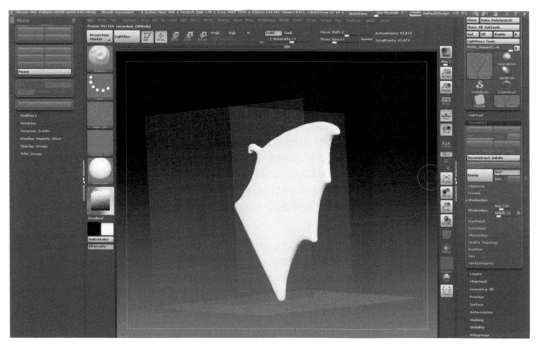

FIG 7.17 *The finished ShadowBox wing object*

perfect side view of the model. Currently it looks like a thick block. Press the
CTRL key and drag a mask rectangle to trim down your shadowbox shape to
proper wing thickness.

You're done! Turn the *Tool.Geometry.ShadowBox OFF* and save your object
using the *Tool.Save As* button. Call it *Wings.ZTL* and save it someplace you can
find it again later.

You could have just used the *MaskLasso* brush to hand draw the wings onto
the ShadowBox, but it was a lot more fun using ZAppLink instead. You can
also use ZAppLink to paint your objects as long as you have *Rgb* mode turned
on when you click on the ZAppLink button. The *Double Sided* option in ZApp-
Link is buggy and you have to enable or disable that option using the *Tool.
Display Properties.Double* button, in addition to selecting *Double Sided* in the
ZAppLink option window.

ZSketch

Load your dragon wing tool into the *Tool* palette using the *Tool.LoadTool* com-
mand if it isn't already loaded. Use the *Tool.SubTool.Append* command to add

a *ZSphere* to your model. Select the *ZSphere* subtool layer, shrink the *ZSphere* down and fit it in the wing.

Make sure that you have your *ZSphere* subtool layer selected. Now click on *Tool.ZSketch.Edit Sketch* or use the *SHIFT + A* shortcut to turn on *ZSketch*. Notice that your *ZSphere* now changes color.

Make sure that *Draw (Q)* mode is on. In the brush palette the regular brushes have been replaced with ones specific to *ZSketch*. Click on the large *Brush* icon for the *Sketch 1 ZSketch* brush located on the top of the left hand tray. Now you can select from an array of brushes unique to *ZSketch*. If you want access to a few more *ZSketch* brushes, open the brush pop-up palette and click the *Load Brush* button and load the *Sketch 2* brush from "C:\Program Files (x86)\ Pixologic\ZBrush 4R6\ZBrushes\ZSketch" or from wherever your ZBrush install folder is located.

Now that we've got *ZSketch* working, we need to draw in the wing bones first. The only problem is that a couple of them are straight lines and there's a trick to drawing straight lines in ZBrush and it takes a bit of work. Turn on *Stroke. LazyMouse* with the *BackTrack*, *SnapToTrack* and *Spline* options turned on. The way this works is you draw out a straight line creating an action line, then you

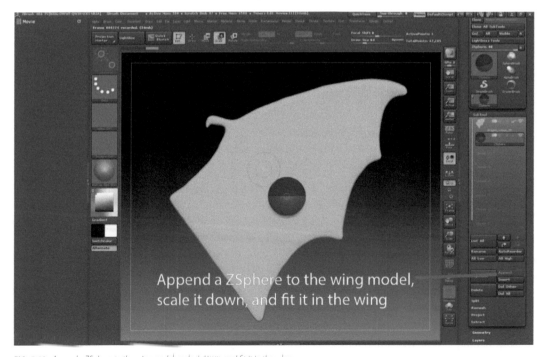

FIG 7.18 *Append a ZSphere to the wing model, scale it down, and fit it in the wing*

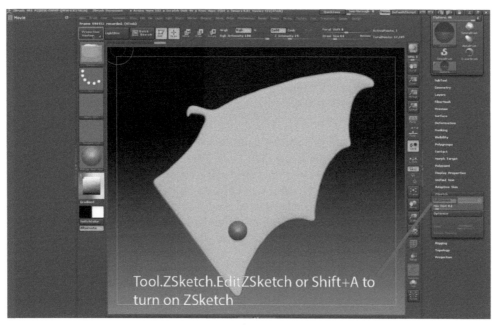

FIG 7.19 Tool.ZSketch.Edit Sketch *or* SHIFT + A *to turn on ZSketch*

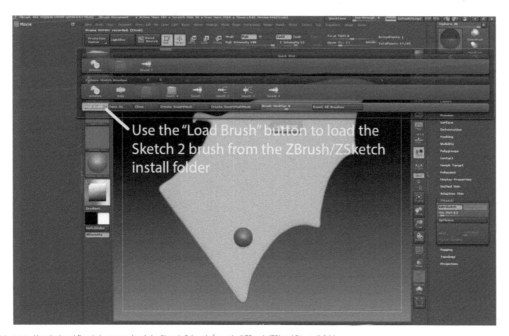

FIG 7.20 *Use the* Load Brush *button to load the Sketch 2 brush from the* "ZBrush/ZSketch" *install folder*

paint the *ZSketch* stroke back along that line. It is quite weird, takes more than a bit of getting used to and never feels natural. Be careful, though, where you end your lines so it doesn't latch onto part of the existing model and go off center plane.

Once you've drawn in the straight lines you need you can turn off *LazyMouse* and disable drawing straight lines. Now you can sketch in the structure for the meat and bones of the wing.

If you need to delete some *ZSpheres* from your sketch, just hold down the *Alt* key and erase over them. Once you are finished with *ZSketch*, press the *A* key or use the *Tool.Unified Skin.Preview* button to see a preview of your resulting mesh. Press *A* again to return to *ZSketch*. Change the *Tool.Unified Skin.Resolution = 256* to generate a fairly detailed mesh, then click the *Tool.Unified Skin. Make Unified Skin* button to create a new tool called *Skin_ZSphere* in your Tool list at the top of the Tool menu.

Use *Tool.Subtool.Append* to add the Skin_ZSpheres model as a subtool to your wing model. Use *Tool.Subtool.Delete* to get rid of the ZSphere subtool.

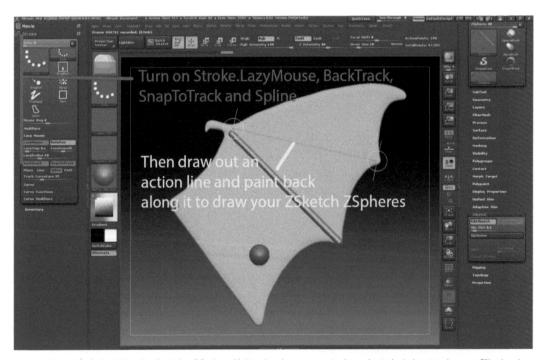

FIG 7.21 *Turn on Stroke.LazyMouse, BackTrack, SnapToTrack, and Spline; then draw out an action line and paint back along it to draw your ZSketch and ZSphere line*

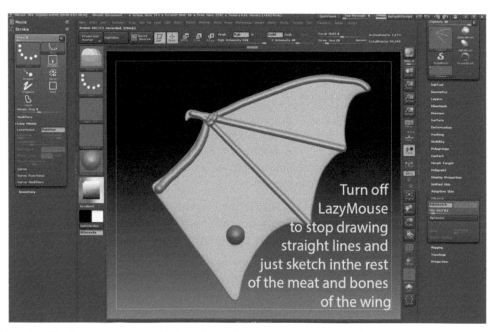

FIG 7.22 *Turn off* LazyMouse *to stop drawing straight lines and just sketch in the rest of the meat and bones of the wing*

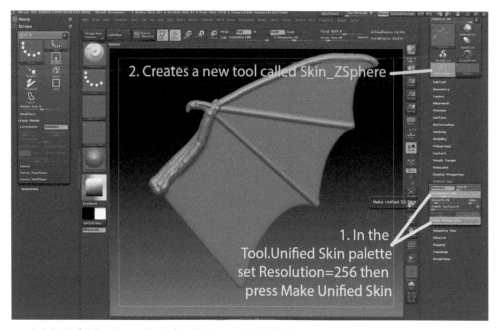

FIG 7.23 *In the* Tool.Unified Skin *palette, set* Resolution = 256, *then press* Make Unified Skin; *this creates a new tool called "Skin_ZSphere"*

Refine the wing

Change the *Draw.Elv* value from −1 to 0. This means that the grid floor will be drawn on the actual center of your objects and not underneath them. Now move your wing so that it is centered inside the muscles and bones you ZSketched.

Select your Skin_ZSphere subtool layer and click on the *Tool.Geometry. MirrorAndWeld.X*. This will force the object to be symmetrical by duplicating and welding half of it to itself. If you end up getting the half of the model you don't like, try *Tool.Deformation.Mirror* first and then use *MirrorAndWeld*.

Combine all of your wing subtools together using the *Tool.SubTool.MergeDown* command. Now set your *DynaMesh.Resolution* to 256 and then *DynaMesh* the object to combine everything into one solid mesh.

To create some surface texture on our wings, turn on *Transform.Symmetry.X*, then select the *Standard brush*, *Alpha 62* brush alpha, *Color Spray* brush stroke, and set *Z intensity* = 10. Now coat the flaps on the wing with this pattern.

FIG 7.24 *Make sure your wing is centered amidst your meat and bones*

FIG 7.25 *After* Tool.Geometry.MirrorAndWeld.X

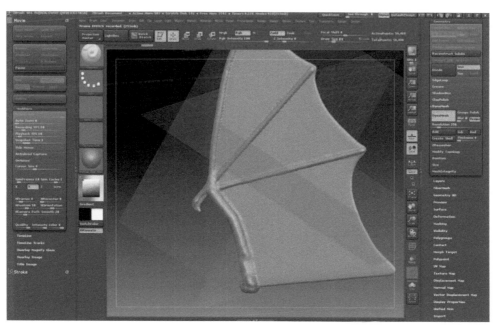

FIG 7.26 DynaMesh *the wing parts all together*

FIG 7.27 *Add a pattern to the wings*

FIG 7.28 *Add scales to the wing muscles*

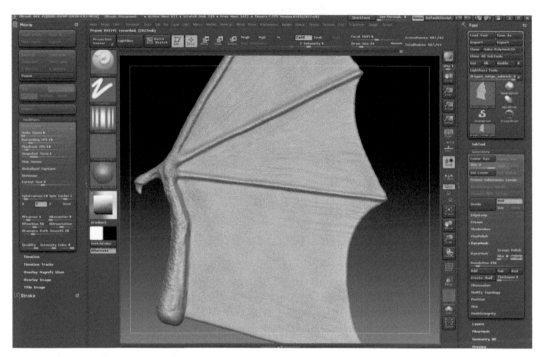

FIG 7.29 *Add creases and streaks to the wing flaps*

Next select the *Standard* brush, *Alpha 62* brush alpha, *DragDot* stroke, and set *Z intensity* = 20. Decorate the muscular part of the wing with scales.

Now try the *Standard* brush with the *Alpha 60* brush alpha, *FreeHand* stroke, and a *Z intensity* = 3. Use these settings to create creases in the wing flaps from front to back to represent fold creases.

Once you are done, save the model using *Tool.Save As*.

Making the Dragon's Body

Introducing ZSpheres

One of the benefits of using ZBrush is how it speeds up the production process. For example, it is becoming common to skip creating concept art using pen and paper, or 2D software like Photoshop and jump right into sculpting a concept model directly in ZBrush. It is easy enough to try out several variations in ZBrush, and if the concept is approved you've already created the basic model! Using DynaMesh is one method for creating a fast sculpt; another is using ZSpheres.

To create a model using ZSpheres, start by selecting a *ZSphere* (the red two-toned ball) from the *Tool* menu and drawing it on your canvas. Now go into *Edit* mode (*T* key) and press the *Q* key to get into *Draw* mode.

Place your cursor over the existing ZSphere and draw out another ZSphere.

Press the *W* key to go into *Move* mode and move this new ZSphere around by clicking and dragging it. Notice how ZBrush adds more in-between ZSpheres to fit the distance between the two? When you are working with ZSpheres, the normal draw, move, scale, and rotate transpose brushes take on different behaviors. You will no longer get the transpose action line when invoking these functions. Instead, simply clicking and dragging on any of the active ZSpheres will allow you to directly transform it. Try the different transform brushes out now. Press the *E* key to use *Scale* mode and click and drag on a ZSphere to scale it. Now try the *Rotate* mode by pressing the *R* key. Notice the difference between rotating a ZSphere and rotating one of the connecting triangular links between the ZSpheres.

Active ZSpheres show up as two-toned red spheres, while linking ZSpheres that create the ZSphere chain show up as a dull red color with a white triangle-shaped bone superimposed upon them. You can rotate the entire chain of ZSpheres without changing its shape by going into rotate or move

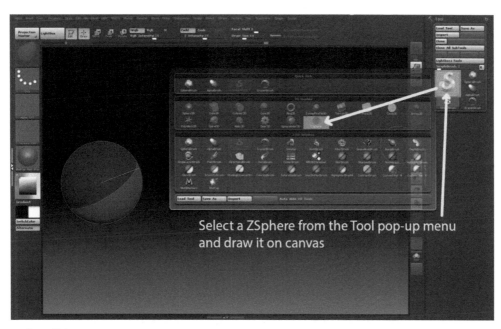

FIG 8.1 *Draw a ZSphere on canvas*

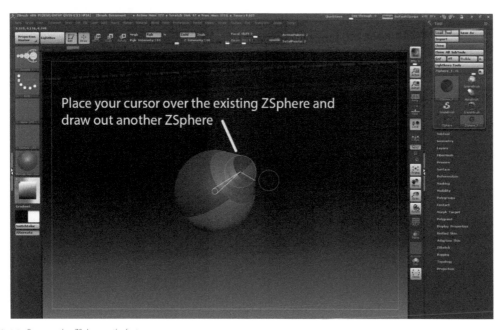

FIG 8.2 *Draw another ZSphere on the first one*

mode and clicking and dragging on one of the white connecting triangles. If you move one of the active ZSpheres, the ZSphere chain will expand or collapse to adjust, adding or removing linking ZSpheres as needed. Using a very small brush size when moving, scaling and rotating ZSpheres will make it a lot easier to edit and allow you to be more accurate in your selections.

When you are in *Draw* mode (*Q*), the small circle that appears in the center of your brush when you have your cursor over an existing ZSphere shows you where a new ZSphere would start if you decided to draw it. The color of this small circle tells you whether or not you're in a good spot. Green indicates a good spot, but when it is red you might end up with problems later on when you try to generate a skin from your ZSphere chain. If part of the ZSphere chain goes transparent or dark it is a warning that you need to rearrange your ZSphere positions to avoid future errors. Any of these mistakes could create geometry later on that is folded in upon itself, twisted polygons, or other problems.

You can refine your ZSphere chain by changing any of the linking ZSpheres to active ones just by clicking on them while in Draw mode. If you change your mind and want to get rid of any of your active ZSpheres, just hold down the *ALT* button while in *Draw* mode and click on the offending active ZSphere to delete it.

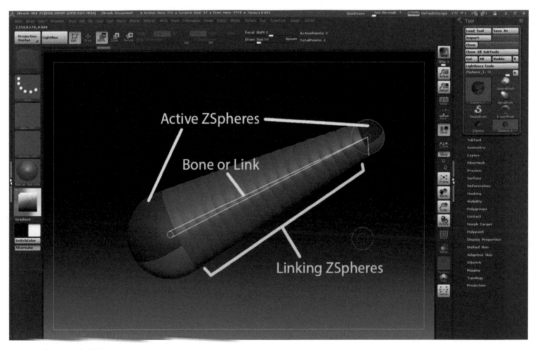

FIG 8.3 *Elements of a ZSphere chain*

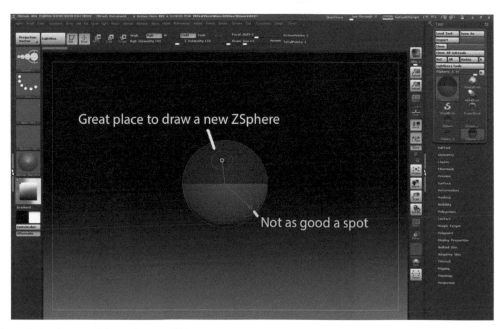

FIG 8.4 *Good and not so good places to draw a new ZSphere*

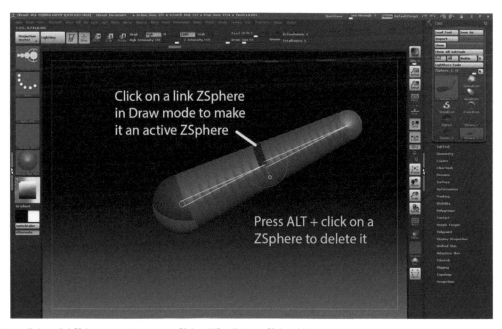

FIG 8.5 *Click on a link ZSphere to turn it into an active ZSphere; ALT + Clicking a ZSphere deletes it*

Go ahead and draw out a simple ZSphere chain to play with and get a feel for how they work. Start by drawing a new ZSphere tool on screen, going into *Edit* mode; then, making sure you are in *Draw* mode, simply draw another active ZSphere on the surface of the original sphere. Switch into *Move* mode using the *W* key and click and drag the newer ZSphere to where you want your chain of ZSpheres to end. Now you can switch back into *Draw* mode (*Q*) and add more active ZSpheres to your chain and move, rotate, and scale them into shape. If you need to draw additional ZSpheres coming off the chain, go right ahead. Be careful, though: once you start increasing the number of ZSphere branches coming off a particular parent ZSphere to more than a few you can start getting errors in your derived surface. If the ZSphere chain turns transparent, that is a sure sign that things aren't going well and you should adjust those ZSpheres until they look normal again.

The white triangles between the ZSpheres, sometimes called links or bones, tell you how the different ZSpheres influence each other. The ZSphere at the thick end of the triangle is the parent; the one at the pointy end is the child. Transformations – that is to say, movement, rotations, and scale – flow from the parent to the child, but not from the child to the parent. Basically, it is just a long-winded way of saying that if you rotate the arm the parent

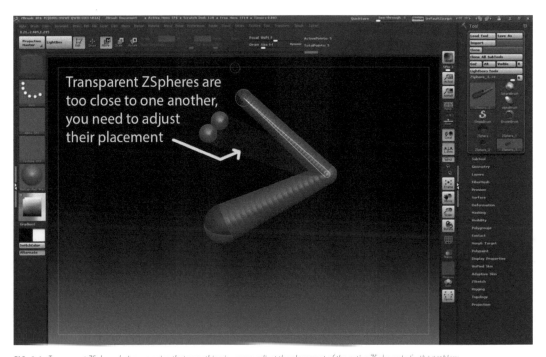

FIG 8.6 *Transparent ZSphere chains are a sign that something is wrong; adjust the placement of the active ZSpheres to fix the problem*

ZSphere is on, the child will rotate with it. The system is actually quite intuitive and it won't take you much time of playing with it to make sense of how it works. Try drawing, deleting, and transforming ZSphere chains until you are quite comfortable with them. Nothing aids learning so much as doing.

There are two ways of converting your ZSpheres into sculptable objects. The first is called *Adaptive Skin* and usually yields good results. To see what your potential adaptive skin looks like for your ZSphere chain, simply press the *A* shortcut key or use the *Tool.Adaptive Skin.Preview* button. Press *A* or the button again to dismiss the preview. You can actually sculpt on the preview itself; but if you switch back into ZSphere mode and make any changes there, anything you have sculpted will vanish with the preview. To actually create a permanent version of the preview, click on *Tool.Adaptive Skin.Make Adaptive Skin* button. This will create a new tool in your Tool pop-up palette called *Skin_ZSphere*, followed by a number in the name which will increment if you create additional skins. Now you can switch to your new tool and sculpt away. It's a good idea to save your ZSpheres out, though; they can be useful for rigging any characters you've made with them later on. When creating or previewing your adaptive skin, you can use the *Tool.AdaptiveSkin.Density* slider to control

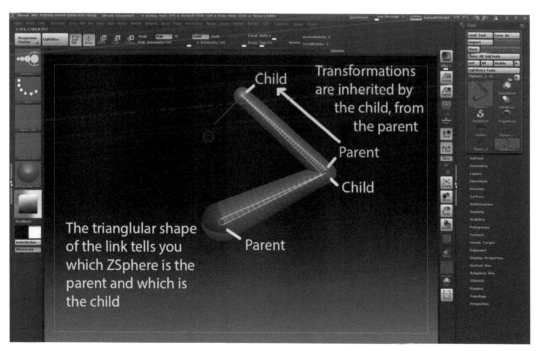

FIG 8.7 *The ZSphere at the base of the link is the parent; the one at the point is the child*

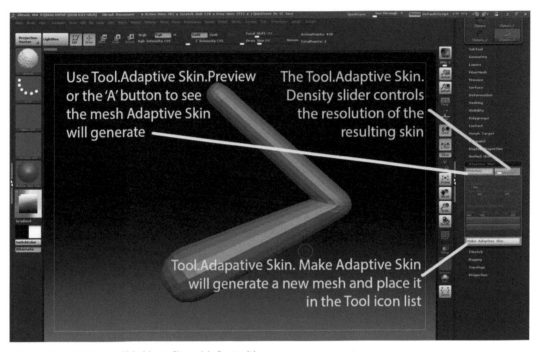

Use Tool.Adaptive Skin.Preview or the 'A' button to see the mesh Adaptive Skin will generate

The Tool.Adaptive Skin. Density slider controls the resolution of the resulting skin

Tool.Adapative Skin. Make Adaptive Skin will generate a new mesh and place it in the Tool icon list

FIG 8.8 *Adaptive Skin: Preview, Make Adaptive Skin, and the Density slider*

the polygonal resolution of the resulting mesh. Higher numbers yield a denser and smoother result.

The other option for generating a useful mesh from your ZSpheres is to use the *Unified Skin* palette found in the *Tool* menu. Unified skin isn't as finicky as adaptive skin and you can just rough out a shape with your ZSpheres in practically any way you see fit. When you're finished with your ZSphere chain, simply press the *Tool.UnifiedSkin.MakeUnifiedSkin* button and observe the results. It is quite similar to using DynaMesh in that it just lays a polygonal grid over the ZSpheres to create the new skin. Adjust the various sliders in the Unified Skin menu to play with your results. Remember that ZBrush creates the new polygonal skins in the Tool menu icon list and you will have to switch your active model to one of the skins to see your results. It is all too easy to forget that ZBrush does this and create a dozen new models while looking for what's on screen to change instead of looking in the Tool icon list.

Using ZSpheres

Now we are going to put our ZSphere knowledge to practical use and construct the dragon's body using that method. Start by appending a ZSphere to the head model.

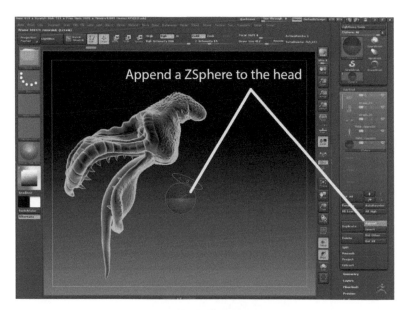

FIG 8.9 *Append a ZSphere to the head model*

FIG 8.10 *Draw a few more ZSpheres to outline where the body will be*

Now move the first ZSphere to where the center of mass should be on our dragon using *Move*; somewhere in the mid gut. Switch to *Draw* mode by pressing *Q* and draw another ZSphere on top of your first one and *Move* (*W*) this second ZSphere to where the neck meets the head. *Draw* (*Q*) a new ZSphere on the bottom and *Move* (*W*) it to where the dragon's body will meet the ground. *Draw* (*Q*) another ZSphere where the tip of the tail will be.

FIG 8.11 *Scaling the ZSpheres into shape*

FIG 8.12 *Continue to refine your shape*

Now click on various ZSphere links to turn them into active ZSpheres and *Move (W)* these new ZSpheres to shape the neck and body. Go back through all of your ZSpheres and *Scale (E)* them so they reflect the size of the body at that place.

Continue to refine your shape by converting link ZSpheres into active ones by using *Draw (Q)* and clicking on the link ZSpheres, then moving them into

FIG 8.13 *Add the shoulders*

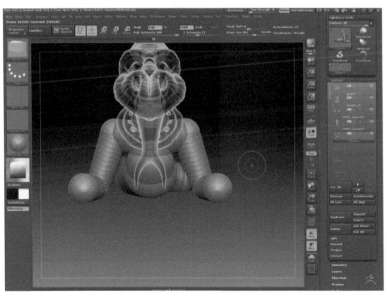

FIG 8.14 *Create the legs and feet*

place and scaling them to fit. Occasionally preview your model by pressing the *A* key to activate the *Tool.Adaptive Skin.Preview* button.

Convert another ZSphere link to serve as the origin point for the shoulders, then draw new ZSpheres using symmetry and move them out to form the shoulders.

139

FIG 8.15 *Preview your mesh by toggling the* A *key on and off*

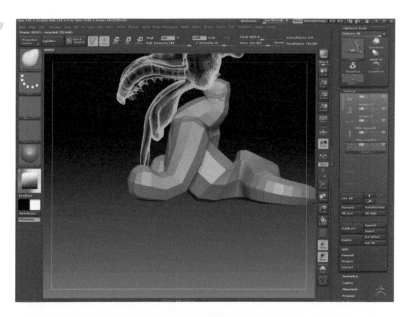

FIG 8.16 *Use the* Make Adaptive Skin *button to create the skin model*

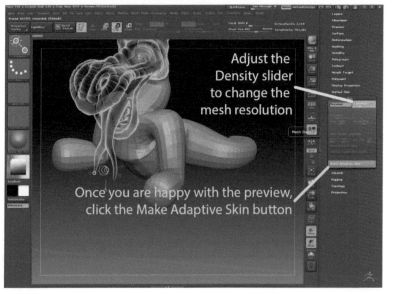

Draw more ZSpheres onto the shoulders to create the legs and finally the feet.

Preview the adaptive skin by toggling the *A* key and adjust the *Density* slider until the results look acceptable. Remember that you are going for simply a

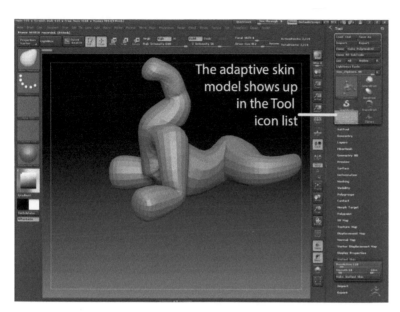

The adaptive skin
model shows up
in the Tool
icon list

FIG 8.17 *The skin model appears in the Tool icon list*

rough starting shape – not a finished or refined model. All you need at this point is a starting place to keep modeling from.

Once you are happy with the preview results make the adaptive skin using the *Tool.Adaptive Skin.Make Adaptive Skin* button.

Look in the *Tool* icon pop-up menu and find the adaptive skin tool you just made; draw it on screen, then go into *Edit* mode. Now *DynaMesh* the body and smooth out any remaining irregularities.

Flattening the bottom

We need to flatten the bottom of the model so that it will eventually appear that it is resting on the ground. Hold down *Shift* and rotate your camera to a side view. Press *CTRL + SHIFT + ALT* and use the *SelectRect* brush. Drag out a selection square and hide any part of the dragon that would be in the ground as it rested.

Now use the *Tool.SubTool.Split.SplitHidden* command to separate the hidden geometry to a new subtool layer.

Select the subtool layer with the bottom geometry in it and use *Tool.SubTool. Delete* to get rid of it. *DynaMesh* the remaining top part to close the resulting holes in the model.

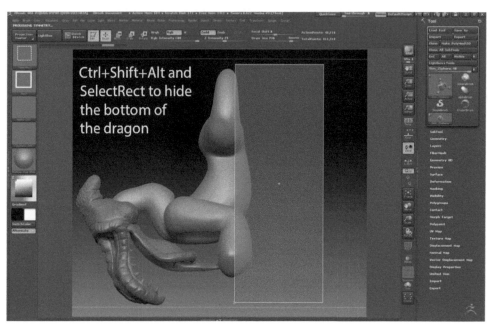

FIG 8.18 *Use* CTRL + SHIFT + ALT *and* SelectRect *to hide the bottom of the dragon*

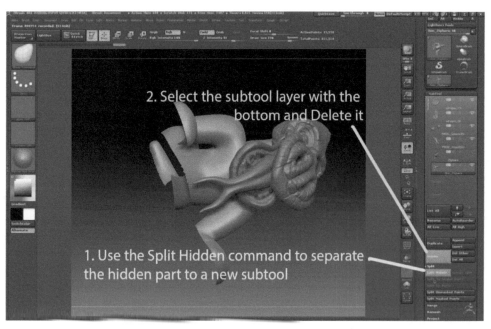

FIG 8.19 *Use the* Tool.SubTool.Split.SplitHidden *command to separate the hidden geometry to a new subtool layer*

Adding secondary features

Now that we've established the overall silhouette and shape of the base model, switch to the *DAM_Standard* brush and start carving in the important secondary features, like the toes.

Use the *Move Topological* brush to push the surface around and make the gaps between the toes. If the polygons become too distorted, simply *DynaMesh* the model again. Use the *Standard Brush* to add a ridge over the dragon's spine.

The *ClayTubes* brush is very useful for bulking up specific areas such as the chest muscles and creating the flap of flesh in front of the armpit area.

Make sure DynaMesh is turned off, then add a level or two of subdivision by using the *Tool.Geometry.Divide* button; then use the *DAM_Standard* brush to carve in major wrinkles and skin folds.

Keep switching between these various brushes and working up the form gradually until it starts to really take shape. The important thing now is to give an indication of the muscle structures that underlie all of our surface features.

FIG 8.20 *Carve in the toes using the* DAM_Standard *brush*

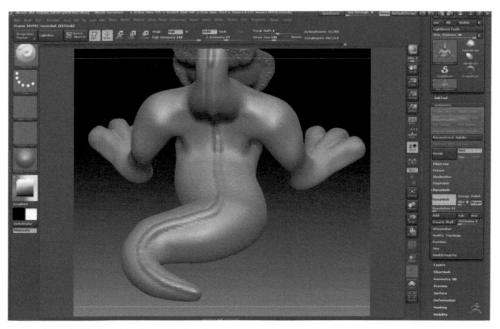

FIG 8.21 *Use the* Standard Brush *to add a ridge over the dragon's spine*

FIG 8.22 *Use the* ClayTubes *brush to bulk up the chest muscles*

FIG 8.23 *Use the* DAM_Standard *brush to carve in skin folds*

So a few hints of the ribcage, the clavicles, shoulder blades, leg bones, and such are what we are trying to indicate at this point. Add a few strokes, then use the *Smooth* brush to blend these into the form.

Inflate the tips of the toes to add some mass there.

The *ClayTubes* brush can also be used to add strips of muscle to the neck and torso. Run the strips horizontally along the length of the torso. Spread them out a bit where the torso curves away, and make the strips denser where the torso curves in on itself.

Use the *Smooth* brush to blend the brush strokes back down and then add another layer of strokes and repeat the process. This way you can build up an effect gradually. Smooth out the muscle strips heavily where the torso stretches the most.

Study the anatomy of the creature you are trying to build. Our dragon has a snake-like torso, so think about a snake's muscle structure and skeleton. The more reference material you can find to aid you in building your fantasy creatures, the more believable they will be.

FIG 8.24 *Add a few strokes, then use the* Smooth *brush to blend these into the form*

FIG 8.25 *Use the* Inflate *brush to puff up the toes*

FIG 8.26 *Add strips of muscles*

FIG 8.27 *Smooth the muscle strips out the most where the skin would be stretched taut*

Tertiary details

Once you are happy with the body it is time to start adding tertiary detail like the scales, skin pattern, and fine wrinkles to the model. Select the scale-looking *Alpha62*, the *ClayTubes* brush, a *Z Intensity* of around *50*, and, most importantly, the *DragDot* stroke type.

Because our dragon's body isn't symmetrical from the waist down we can't use symmetry on those parts. Just go over the whole body, carefully placing scales and varying your brush size to change the size of the scales.

Click on the *Brush Alpha* icon and open up the alpha pop-up icon menu. Click on the *Import* button and load the "Scaly Skin 22" file from the ZBrush install *ZAlphas* folder "C:\Program Files (x86)\Pixologic\ZBrush 4R6\ZAlphas".

Use this snake skin pattern wherever you want to change the skin texture up a bit and to add some variety. I used it a lot on the snake-like torso and tail of my dragon.

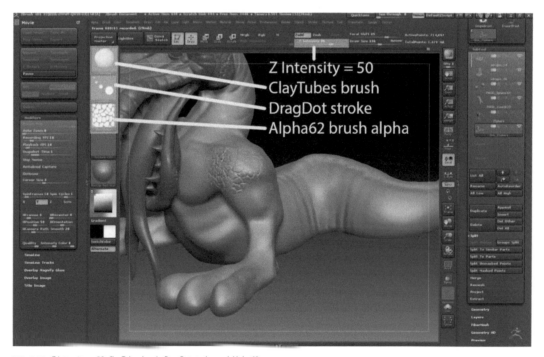

FIG 8.28 *Z Intensity = 50, ClayTubes brush, DragDot stroke, and Alpha62*

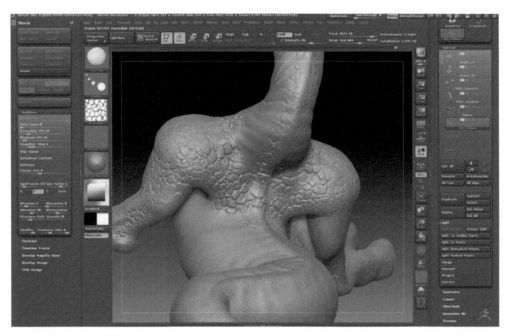

FIG 8.29 *Use this brush to add scales all over the body*

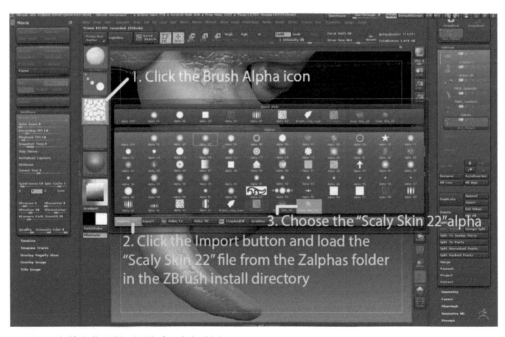

FIG 8.30 *Import the "Scaly Skin 22" brush alpha from the hard disk*

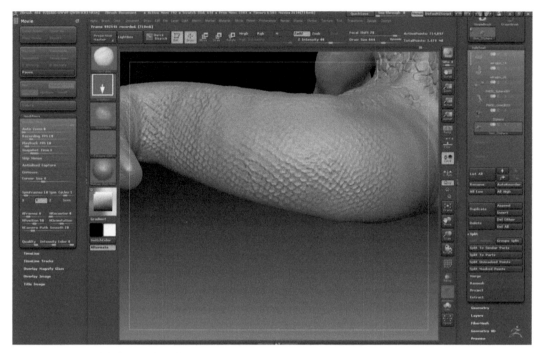

FIG 8.31 *The scaly skin alpha drawn on the model*

Adding claws with the IMM brush

Go to your brush icon menu and choose the *IMM_Toon* brush.

After loading the *IMM_Toon* brush, if you press the *M* key you will access a pop-up menu that lets you select from a list of premade parts built using the brush's theme. For the dragon I chose the *Pointy Nose* mesh.

IMM stands for "Insert Multi-Mesh" and these types of brushes are designed to let you add various elements onto an existing model extremely quickly. In this case I am going to use the *Pointy Nose* element from the *IMM_Toon* brush as claws for my dragon. Simply click on your model to insert a copy of the brush mesh you have chosen.

The IMM brushes automatically mask off your original model, making it a breeze to use the transpose move, scale, and rotate brushes on the new element without affecting your original model. Use these brushes to move the new element into place on the tip of one of the dragon's toes.

The *Tool.Masking.Clear* button can get rid of the mask when you are done. Don't forget that you can use the *MoveTopological* brush to adjust either the claw or the toe without affecting the other model since the *MoveTopological* brush respects model boundaries.

150

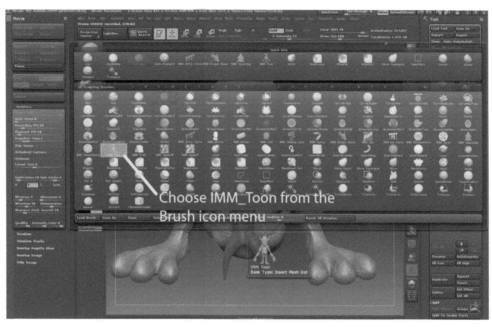

FIG 8.32 *Choose the* IMM_Toon *brush from the brush icon list*

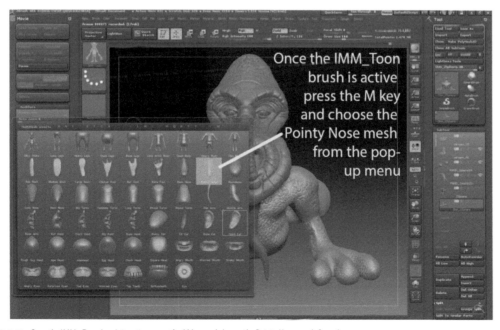

FIG 8.33 *Once the* IMM_Toon *brush is active, press the M key and choose the* Pointy Nose *mesh from the pop-up menu*

FIG 8.34 *Click on the model where you want to insert the mesh*

FIG 8.35 *Use the Transpose (move, scale, and rotate) brushes to adjust the position of the claw*

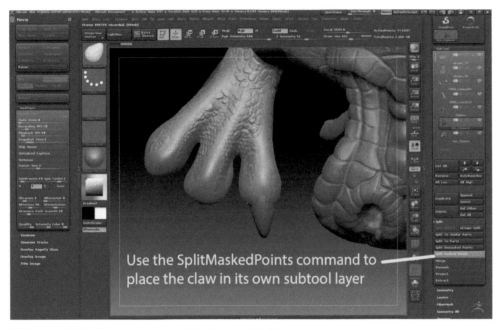

Use the SplitMaskedPoints command to place the claw in its own subtool layer

FIG 8.36 *Use the* SplitMaskedPoints *command to place the claw in its own subtool layer*

Better yet, you can leave the mask on and use the *Tool.SubTool.Split.SplitMaskedPoints* button to separate the claw into its own subtool.

Now you can duplicate the subtool and position another claw on a different toe. Repeat this process again and you have all of the toes on one foot. Then you can merge all of the claw subtools into one, clone, then mirror it onto the other foot.

Wings

For a final step, load the wing we previously made into our tool list using the *Tool.LoadTool* command. Now use *Tool.SubTool.Append* to add the wing onto the dragon. Use the transpose move, scale, and rotate brushes to fit the wing on the body. Once you are satisfied with the placement of the wing, *Tool.Sub-Tool.Duplicate* the wing subtool and use *Tool.Deformation.Mirror.X* to mirror it onto the other side of the dragon as well.

To merge the wings and the body together I used *DynaMesh* with my *Resolution* set extremely high (probably too high, as a matter of fact) at *1024*. This gave me a mesh of around 1 million active points, which is approaching the limit of ZBrush's effective functionality (you can go higher, but the program quickly becomes so sluggish it is difficult to use). I'm going to leave the claws as separate subtools so they are easier to color later on.

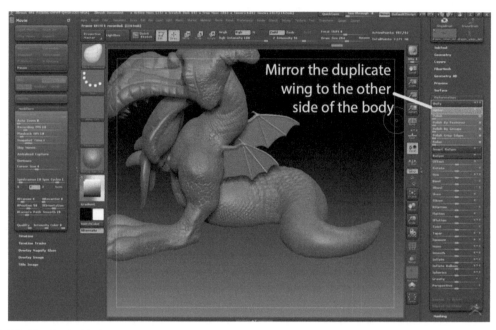

FIG 8.37 *Mirror the wing into place*

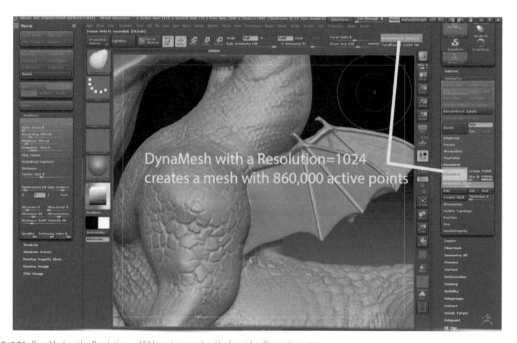

FIG 8.38 DynaMesh *with a* Resolution = 1024 *creates a mesh with almost 1 million active points*

UVs and Masking

Well, we've come a long way so far, but there are a few things you have to know before you can progress any further. The first one of these is masking.

Masking

Masking is one of the most powerful and useful features and ZBrush and is something you must master to fully utilize the program. A mask provides a means of protecting selected parts of the model from being painted or sculpted upon. There are a number of functions that will generate masks for you or allow you to paint your own masks by hand.

When working on your object in *Edit* mode you can quickly apply a mask using your mouse by holding down the *CTRL* key. This activates ZBrush's current *Mask* brush. If you look up at the *Brush* palette icon on the top left side of the interface while holding down the *CTRL* button you will see the currently selected masking brush. Click on the masking brush icon and choose the *MaskPen* brush.

Now you can hold down *CTRL* and paint masks on your object. These masking brushes work with the stroke and alpha pop-up palettes just like regular brushes and can be combined to create any number of unique effects. Holding down *CTRL* and the *ALT* button will let you use the currently selected mask brush to erase the mask. *CTRL + clicking* on the empty background will invert the mask, as will using the *Tool.Masking.Inverse* command. *CTRL + clicking* the object will blur the mask just like using the *Tool.Masking.Blur* command and *CTRL + ALT + clicking* the object will invoke the *Tool.Masking.Sharpen* command. Blurring the mask a bit can prevent any nasty edges from appearing when you paint your model. The *Grow* and *Shrink* commands in the *Masking* menu will expand or contract your current mask by a small increment. You can

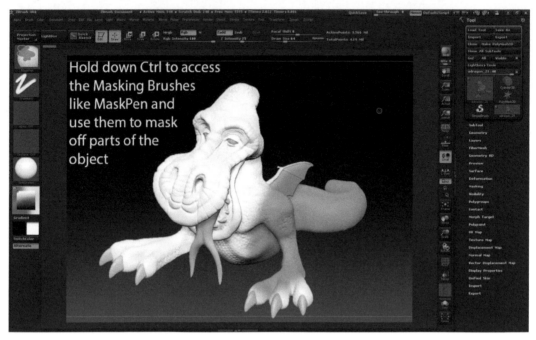

FIG 9.1 *Hold down* CTRL *to select the MaskPen brush*

use the *MaskAll* button to mask off the whole object or simply just *CTRL + click* the background if your object doesn't have a mask on it.

Try it out! Create a mask using *CTRL + MaskPen* on your model. Once you have created your mask, try sculpting or painting in the area you have masked off. You won't be able to affect the masked-off areas, which is exactly the point of masking. Learning the various masking tools in ZBrush is essential to being able to paint your object with any sort of complex detail. Masking can be used, for instance, to paint a camouflage pattern on an airplane. You'd simply put down your base color, create a mask in the shape of the camo pattern, and then paint on the next color. Clear the mask using *Tool.Masking.Clear* and see your results. The same layered approach can be used for countless variations and color patterns. Let's take a look at some of ZBrush's other masking tools.

To mask off a perfect circle, select the *MaskCircle* brush, then either the *DragDot* or *DragRect* stroke. Draw your circles upon your model and use the *Masking.Sharpen* command to crisp them into a clearer shape.

To draw a straight line you can use the *MaskRect* brush. Use *CTRL + ALT* and *MaskRect* to trim the line into whatever shape you desire. Or you can use the *MaskPen* brush and turn on *Stroke.LazyMouse.LazyMouse* and activate the *LazyMouse BackTrack* tool with the *SnapToTrack* and *Spline* options turned on.

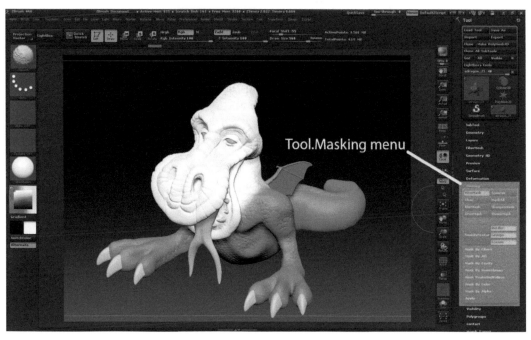

FIG 9.2 *The* Masking *menu*

If you don't remember this from an earlier chapter, the way this works is you create an action line, then paint the brush stroke back along that line. To draw a complex curved mask, hold down the *CTRL* key to activate masking and select the *MaskCurve* brush from the brush pop-up palette. After you start to draw the line, hold the *Shift* down to snap the line to 5-degree increments. Tap the *ALT* key once to change from a straight line into a curved one and place a point at that location. Tap the *ALT* key twice to insert a sharp corner at that spot. You can move the *MaskCurve* line around by pressing the *Spacebar* and holding it down. Remember that ZBrush will mask off whatever is on the shaded side of the curve. You can control which side of the line is shaded based upon which side of the screen you start drawing the curve from.

The *MaskRect* brush is useful for quickly selecting large rectangular areas; but the *MaskLasso* brush is much more practical, in general. *MaskLasso* allows you to very quickly mask out an arbitrary section of your model and is quite easy to control. Remember that you can use *CTRL + ALT* to deselect areas as well. Keep in mind that it is almost always easier to mask the smallest section you can, then invert to select large areas.

MaskCurvePen is rather odd. You draw the curve and then adjust it to create the mask. It mirrors the behavior of the other *Curve* brushes in ZBrush.

157

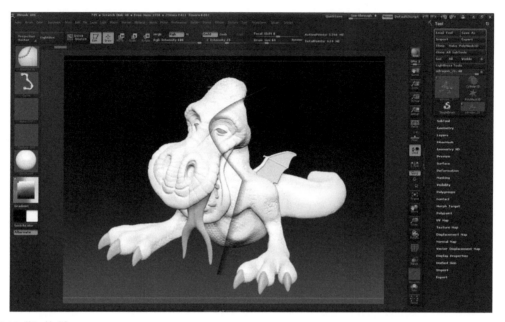

FIG 9.3 *Using* MaskCurve

FIG 9.4 *Using* MaskRect

While the masking brushes are useful in their own right for painting, nothing beats the various masking commands found in the *Tool.Masking* palette.

Masking palette

Mask by cavity

Mask By Cavity does an incredibly efficient job of masking out the creases and crinkles on our model. This command will analyze the surface of the model and create a mask based upon the curved recesses present in the model. By default, it will mask off all of the crevices in the model. Use the *Blur* slider to adjust the granularity of the effect. A low blur setting will mask out very fine details, whereas a high blur value will give large areas of softer shadows. *Intensity* can be used to fine-tune the results and even to invert the results if you input a negative number. Click the *Cavity Profile* command to access the graph that controls precisely how ZBrush will create the cavity mask.

To fully leverage the cavity mask you will have to understand how the graph controls work in ZBrush. Though we are editing the settings for the *Cavity Profile* specifically, the same interface is used throughout ZBrush for all of the

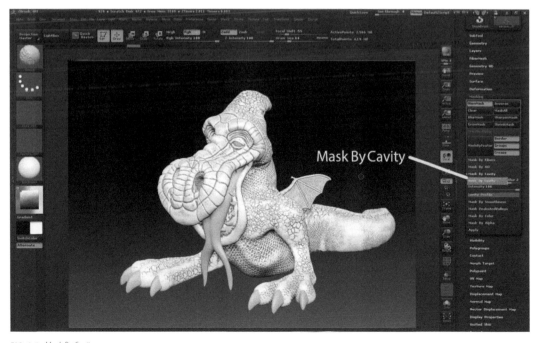

FIG 9.5 *Mask By Cavity*

different graph profile settings. The commands at the bottom of the graph are the easiest to understand. *Undo, Save, Load, Copy, Paste, Reset*, and the *Flip* horizontally and vertically buttons are all pretty self-explanatory. The *Noise* slider adds increasing amounts of variability into any cavity masks you create. *Offset* moves the left side of the graph curve up or down. *Focal Shift* pushes the whole curve either right or left. The most useful aspect of the graph curve is that you can edit the curve directly by clicking in the graph window itself. First, set your *Focal Shift* to *0* so we get a nice linear graph curve. If you click on the gray graph line itself you will add a new graph point that bends the line. Simply click on this graph point and drag it around to change the graph profile. If you want the lines of the graph to be straight instead of curved, simply drag that point off the edge of the graph and back onto it to change the point from a curve point to a corner point. If you want to delete a specific point, just grab that point, drag it off the edge of the graph and let go. You can add as many points and change the graph profile as much as you like. If you mess up horribly, simply press the *Reset* button to restore the default profile. You can even adjust the beginning and end points themselves. Once you've finished editing the graph profile, click the *Mask By Cavity* button to observe the results. Since the cavity mask function computes so much faster than the *Ambient Occlusion* mask and yields similar results,

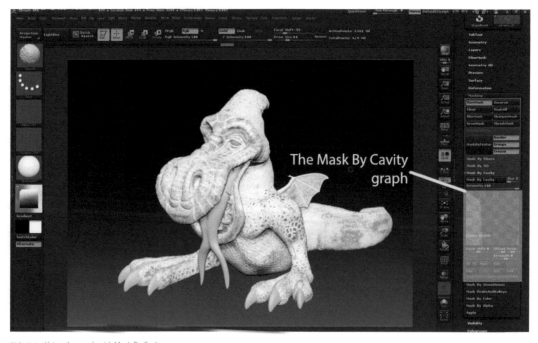

FIG 9.6 *Using the graph with* Mask By Cavity

I find that I use *Mask By Cavity* more frequently than any of the other masking solutions.

Mask by smoothness

MaskBySmoothness analyzes the curvature of the object's surface to create the mask. The *Range* slider controls the range of the mask from where a surface change occurs. *Falloff* controls the transition between masked and unmasked areas. The higher the value, the less transition there is. To really understand what these controls are doing, take a little time and play with the numbers and observe the results until you get a feel for how these commands operate together. This is a really useful masking feature that allows you to isolate areas of transition from one planer angle to the next. It is quite good at highlighting edges.

Mask peaks and valleys

This masking command analyses the – you guessed it – peaks and valleys of the model to create the mask. *PVRange* controls the amount of falloff in the mask and *PVCoverage* controls the size of the resulting mask. This is another

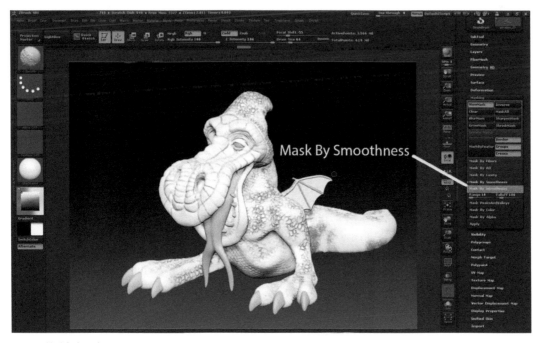

FIG 9.7 *Mask By Smoothness*

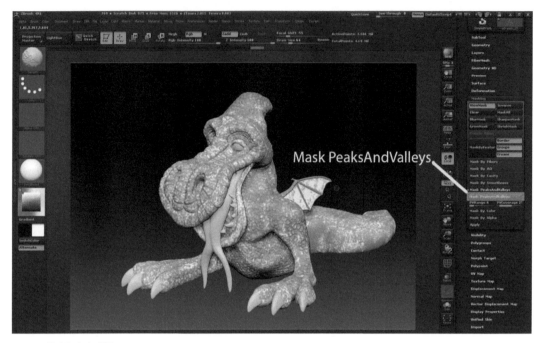

FIG 9.8 *Mask Peaks And Valleys*

command that you really have to play with to come to grips with what it does as the results tend to be a bit unpredictable.

Mask by color

This opens up a sub-palette with three simple masking options. All of these masking techniques require that your model be painted before they will properly work:

- *Mask By Intensity* creates a mask based on the dark and light patterns of the current colors on the model – extremely useful once you've started painting.
- *Mask By Hue* tries to create a different mask intensity for each hue present in the model.
- *Mask By Saturation* uses color saturation as the basis for your mask. Saturated areas become more masked than less saturated ones.

Mask ambient occlusion

MaskByAO MaskAmbientOcclusion creates a mask on the model from the shadows generated by an ambient light. Ambient light is a soft overall lighting

effect equivalent to the light of an overcast day. It creates a rather soft shading effect that is useful as an element for painting textures on a 3D model. You can control the intensity of the mask using the *Occlusion_Intensity*, *AO_Scan-Dist*, and *AO_Aperture* sliders. Each of these sliders provides a slightly different modification of the resulting mask. Unfortunately, since the effect of each slider's value varies depending upon the model, there isn't a specific set of numbers for the sliders that will give the same results for every model. You literally have to play with the settings until you get the result you want. Having said that, *Occlusion_Intensity* affects the intensity of the mask, *AO_ScanDist* changes the maximum size of the resulting mask, and *AO_Aperture* affects the concentration of the mask. Usually you just want to leave *AO_Aperture* set to its default of 90 and play with the other two settings to get predictable results.

The downside to using ambient occlusion (AO) masks is the time it takes to generate them. AO masks are by far the most computationally expensive mask to create and you don't want to have to wait around to for ZBrush to generate the same mask twice. That is why there is a way of saving each of your masks for later; but to do that we will need to give our object UVs. In the same way, *MaskByAlpha* and *Apply* are only useful once we have applied UVs to our object. So, guess what we have to learn next?

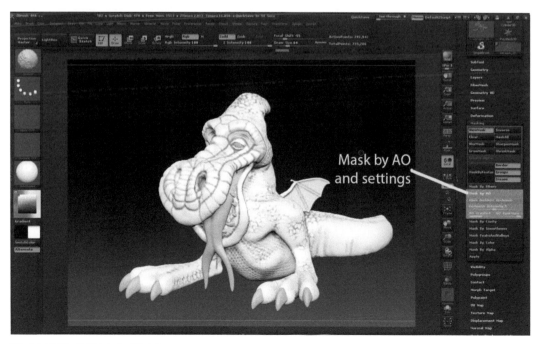

FIG 9.9 *Mask By AO.Mask Ambient Occlusion*

Understanding UVs

What are UVs? UVs provide a method of pinpointing a specific location on the surface of our model. Technically speaking, U and V stand for the X and Y axis as measured along a surface – in this case, the complex surface of our model. UVs are used to provide a means of translating our object from 3D space to a 2D image. Once you have your object's UVs in place, you can generate all of the different image maps (usually called texture maps) for use with your model. Working natively in ZBrush, we are going to create shadow maps for storing our alpha masks and color maps for storing our painting information.

There are many ways of generating UVs for a model and just as many different tools and programs capable of doing so. For a video game or movie production model it is essential to have good, clean, well-laid-out UVs, and artists can spends many hours or even days generating these. However, for our purposes a quick and dirty way of generating UVs will suffice since we are just going to use this model in ZBrush and not worry about exporting it to another program.

To understand what we are looking for in our UV map you have to understand how ZBrush approaches painting a 3D tool. ZBrush uses a polypaint-based approach to coloring its models. This means that ZBrush applies color to an entire polygon when it paints objects. This has several repercussions. One is that you need to have a fairly high-resolution object in order to paint effectively. A low polygon object will give you a blurry result and not be able to hold any detail. Second is that you need to provide at least 1 pixel worth of active space on your UV map for each polygon in the model. You can figure out how many pixels are available in your UV map based upon the size of the map. A 2048-sized map will be 2048 pixels wide by 2048 pixels tall. This provides us with a total of 2048 multiplied by 2048, or 4,194,304 available pixels in our map. Given that the UV layout itself will consume some of this space depending upon what sort of UV mapping method we use, we will end up with somewhere between 50% and 90% of the available pixels for use. The primary goal when creating this sort of quick and dirty functional UV map is to maximize the amount of space on the map used for UVs and minimize the amount of wasted empty space.

Map projections

The easiest way to visualize how a UV map works is to look at a few different world maps. The idea of a world map is pretty simple – but the mechanics of taking the world, which is roughly a 3D sphere, and projecting it upon a 2D surface creates all sorts of interesting problems. Every so-called projection of the 3D world onto this 2D surface creates differing amounts of distortion in

inverse proportion to the number of seams or edges in the map. For the basic Mercator projection of the world map which we are all familiar with (even though you might not have realized it was called a Mercator projection), the world is sliced down the middle of the Pacific Ocean and unfolded. The problem with this map is that it is heavily distorted at the poles. The continents get stretched out as they approach the poles and Antarctica gets turned into a weird strip at the bottom of the map that looks nothing at all like itself. The advantage to this map is that it is easy to read.

You can decrease the level of distortion in the map by cutting in more seams on the surface of the world in order to unfold our map. A bit of clever carving and you can end up with a Goode homolosine projection or something similar. This map preserves the shapes of the continents a lot better (sorry again, Antarctica), but creates a lot more seams and is a lot harder to read. You will also notice that this map has a lot of unused negative space around it that conveys no information at all.

That is the tension when creating UV maps. You can either have a map that is easy to read and has few seams, or one that has more seams and has less distortion but is harder to read. ZBrush can generate a very readable UV map using the *UVMaster Zplugin*, but that would be a lot of extra work for our limited needs at the moment. What we are looking for is a map projection for our object that minimizes unused UV space, has very little distortion, and most importantly can be generated quickly. Since we aren't exporting these maps

FIG 9.10 *Example of a Mercator projection world map*

FIG 9.11 *Example of a Goode homolosine projection world map*

for use in other programs, they don't have to be legible. This means that we can have lots of seams and cuts – so many, in fact, that we create what I like to call a "shatter map" in which each polygon is separated out and placed flat on the 2D plane. While this is very accurate and uses our UV space very efficiently, it also creates a map that is absolutely impossible for a human to read. That's OK, though, because ZBrush can understand it just fine.

Creating UVs in ZBrush

With that in mind, let's go to the *Tool.UV_Map* sub-palette and look at our options for generating UV maps in ZBrush. First off, let's set our *UV Map Size* to a value that will work well with our model. A map size of 1024 would be too small since it would provide us with only around 1 million active polygons and our model is already bigger than that. A 4K or 4096-size map would work, giving us approximately 16 million pixels to work with; but it would be a bit of overkill and would slow down ZBrush needlessly. So a 2K or 2048-size map it shall be. The roughly 4 million pixels a 2048 UV space provides should be enough to hold our color data even if we use a UV map since the model I am working on has around 1.1 million polygons in it. Simply click on the 2048 button under *UV Map Size* to set it to the appropriate value. The *UV Map Border* slider sets the number of pixels that ZBrush will fit in between each of the UV areas it creates. This gives ZBrush some flexibility when reading the UV map

The *Uvc*, *Uvp* and *Uvs* buttons in the *Create* sub-palette will project the UVs of our object onto a cylinder, plane, or sphere, respectively. Unfortunately, none

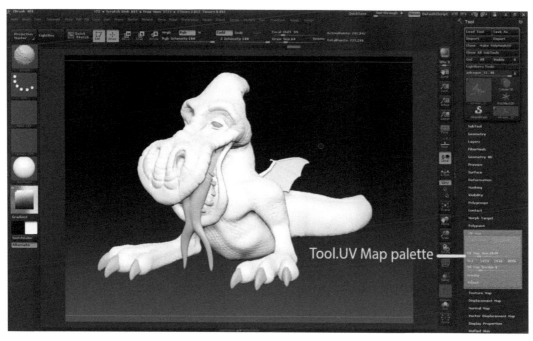

FIG 9.12 *The* Tool.UV_Map *sub-palette*

of these projections will help us much with our complex curved surface that we've created. The *FiberUV* button is a specialty button for creating UVs for ZBrush *Fibers* and isn't available to us at the moment. We do have access to the *UVTiles*, *AUVTiles*, *PUVTiles*, and *GUVTiles* commands. All of these buttons will automatically give our model usable UVs, but each will do so in a slightly different way. Of these commands, *PUVTiles* is the newest process and generally considered the most efficient, so that is the one we will use. First, you have to be working on the lowest available subdivision level of your model. Check in *Tool.Geometry* and make sure your *SDiv* slider is set to 1. Now go to the *Tool. UV Map* sub-palette, check that the *UV Map Size* is set to *2048*, and press the *PUVTiles* button and give ZBrush a minute or two to process the command.

You may have to go back and increase your *UV Map Size* to *4096* and adjust your *UV Map Border* down to *2* depending upon how many polygons are in your model. While it looks like nothing has happened, ZBrush has actually added a lot of new information to your model. To see what has occurred, go to the *Tool. Texture Map.Create* sub-palette and click on the *New From UV Map* button.

Your model will break out into a mosaic of colored tiles. This is just showing you how ZBrush has projected your model. To turn this off, click on the *Tool. Texture Map.Texture On* button and your model should go back to the way it

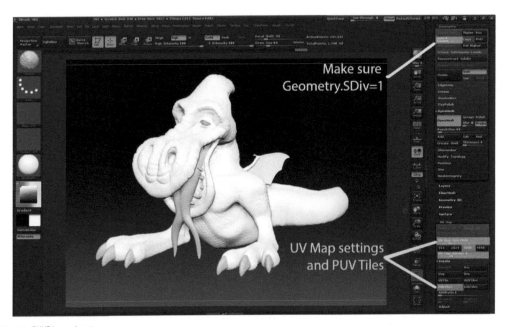

FIG 9.13 PUVTiles *and settings*

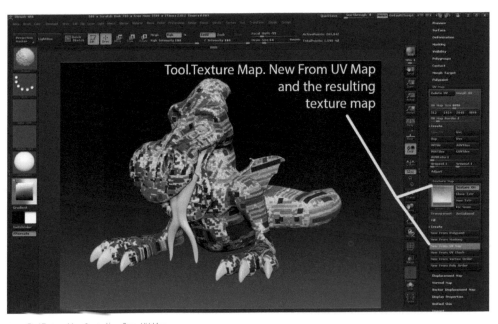

FIG 9.14 *Tool.Texture Map.Create.New From UV Map*

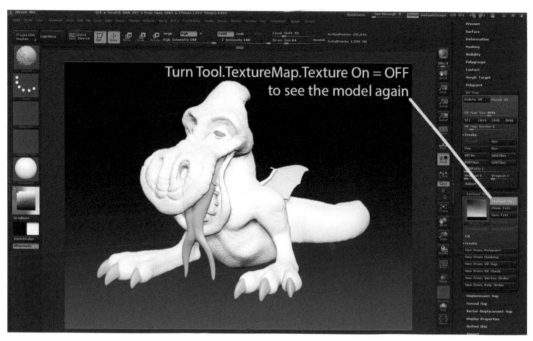

FIG 9.15 *Turn off the texture by clicking the* Tool.Texture Map.Texture On *button*

looked before, but the UV information is now embedded in the model and we can use it to save our masks.

Please be aware that if you change the geometry on your model significantly, by using *DynaMesh*, re-topologizing it, or applying a unified mesh to it, you will destroy the existing UVs. The UVs are actually embedded in your polygons and if you radically change, rebuild, or destroy them you will lose your UVs. So save your tools frequently and be careful.

Saving masks

Now that we have our UVs, let's return to *MaskByAO.MaskAmbientOcclusion*. Set your *Mask Ambient Occlusion* slider to 5 and your *AO ScanDist* to 0.5 and press the *Mask Ambient Occlusion* button. You may have to tweak these values to get a usable result on your own model. To save this mask for reuse later, click the *Create Alpha* button found under the *Masking* palette.

The mask alpha will immediately show up on the left hand side of the screen in the *Alpha* selector. Now it is stored in ZBrush for this session. If you'd like to permanently keep it, click on your alphas icon in the *Alpha* menu and select

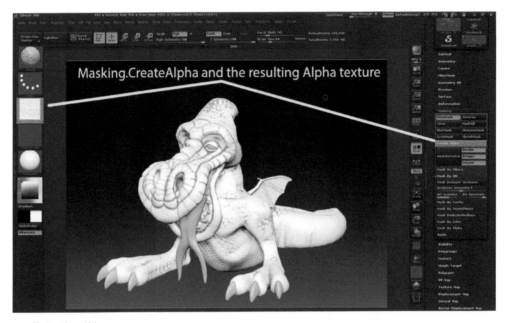

FIG 9.16 *Masking.CreateAlpha*

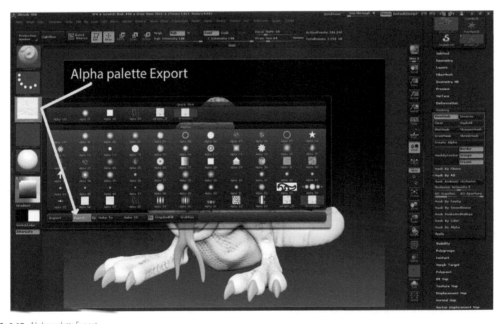

FIG 9.17 Alpha *palette* Export

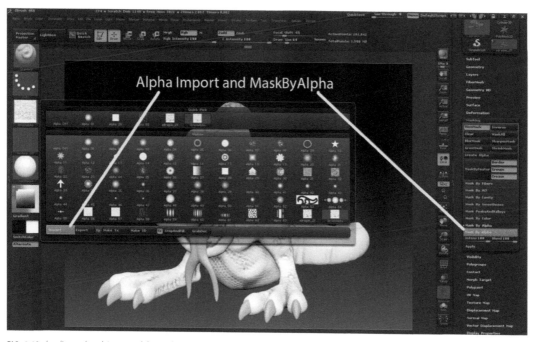

FIG 9.18 *Loading and applying your alpha mask*

the *Export* button from the *Alpha* pop-up menu. This will allow you to save out the alpha mask as a PSD, BMP, or TIF format image file.

Clear your current mask by clicking on the *Tool.Masking.Clear* button or simply hold down *CTRL + clicking and dragging* on the background (just like the shortcut for activating *DynaMesh* although *DynaMesh* will not work with any part of your model masked). Later you can load this image back into the *Alpha* palette by clicking the *Import* button and choosing your alpha image file that you have already saved out. To apply your mask, make sure the alpha you want to apply is active in the *Alpha* palette and currently displayed as the alpha icon on the main screen of ZBrush. Go to *Tool.Masking.MaskByAlpha* and click on the *MaskByAlpha* button. This will apply your alpha image to your object as its current mask. Before you apply the mask using the *MaskByAlpha* button, go to the *MaskByAlpha* menu and change the *Intens* slider to control the mask's intensity on the model and/or the *Blend* slider to blend it with any existing alphas already on the model.

Applying masks

The *Mask Alpha* button in the *Apply* sub-palette is used to mix the current mask on the object with the selected mask in the *Alpha* palette. *Mask Txtr* will mix the current object mask with the selected texture in the *Texture Map*

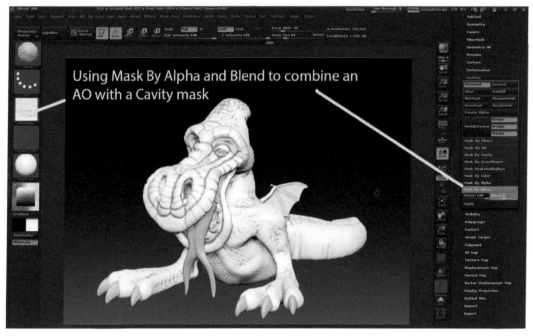

FIG 9.19 Using Mask By Alpha, Blend = 51, to blend my AO mask map with a Cavity Mask

sub-palette (which we will work with later), while *Mask Intensity* controls the amount of mixing that occurs, with higher values giving darker values being added to the selected alpha or texture.

Now that we've covered all (or at least most) of the various masking tools and features, try using them to assist you in sculpting. *Mask By Cavity* can be quite useful for crisping up the features of your model; likewise, painting the mask of the iris in the eye, then inverting your selection and sculpting in the iris using a layer brush is an excellent alternative to free handing it the way we did during the demo, and that is just one example of the usefulness of masking.

Painting the Dragon

Adding a material

While you are painting it is best to have a material on your object that is a matte white so the colors you are putting on the model are represented accurately. Choose a material like *SkinShade4*, *Blinn*, or *MatCap White*. Sometimes it is useful to apply the *FlatColor* material and white color value to get a view of your model with just the colors on it and no shading. By default, the entire model will update to the new material automatically. This is a quick way to test out different materials and to see which one works best for your model. If you want to permanently apply a material to your model, choose the *M* button on the top shelf, set *Rgb Intensity = 100*, and use the *Color.FillObject* command.

It is important to choose a material that suits your character at the end of the process; but keep in mind that materials have a drastic effect upon the look of the model and can obscure or radically change the look of the colors you've placed on the model.

Materials can be quite useful for defining the look and feel of the surface of an object. Scales, stone, fabric, and metal are just a few of the types of surface that can be quickly represented using just materials alone. Take a few minutes to play with the various materials available in ZBrush by applying them to your object and simply observing the result this has on the object's colors and surface quality. Based upon this experimentation, figure out which materials you think are best for representing the dragon's skin. Do you want a shiny iridescent surface like *MatCap Pearl Cavity*, a colorful slick metallic surface such as *Chrome Blue Tint*, or a straightforward and plain material like *MatCap White01*? The answer will greatly define the feel of your finished model. Remember that there is no substitute for experience in this and you just have to experiment at first. After working with ZBrush for a while, you will get a good feel for which materials work best to represent specific looks.

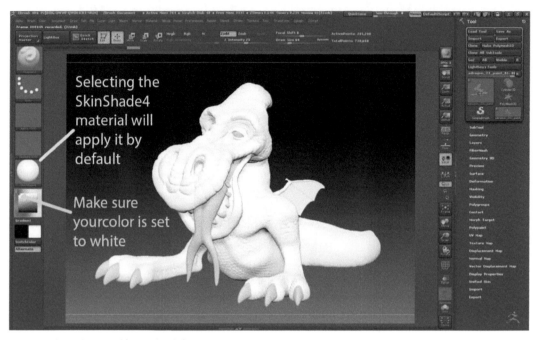

FIG 10.1 *Select a white material for your object before painting*

Approach to painting

Let's start by talking about the overall approach to painting a model. Start off by applying your main areas of color. Don't worry about the shading or highlights, or even the small parts and details; just fill in a basic color. Simply choosing a color will automatically update the entire model unless you have already applied a color to it. To permanently assign the color to the model, set *Rgb Intensity = 100*, then use the *Color.FillObject* command.

The basic method for adding shadows is to use a darker shade of your main color. So, for a green cloak you would use a darker shade of green. For simple highlights you can use a lighter shade of your main color. Use masking to paint in shadows, then highlights. Make sure that you don't obliterate the mid-tones when you paint your shadows and highlights in. You need the mid-tone for a transition area between the two. The basic approach is to paint in your flat colors, then shadows, then highlights, and finally add in any details. You could do all of this by hand, but there's an easier way.

The ambient occlusion (AO) mask is especially useful in painting your shadows. Remember that an AO mask is created from the soft shadows cast on

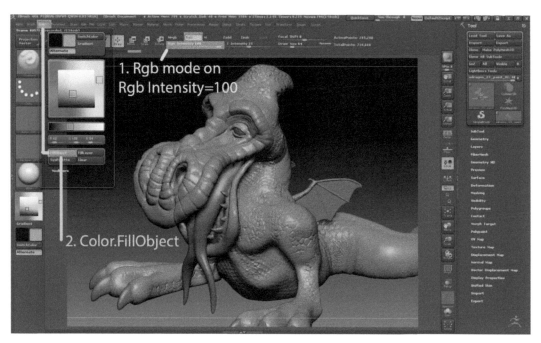

1. Rgb mode on
Rgb Intensity=100

2. Color.FillObject

FIG 10.2 *Apply a base color using the* Color.FillObject *command*

the object by indirect lighting (ambient lighting). Use it to isolate and paint in your shadows. Click on the *Tool.Masking.Mask By AO.Mask Ambient Occlusion* command to generate your AO mask. Seeing how long this process takes now is a good time to leverage what you learned in the chapter on UVs and Masking to save out this mask so you don't have to wait for it to generate again. Invert this mask using the *Masking.Inverse* command or by just clicking on the background canvas once. If the edges of the mask are too sharp, apply a *Masking.BlurMask* to it or just *CTRL + click* on the mask itself to blur it. Turn off the *Masking.ViewMask* toggle button so you can see how your paint affects the looks of the model. Just don't forget the mask is still there!

Using a *Standard* brush and *Color Spray* stroke to add some variability to my colors, I choose a darker value of my original color and set my *Rgb Intensity = 10* and begin to paint in the shadow areas of the model. The inverted AO mask prevents this dark shadow color from being applied anywhere it shouldn't and by using a paint brush to apply the color instead of a fill I can control the intensity of the shadow areas exactly how I want them.

You will have to experiment to find the perfect color match. Remember that you are not trying to make the shadows darker, but rather deeper. Try adding

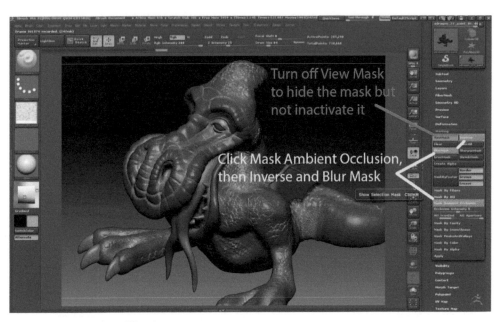

FIG 10.3 *Using the ambient occlusion (AO) mask*

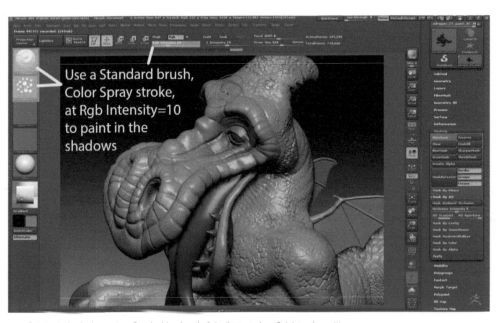

FIG 10.4 *Painting in the shadows using a Standard brush and a Color Spray stroke at Rgb Intensity = 10*

a hint of blue or purple to the shadows since shadows are usually a bit cooler. Observe colors from real life. Notice how color actually changes over a form as it proceeds from light to dark. Get some examples of various fabrics or metals and set them in sunlight to see what happens. Nevertheless, be aware that colors often have to be overstated in order to avoid looking dull and lifeless. Merely mimicking reality isn't adequate; you will have to use your artistic judgment to achieve a believable look.

Things start to get interesting once you go beyond these basic methods. Try adding unusual shadow or highlight colors to liven up a model or achieve a special effect: green shadows on a pink or flesh-colored model makes for a great zombie; purple shadows on a blue base color or maybe red or green shadows on a yellow color; yellow or brown shading on a red base. Colored shadows over a gray mid-tone, for example, may be used, or any rich color layered over white. For something very light colored, try painting it in the lighter color first and just adding shadows. To get a rusted or weather-beaten look, add an overall tint of orange or brown after finishing everything else. Adding in purple or blue can give life to a black object. In general, try using very transparent applications of different colors and building up an overall effect to achieve a degree of luminosity.

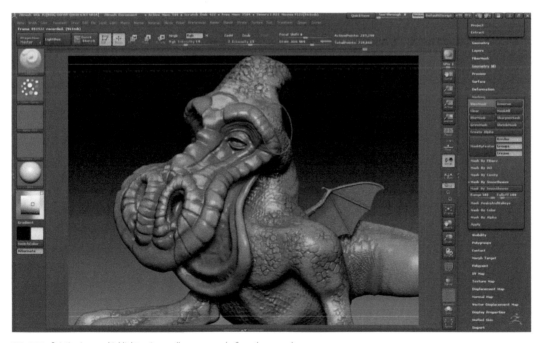

FIG 10.5 *Painting in some highlights using a yellow-green and a Smoothness mask*

For the dragon, I alternated between using a *Cavity* mask and the *Smoothness* mask, inverting them if I wanted to paint in shadows and using them without modification if I needed highlights. You can adjust the graph curves for each masking method to generate larger or smaller areas of highlight and shadow. The colors I used varied from a blue-green for shadow areas to a bright yellow-green for the highlights. Once you understand the basic idea of creating a mask and adjusting it to taste using blur, invert, and the graphs, it isn't difficult to paint in your shadows and highlights. It just takes patience to apply the layers of colors that will create a nice effect.

An important side note is that when you switch to the *Smooth* brush to blend in your colors, check and make sure that you don't also have *Zadd* turned on the top shelf. Since *Smooth* is a completely separate brush, it keeps track of its *Rgb* and *Zadd* states independently of your paint brushes. It is all too easy to forget this and accidently delete important details before you notice.

I also played with adding some very thin applications of orange to mute the saturation of the greens a bit in areas I wanted to tone down.

A useful trick is to pick out anywhere one part of the model meets another – in effect, outlining this part of the model. Anywhere two different materials

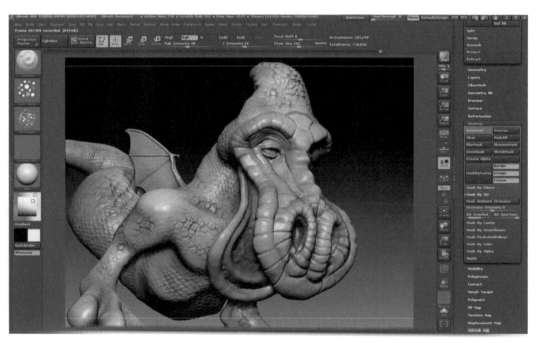

FIG 10.6 *Using an AO mask and painting in a brighter yellow-green highlight*

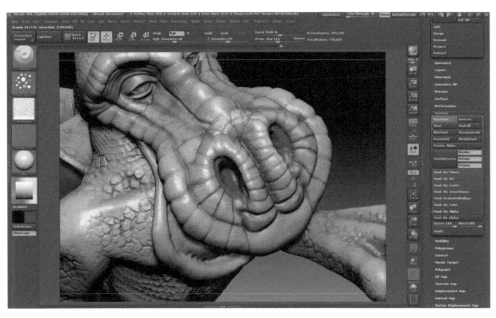

FIG 10.7 *Inverting the AO mask and painting blue-green shadows on the model*

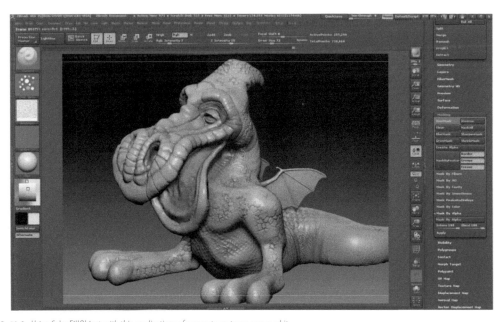

FIG 10.8 *Using Color.FillObject with thin applications of orange to mute my greens a bit*

come into contact is appropriate to try this on. It is a subtle effect you are going for, though. Don't overdo it! Use a very transparent dark gray or dark brown for this effect and, again, be subtle. If there is anywhere you would like to highlight, try intensifying the colors there a little bit to brighten that spot up and make it stand out.

Decide where you want people to look and do something to the model that makes them focus on that spot. Decals, tattoos, scars, or anything else that calls attention to itself can work. Be imaginative!

In ZBrush you can blend paint strokes using thin applications of color by lowering the *Rgb Intensity* slider. This allows you to paint in thin, translucent applications of color (called glazes in traditional oil painting), which builds up the color gradually. This approach can give you the same sort of luminous result the Old Masters such as Leonardo, Michelangelo, and Raphael got in their paintings! It is the same technique they used, just with digital instead of oil paint.

I added touches of browns, reds, and purples to the wings to differentiate them from the scales, using a low opacity to build up a nice streaked color effect.

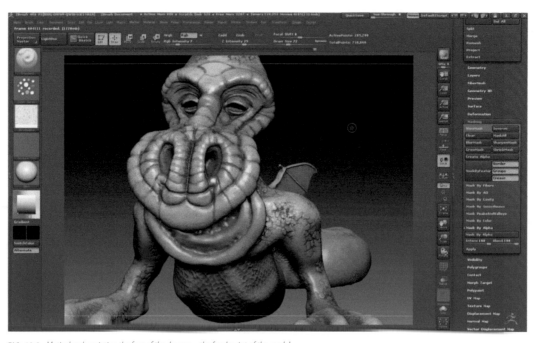

FIG 10.9 *Meticulously painting the face of the dragon — the focal point of the model*

FIG 10.10 Portrait of Baldassare Castiglione *by Raphael*

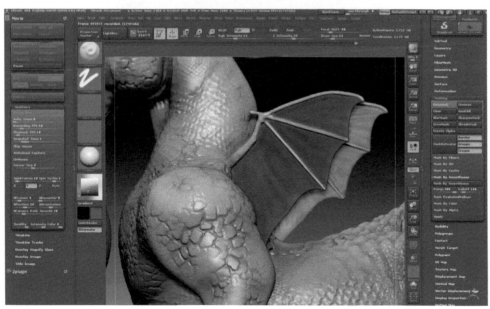

FIG 10.11 *Painting thin, translucent applications of color on the wings*

Painting using masks

The AO mask is great for your overall shadows, whereas the cavity mask is perfect for adding in shading on fine details, such as scales. Simply generate the mask, then invert it to define where your paint should go. Blur the mask a few times to soften the edges, then use *Color.FillObject* with a low *Rgb Intensity* setting. You can always repeat the *FillObject* command to strengthen the effect if you want. *MaskBySmoothness* is useful for selecting your edges and applying either wear and abrasion or a highlight.

Speaking of highlights, it is easy enough to adjust the graph curves for the AO masking or cavity masking commands and to generate an alpha mask for your highlight placement. Simply choose a highlight color and apply to your model with a brush or the *FillObject* command. Don't forget to blur the edges of your alpha masks just a bit so you don't get any nasty hard edges.

From here, just keep going until you are satisfied with the look of the model. Then switch to your other subtools and paint them using the same techniques. I cheated a bit on the claws and just used the *MatCap Gorilla* material on them. You always try to save time where you can in order to speed up production. The claws aren't going to be the focal point of the finished painting,

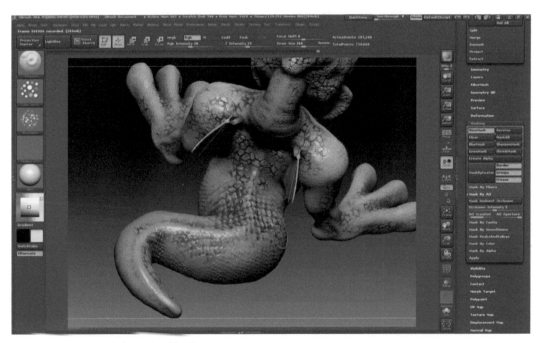

FIG 10.12 *Painting in more shadows with an AO mask*

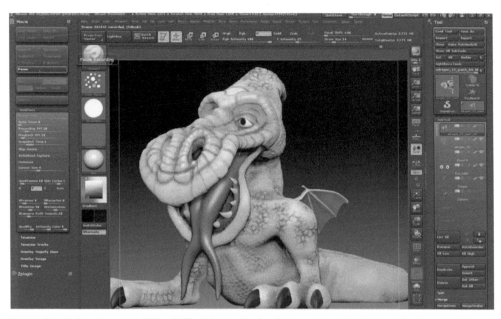

FIG 10.13 *Isolating the lower jaw using the* CTRL + SHIFT + SelectLasso *brush, and using a cavity mask to help paint in the colors and shading on the dragon's mouth*

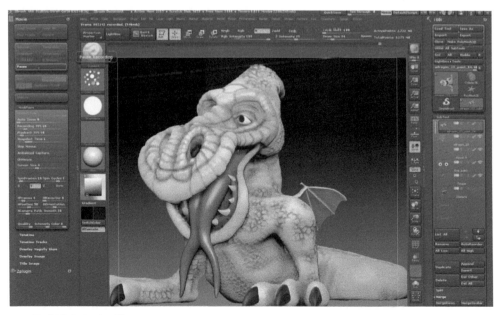

FIG 10.14 *The finished painted model*

so why spend a lot of time working them up? The same thing applies to the bottom of the dragon and the rear-facing pieces of the model. When taken to an extreme, if you know from the beginning where your camera is going to be, you shouldn't even bother modeling things that won't be seen. You can occasionally see this in video games if you look really closely at the scenery or parts of models people don't normally bother paying much attention to.

Using *Decimation Master* to reduce the size of your model

Because our model is starting to get quite a large polygon count, we will switch gears entirely and take a look at the *Decimation Master* plug-in for ZBrush in order to fix this. ZBrush can get bogged down if any one tool or sub-tool exceeds around 1 million polygons. While it can easily display several million polygons on screen at one time, it can only do so if the object is broken up into easily handled pieces. Somewhere between 0.5 million and 2 million polygons in one object and ZBrush starts developing a tendency to lag, generate more errors, and crash frequently. While the default auto-save function eliminates some of the pain and frustration associated with crashing, you are still better off avoiding the problem altogether by planning your model out. In this case, since it would probably create more problems that it solved by cutting the dragon into pieces, I will take an alternate approach and decimate the model. The process is a bit like *DynaMesh* in that you are replacing the model's geometry with something new, also called re-topologizing; but in this case instead of a new grid-based form for sculpting, as in *DynaMesh*, you will be creating a low polygon form that tries to minimize the total number of polygons used in the model.

Decimation Master will computationally go through and re-topologize (generate a new polygon mesh for) your model while preserving the details that you have created. There are several different means of re-topologizing a model in ZBrush, but *Decimation Master* is one of the user friendliest. Re-topologizing is a big topic for ZBrush and is especially important if you are going to take a model into a video game engine or professional animation package such as Maya or Softimage. However, since it is really only important when you are working with another software package, it falls largely outside the scope of this book and I won't go into depth about it other than to explain what it is about and to demonstrate one approach. Remember that most 3D packages cannot handle the polygon counts that ZBrush is capable of generating, so this process is critical if you want to export your models into another package. Do not try to simply export 1 million polygon object from ZBrush into some other 3D package. You will just crash your computer! If you need to do so, use *Decimation Master* to reduce the polygon count to something reasonable beforehand.

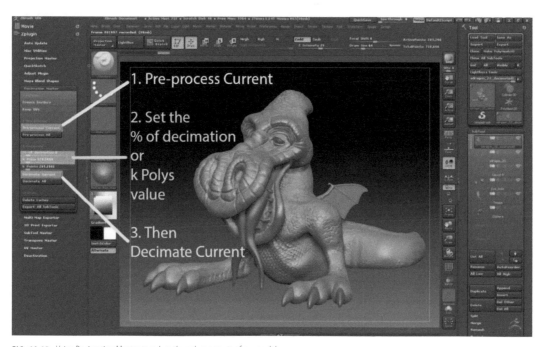

FIG 10.15 *Using* Decimation Master *to reduce the polygon count of our model*

To use *Decimation Master*, first save a backup of your ZBrush tool (.ZTL) using the *Tool.Save As* command. It isn't uncommon for ZBrush to crash while trying to process a complex command like this, so it pays to be careful. Go to *Zplugin.Decimation Master* and click on the *Pre-process Current* button. This runs the calculations for the currently selected subtool. If you wanted to process all of the subtools in a given model, you could use the *Pre-process All* button instead. Now set the *% of decimation* = 3 or the *k Polys* = 5–15. The *k Polys* command tries to crunch the model down to a specific target number set in thousands of polygons. Now press the *Decimate Current* command to run the process. A useful function within Decimation Master is the *Keep UVs* button. Toggle this button on before pre-processing your models to save your current UV layout. This is useful because it allows you to create the UVs and textures on your high-resolution models first, then use decimation master to generate a low-resolution model which you can export to another package. Once there you can apply the texture maps you generated from the high-resolution versions onto your low-resolution models.

After decimating your model and exporting all of your textures you can go to *Tool.Export* and save the model out as an OBJ file type, which can be imported into most other 3D packages.

Creating the Collar Using Insert Mesh

Our dragon needs a little decoration, something to break up the colors and patterns forming him while still looking appropriate. How about a collar? Since he looks like someone's pet, this will serve to confirm that association and let us demonstrate a few more techniques in ZBrush too!

The collar part

First, let's go to the *Tool* pop-up menu and select a *Ring3D* tool and draw it on screen, then go into *Edit* mode. Under *Tool.Initialize*, set the following values *SRadius = 9*, *Coverage = 360*, *Scale = 1*, *Twist = 0*, *SDivide = 4*, *Ldivide = 256*, and *Itwist = 45*. Then select *Tool.MakePolyMesh3D* so we can sculpt it. Use the *Transpose Move* brush to make the ring a bit taller so that it looks more like a collar.

Go to the *Tool.PolyGroups* palette and click *GroupByNormals*. This will create a set of polygroups, a special collection of selected polygons, on the model. These polygroups can then be used as a quick way of selecting previously assigned groups of polygons. *GroupByNormals* creates these new polygroups based upon the direction each polygon in the model is facing. Polygons that are facing radically different directions than the others are put into their own polygroups. Turn on the *PolyF* (Polyframe) toggle button to see your geometry. The *Tool.Geometry.Crease.CreasePG* will preserve the collar's sharp edges while we subdivide it using the *Tool.Geometry.Divide* twice. Get rid of the crease effect by using the *Tool.Geometry.Crease.UncreasePG* command and *Divide* again.

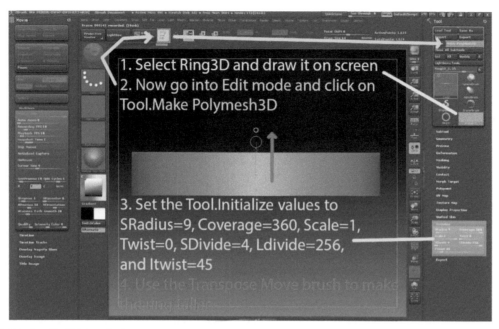

1. Select Ring3D and draw it on screen
2. Now go into Edit mode and click on Tool.Make Polymesh3D

3. Set the Tool.Initialize values to SRadius=9, Coverage=360, Scale=1, Twist=0, SDivide=4, Ldivide=256, and Itwist=45

4. Use the Transpose Move brush to make the ring taller

FIG 11.1 *Turn a* Ring3D *into a collar shape*

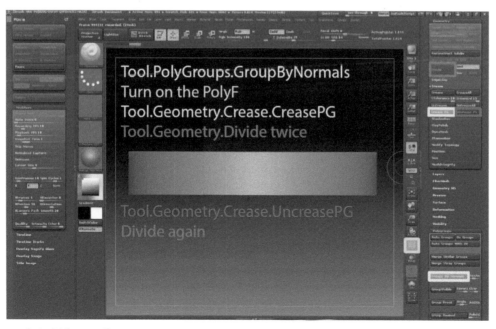

Tool.PolyGroups.GroupByNormals
Turn on the PolyF
Tool.Geometry.Crease.CreasePG
Tool.Geometry.Divide twice

Tool.Geometry.Crease.UncreasePG
Divide again

FIG 11.2 *Setting* PolyGroups *and* Crease

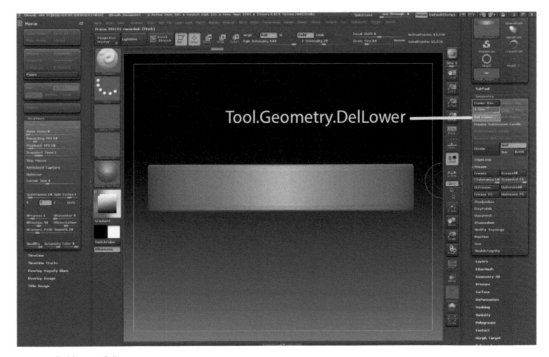

Tool.Geometry.DelLower

FIG 11.3 *Tool.Geometry.DelLower*

The *Tool.Geometry.DelLower* will delete our lower subdivision levels on our model, leaving us with just a high-resolution mesh.

A lot of commands in ZBrush will not work on models that have multiple subdivision levels, so this is a required step. Next we need to use the *Tool.PolyGroups.GroupVisible* to place everything in this model into one polygroup, otherwise you could get some very unusual results later on!

When working in 3D with any of the high-end software packages such as ZBrush, 3ds Max, or Maya, it doesn't take much to introduce errors into the model. A complex process such as *DynaMesh* (or anything else, for that matter) can easily result in errors which will ruin your model.

Decorations

Let's make some decorations for the collar. Select the *Cone3D* from the *Tool* pop-up menu and Initialize it to *HDivide = 4, TaperTop = 50*, and *Zsize = 20*. For this next step it is critically important that you lock the view perfectly above the cone using *SHIFT + rotating the view*.

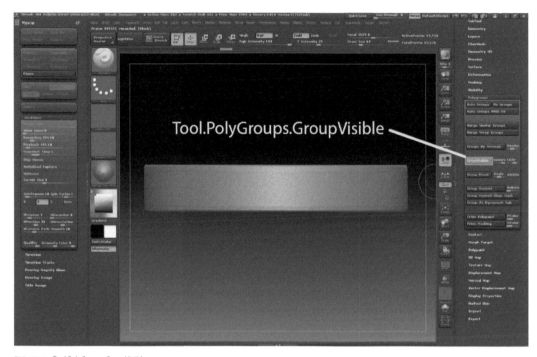

FIG 11.4 *Tool.PolyGroups.GroupVisible*

Now go to the *Brush* pop-up palette and use the *Create InsertMesh* button to create a new brush. When ZBrush asks you if you want to append or create a new brush, tell it you want to make a new brush.

Now switch to your collar. Select your new *InsertMesh Brush* that you just created. Open the *Stroke* menu and go to the *Curve* palette and turn these options *on*: *CurveMode*, *Bend*, and *Snap*.

Draw a line while holding down *SHIFT* and go off the edge of the object until the line noticeably changes; this will draw a cone pattern all the way around the entire object.

For some reason it almost always messes up part of the circle by creating a little bump where you started. That's OK; you can tweak the curve. Just find the point on the curve controlling your insert mesh that's a bit off. Place your mouse over it – the mouse icon should turn blue. Now you can move the curve around.

If you change the size of the brush when it is red, then click on the Curve line when the brush turns blue, you will update the size of your *InsertMesh*!

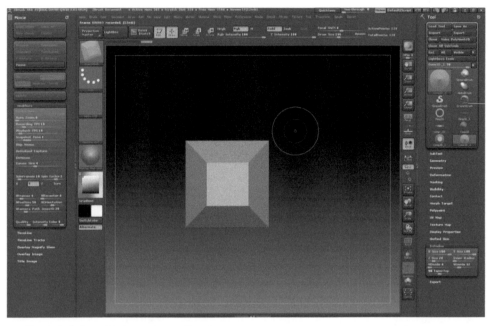

FIG 11.5 *You must be looking straight down at the pyramid-cone!*

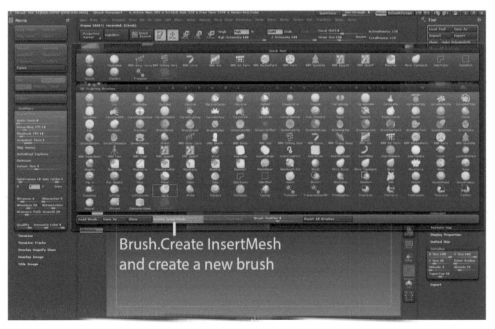

FIG 11.6 Brush.Create InsertMesh *and create a new brush*

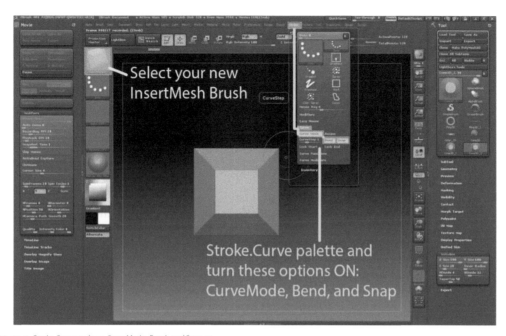

FIG 11.7 Stroke.Curve *and turn* CurveMode, Bend, *and* Snap *on*

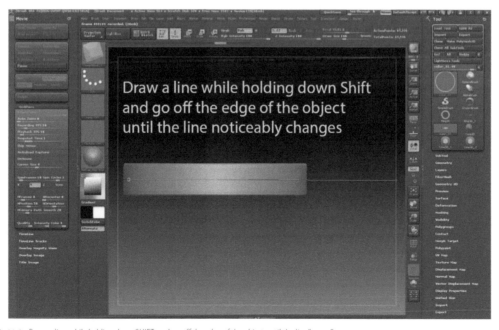

FIG 11.8 *Draw a line while holding down* SHIFT *and go off the edge of the object until the line "snaps"*

Since the collar should be masked off right now anyway, let's go ahead and leverage that by using the *Tool.PolyGroups.GroupMasked* to assign polygroups to this object. Turn on *PolyF* to check your groups. The collar should have one color and another color on the *InsertMesh*. You can get rid of the mask now by using *Tool.Masking.Clear*.

CTRL + SHIFT + click the collar to hide the *InsertMesh* you've added. Set your *Material* to *MatCap Gorilla* and the color to a dark blue-gray. Turn *Mrgb* mode on and set the *Rgb Intensity = 100*. Now use the *Color.FillObject* command to apply the material and color to our collar. Then *CTRL + SHIFT + click* the background to unhide everything.

CTRL + SHIFT + click the *InsertMesh* to hide the collar. Set your material to *MatCap Metal02* and the color to a light/mid grey. With *Mrgb* mode on and *Rgb Intensity = 100*, repeat the *Color.FillObject* command. This applies the color and material to the row of little pyramids our *InsertMesh* brush created. *CTRL + SHIFT + click* the background to unhide everything. Now save your tool.

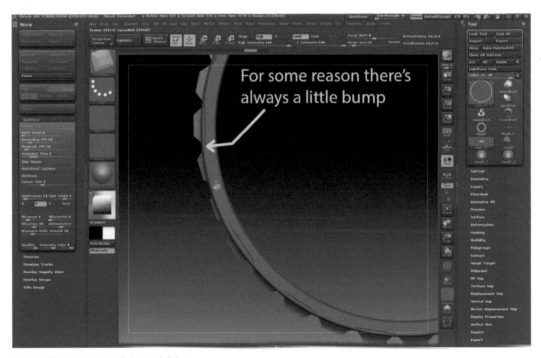

FIG 11.9 *For some reason there's always a little bump*

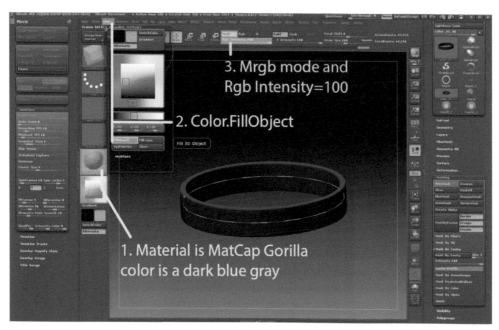

FIG 11.10 *Pick* MatCap Gorilla *material and a dark blue-gray color, then* Mrgb *mode and* Rgb Intensity = 100; *finally, use* Color.FillObject *to apply the material and color to the object*

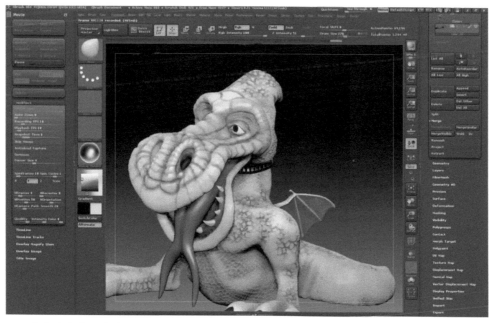

FIG 11.11 *The finished collar on the dragon*

Make sure both your dragon model and collar model are loaded into the *Tool* pop-up palette. Draw the dragon on screen. Go into *Edit* mode. In the *SubTool* menu, click the *Append* button and add the collar tool to the dragon model. Use the *Transpose Move* and *Move Topological* brushes to fit the collar to the dragon's neck. Save out your combined tool file.

Recoloring the Model

The why

I've decided that I'd rather have a dragon that isn't green. I could go back in and repaint it, but there should be a quicker way of doing this. My first thought was to use the *Projection Master* button located in the upper left-hand corner and its set of 2.5D brushes. I could create a color texture

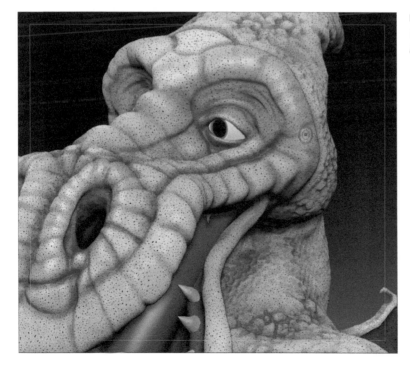

FIG 12.1 *Look at all the black spots! Yuck! Errors in the texture map due to UV fluctuation*

map of the dragon's current paint job, take that into my image editing program, and hue shift it to a new color. Then I could just import it back into ZBrush and apply it to my model. Unfortunately, when I generated the color map using the UVs I had already created I got a lot of nasty black spots. The black spots were caused by UV fluctuation – which is to say, the UVs on the object were shifting around ever so slightly. This happens due to the level of precision with which the numbers for the UV coordinates are stored. Not enough precision in the decimal places leads to ever so slight alterations in the UVs. Normally this isn't an issue; but with a model that has thousands of small UV pieces it can become a serious problem – like now. All of this means that I need to have a larger UV border setting when I make the UVs. This narrows it down to two choices. Use a really large texture map to provide that extra leeway the UVs need or break the object up into multiple parts and generate the maps individually for each. Keeping the object as one piece sounds better than undoing a lot of our work, so it is time to go back in, re-UV the object, and regenerate the maps.

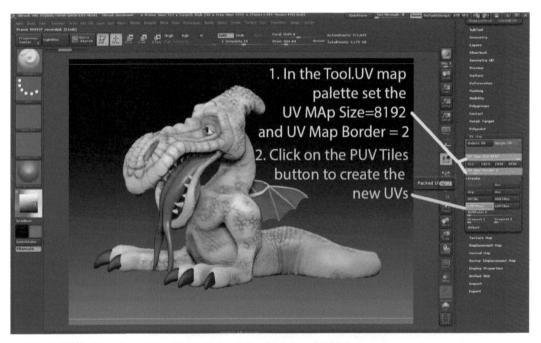

FIG 12.2 *Tool.UV Map.UV Map Size = 8192 and UV Map Border = 2, then click the Create.PUV Tiles button*

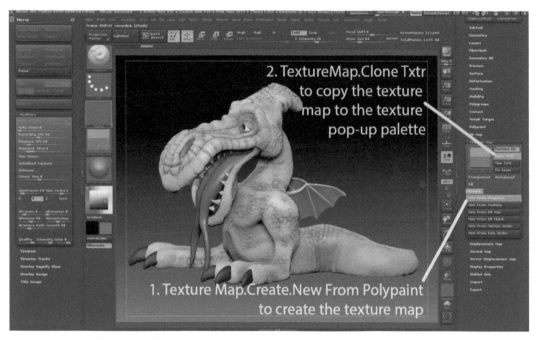

FIG 12.3 *In the Texture Map palette, use* NewFromPolypaint *to create your texture map; select the* Clone Txtr *button to copy it to the Texture pop-up palette*

The how: Re-UVing the model

This part is simple enough. Just select our dragon's subtool layer. Go to the *Tool.UV Map* palette and set the *UV Map Size = 8192* (actually maxed out) and *UV Map Border – 2*. Now click on the *Create.PUV Tiles* button to make the new UVs and wait . . . quite a long while, actually. This is going to be a huge UV map and it is best to just walk away from the computer and let ZBrush think.

After ZBrush processes the last command, open the *Texture Map* palette and click the *Create.NewFromPolypaint* button to generate your texture map from the paint on your model. After ZBrush generates the map, click the *Texture Map.Clone Txtr* button to copy it to the Texture pop-up palette.

Creating and adjusting the color texture map

Look on the left hand side of the screen and find the copy of your texture map that has appeared in the Texture pop-up palette. Click on this icon, then export the file as a *Photoshop PSD* image type using the *Export* button at the bottom of this pop-up menu.

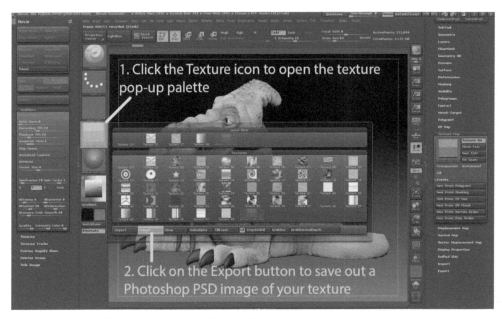

FIG 12.4 *Use the Texture palette* Export *command to save out a* Photoshop PSD *of our texture map*

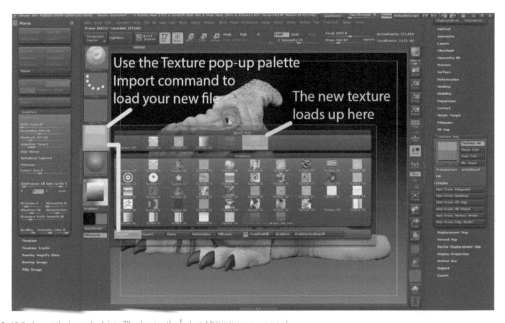

FIG 12.5 *Import the image back into ZBrush using the Texture palette import command*

Now just open up the texture image in Photoshop or GIMP (or whatever image editing software you like) and hue shift the image to a red or blue, or whatever different color you prefer. Save out the image file as a new name, something like red_texture.bmp perhaps, and import the hue-adjusted file back into ZBrush using the Texture pop-up palette *Import* command.

Applying the modified texture map to the model

I want to leave the mouth colors alone though, so I will use the *CTRL* brush to enable masking and mask out the areas where I want to preserve the original colors.

Now make sure you are in *Rgb* mode, then go to the *Tool.Texture Map* palette on the right-hand side of the ZBrush interface and click on the texture map icon. This will bring a pop-up list of all of the texture maps you have loaded into the program. Select the color-adjusted texture map from the list.

Use the *Tool.Polypaint.PolypaintFromTexture* command to fill the model with the color from the new texture map. It should ignore any area that you have masked off. If not, you can always go into that area and repaint it. Once you

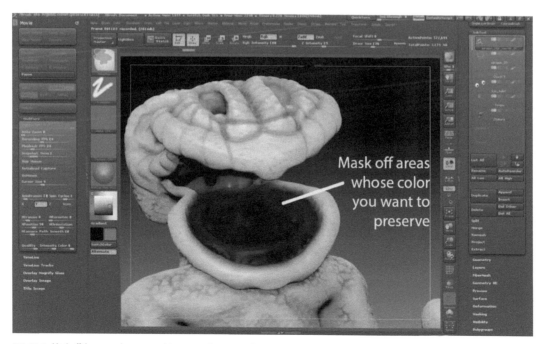

FIG 12.6 *Mask off the areas where you want to preserve the current colors*

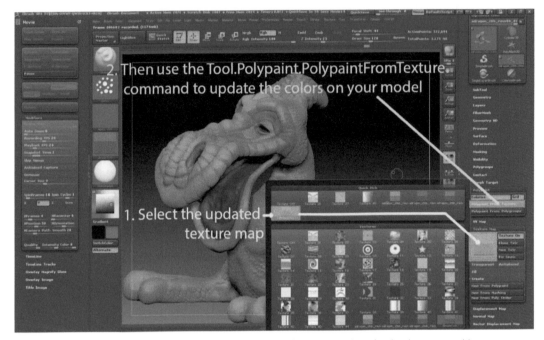

FIG 12.7 *Select the updated texture map and use the* Tool.Polypaint.PolypaintFromTexture *command to update the colors on your model*

have transferred the paint from your texture to the model, go into *Tool.Texture Map* and turn the Texture On button *off*. I had a few touch ups to do so I used the color picker function of the color swatch to choose my color (simply left click and hold down over the color swatch and drag onto the model where you want to grab the color from), and I painted those areas in using the standard brush. Save your model using *Tool.Save As*.

Making a Fire Hydrant

Some chapters are bigger than others and this one is the biggest of them all! There's a lot of material covered in this chapter, so make sure you take your time when going through it. We're going to build a rather complicated inorganic structure – a fire hydrant. It has lots of different shapes, indentations, bolts, and protuberances and we will cover a lot of techniques making it.

FIG 13.1 *The fire hydrant we are going to build*

Centerpiece

The first piece we will build is the centerpiece, or main part of the hydrant. It is basically a tube with a flat flange at both ends. We're going to use a method for extruding the shapes very quickly by using masks along with the transpose brushes. Start by going to the *Tool* menu and clicking on the large tool "S" icon there. From the pop-up menu select the *Cylinder3D* object. Draw it on the canvas while holding down the *SHIFT* key to snap the cylinder to an axis. Now press the *Edit* button or the *T* shortcut key to edit the object. Find the *Initialize* palette under the *Tool* menu and open it. Set the *HDivide* slider to *256* in the *Initialize* palette.

Press the *Tool.MakePolymesh3D* button to turn the cylinder into an object you can sculpt. Activate the *Move Transpose Line* by clicking the *Move* button at the top of the page or by pressing the *W* shortcut key on your keyboard. Drag a new transpose line from the bottom of the cylinder to the top. Click the inside of the topmost circle on the transpose line, hold down the *SHIFT* key so you don't accidentally bend the cylinder, and drag upwards. This will make the cylinder taller.

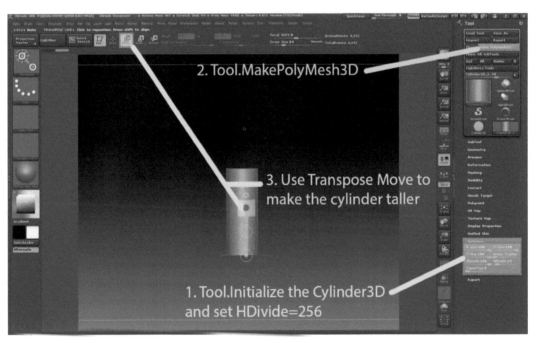

FIG 13.2 *Initializing and Transposing the Cylinder3D*

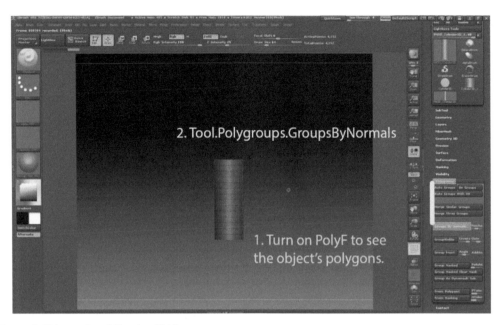

FIG 13.3 *Tool.Polygroups.GroupsByNormals and PolyF*

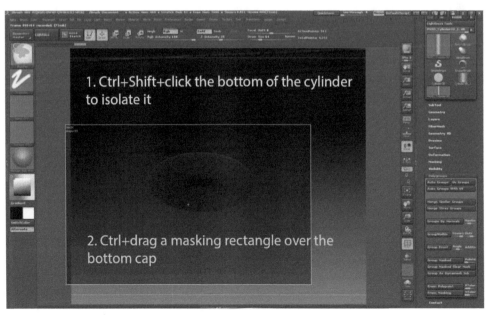

FIG 13.4 *Use* CTRL + SHIFT + click *the bottom to isolate it, then use* CTRL + drag *to mask it*

Now we are going to place the top, bottom, and sides of our cylinder into different groups so we can access some new modeling features. Use the *Tool. Polygroups.GroupsByNormals* command to do this. Turn on the *PolyF* button to see the polygroups on your cylinder.

Isolate the bottom of the cylinder by holding down the *CTRL* and *SHIFT* keys and clicking on the bottom. Now hold down the *CTRL* key to access the *Mask-Pen* brush, then click and drag a masking rectangle over the visible bottom of the cylinder.

CTRL + SHIFT + click on the canvas to reveal all of the hidden parts of the cylinder. Now *CTRL + click* the background to invert the mask so the bottom cap is the unmasked portion of the cylinder.

Activate the *Scale Transpose Line* by clicking the *Scale* button at the top of the page or by pressing the *E* shortcut key on your keyboard. Carefully click once on the center of the bottom of the cylinder. If you still have *PolyF* on, it will be the point where all of the polygon lines converge. Doing this creates a transpose line perpendicular to the point you clicked on the model. The transpose line should now point directly out from the bottom face of our cylinder. Hold the *CTRL* key down and click inside the middle circle of the transpose line to extrude outwards a new bottom.

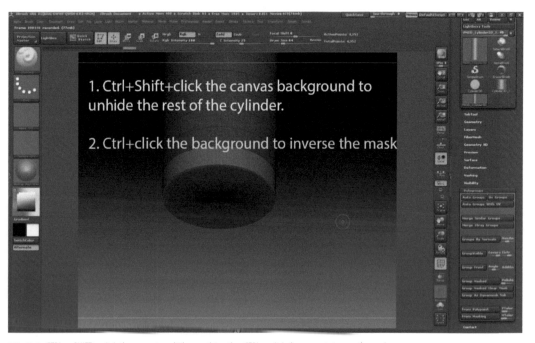

FIG 13.5 CTRL + SHIFT + click *the canvas to unhide everything, then* CTRL + click *the canvas to inverse the mask*

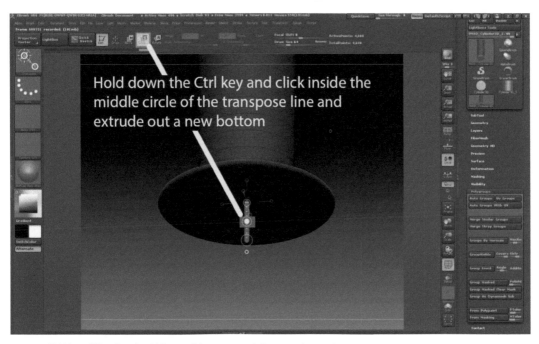

Hold down the Ctrl key and click inside the middle circle of the transpose line and extrude out a new bottom

FIG 13.6 *Hold down CTRL and use the middle rung of the transpose scale line to extrude a new bottom*

When using the *Scale Transpose Brush*, if you click and drag the middle circle you scale on two of the axes to widen the model; if you use either end rung on the tool, you scale the object uniformly.

Switch to the transpose move brush. *CTRL + click and drag* the middle rung of the move transpose action line to extrude the bottom of the cylinder downwards. Press *SHIFT* while you do so to constrain the move to the axis so that you get a straight extrude.

Now we can get rid of the mask by using the *Tool.Masking.Clear* command or simply *CTRL + click and drag* a masking selection rectangle on the background. Next *CTRL + SHIFT + click* on the background to make sure everything is visible, or you can use *Tool.Visibility.ShowPt* command to the same effect.

To create the other end of our cylinder just use the *Tool.Geometry.ModifyTopology.MirrorAndWeld* command with the *Z* axis selected. This will copy one end of the object to the other. If you don't get the exact results you want, undo (*CTRL + Z*) and use the *Tool.Deformation.Mirror* on the *Z* axis to flip the object, then try *Mirror And Weld* again. Make sure that you don't have anything hidden or masked before invoking these commands. You may have to use a different axis for the mirror and weld and deformation commands. If ZBrush

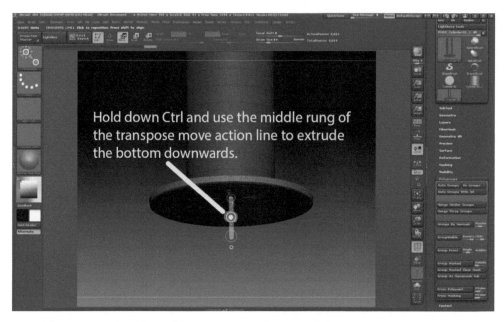

FIG 13.7 *Hold down CTRL and use the middle rung of the transpose move action line to extrude the bottom downwards*

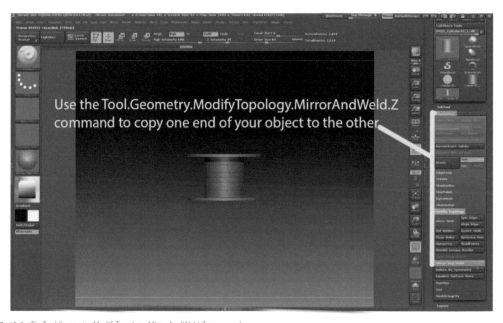

FIG 13.8 *The* Tool.Geometry.ModifyTopology.MirrorAndWeld.Z *command*

refuses to execute the command, make sure that you don't have any subdivision levels on your model. If you do, use the *Tool.Geometry.DelLower* command to get rid of the lower subdivision levels. Mask off the bottom part of your resulting shape and use the *Move Transpose Brush* to adjust your object's size until it looks correct.

Top and bottom flange

The next part we are going to build is the shaped cylindrical pieces that fit at the top and bottom of our center part of the hydrant. Start by using *Tool. SubTool.Append* to add a new *Cylinder3D* to our existing model.

Turn on the *Transp* and *PolyF* buttons to see your objects better. Use the *Tool. Polygroups.GroupsByNormals* command and then the *Tool.Geometry.CreasePG* to preserve your sharp edges exactly as we did to the first cylinder. Now use *Tool.Geometry.Divide* (*CTRL + D*) a few times to subdivide the cylinder.

After this, use the *Tool.Geometry.DelLower* command and *Tool.Geometry. Crease.UncreasePG* to get rid of the crease effect.

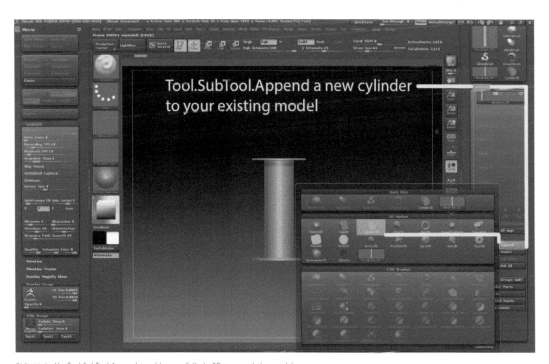

FIG 13.9 *Use* Tool.SubTool.Append *to add a new* Cylinder 3D *to our existing model*

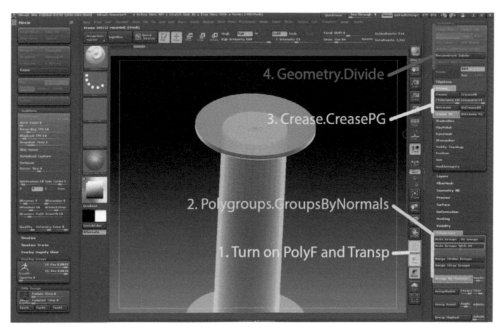

FIG 13.10 *Polygroups.GroupsByNormal, then Tool.Geometry.CreasePG and Tool.Geometry.Divide*

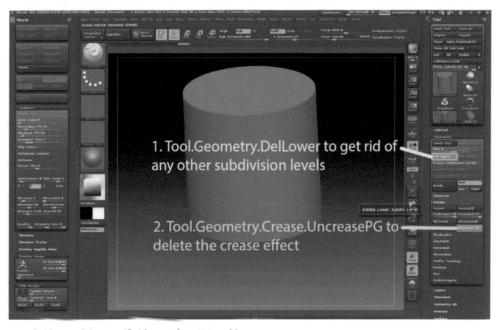

FIG 13.11 *Tool.Geometry.DelLower and Tool.Geometry.Crease.UncreasePG*

Select the transpose move brush (*W* shortcut) and use it to move the new cylinder to the top of the first piece we modeled. Change to transpose scale brush and scale the new piece to fit on top. You can also use the transpose brush to scale as well. Put the bottom of the transpose move action line at the bottom of the object you wish to scale. Place the top rung of the transpose action line above the top of the object. Now just click in the middle of the top-most rung and drag down. This scales the object along the action line. If the object starts to disappear when you try this, then you've got the rungs backwards and need to reverse how you drew the action line. Holding down SHIFT while you do this action locks the movement to the axis defined by the action line.

Now, repeat exactly as we did for the first piece, except to isolate the top of the cylinder using *CTRL + SHIFT + click*, then *CTRL + drag* a mask rectangle selection and mask the bottom cap. Next *CTRL + SHIFT + click* on the background to reveal all, then *CTRL + click* the background to inverse the mask so that the top cap is the only part left unmasked.

This time, use the transpose move brush. Hold down *CTRL + click and drag* the middle rung on the transpose line up while holding down *SHIFT* to constrain

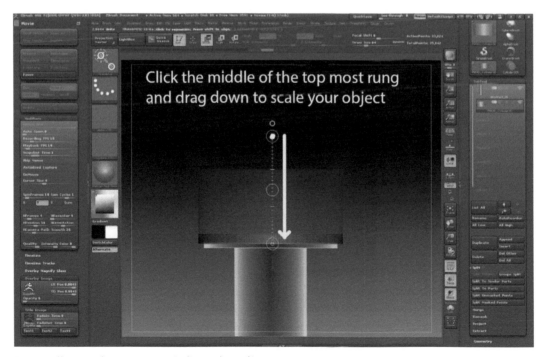

FIG 13.12 *You can use the transpose move action line to scale your object*

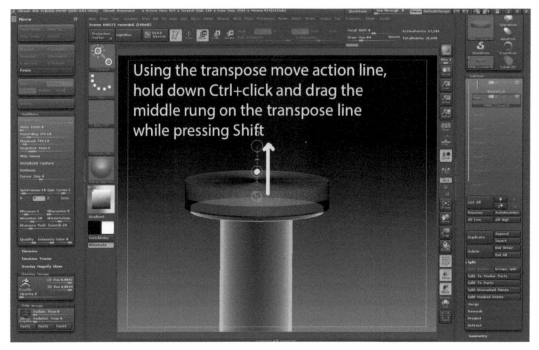

FIG 13.13 *Using the transpose move action line, hold down CTRL + click and drag the middle rung up on the transpose line while pressing SHIFT*

the move to the axis. This will extrude a new top polygon. Switch to the transpose scale brush and scale the top polygon down a bit so you get a nice beveled shape.

Now click on *Tool.Masking.Clear* to get rid of any masks still active.

Make sure you have your transpose move tool active. Hold down *CTRL + click and drag* the middle rung on the transpose line up while pressing *SHIFT* to clone the entire cap piece you just made and move it to the other end of the hydrant. It is the exact same action as before, except this time nothing is masked off, so it clones the whole piece of geometry. Now just fit the new bottom piece into place.

Making the cap

The top part of the fire hydrant is essentially a hemisphere with some subtle indentations in it. We will deal with the basic shape first and add in the indentations a bit later using a different technique. When you are building models in 3D, it is always a good idea to work from the general to the specific. Establish the overall form and silhouette of an object first. If those aren't right

then nothing else about the model will really matter. Once you have the major forms blocked in add the secondary details – things that don't affect the silhouette usually but nevertheless define the overall look of the model. Last come the tertiary details – the small shapes that give the object personality and make it unique. It is good practice to work on these stages one after another. Wait until you've finished nailing down the silhouette and overall shape before you move on to adding the major features and finish the major features before you start adding fine details.

To build the round cap of our hydrant begin by adding a *Sphere3D* onto the top of the upper section. Use the *Tool.SubTool.Append* command to add a *Sphere3D* primitive to our shape. Use the transpose, move, and scale brushes to scale the sphere a bit and move it into the correct place. Click on *Tool. Geometry.Divide (CTRL + D)* two or three times to create enough geometry to work with later on.

Use *CTRL + SHIFT + SelectRect* and drag a selection box over the bottom half of the sphere to hide the top half.

Use the *Tool.SubTool.Split.SplitHidden* command to separate the hidden lower half of the sphere into its own sub-object layer. Make sure that you have the

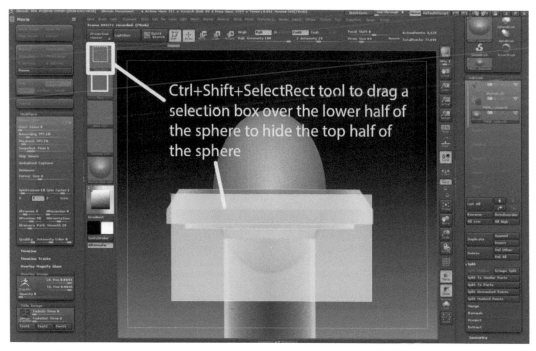

FIG 13.14 CTRL + SHIFT + SelectRect *and drag a selection box over the lower half of the sphere to hide the top half of it*

211

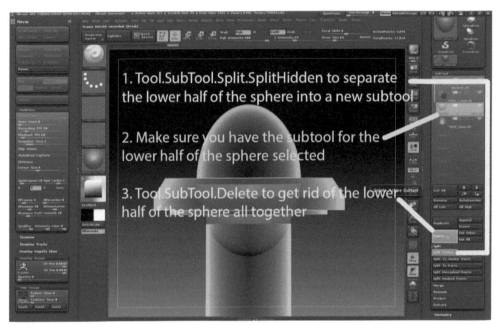

FIG 13.15 Tool.SubTool.Split.SplitHidden, *then* Tool.SubTool.Delete *the lower half of the sphere*

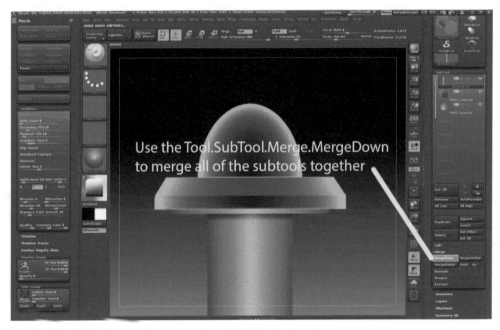

FIG 13.16 *Use the* Tool.SubTool.Merge.MergeDown *command to merge all of the subtools together*

lower half of the sphere selected in the subtool layers list and click the *Tool. SubTool.Delete* button to delete the bottom half of the sphere.

Afterward, press the *Tool.SubTool.Merge.MergeDown* button several times and merge together all of your current subtools.

Mask off the bottom section of your object and use the transpose, move brush to adjust the height of your object if needed. Save your file using *Tool. Save As*.

Top bolt

The hydrant has this little interesting bolt contrivance on top that we will need to build. Click the *Tool* icon and in the resulting pop-up menu select the *Cylinder3D* and draw it on screen. Activate it by going into *Edit* mode (*T* key). Set the *Tool.Initialize.HDivide* slider to 256 so the sides of our new cylinder are smooth. If you haven't already loaded your hydrant into ZBrush for this session, do so now using the *Tool.LoadTool* button. Now go to the *Tool* pop-up menu and select your hydrant. This will switch in your hydrant as the active tool on screen. Use *Tool.SubTool.Append* to add the new *Cylinder3D* to your

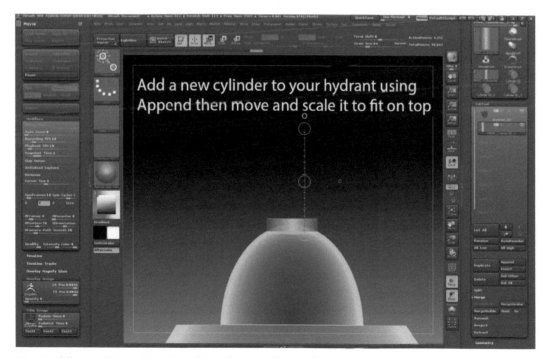

FIG 13.17 *Add a new cylinder using* Append *to your hydrant, then move and scale it to fit on top*

hydrant. Transpose, move, and scale the cylinder into place on top of the hydrant.

Use *Tool.SubTool.Duplicate* to copy the cylinder subtool. Move and scale this new subtool into position above the first cylinder. *Tool.SubTool.Duplicate* to copy the cylinder subtool again and move and scale it into position above the second cylinder. You should end up with a pyramid stack of three successively smaller cylinders one on top of the other.

We have to carve these cylinders into the appropriate bolt shapes. The top bolt on the hydrant is uniquely a five-sided bolt, so set *Transform. ActivateSymmetry.Z*, turn the radial symmetry *(R)* button on, and set the *Radi-alCount = 5*. Press down *CTRL + SHIFT* and select the *Clip Curve* brush. Maneuver your camera so that you are looking straight down on the top cylinder. You will have to press the *SHIFT* key when you get close to that view to get the camera to lock directly above the cylinder. Make sure you have the topmost cylinders subtool layer active and use *CTRL + SHIFT + click and drag* out a clip line to chop off one fifth of the outer edge of the top cylinder. Because we have radial symmetry active this will form a pentagonal shape out of our cylinder. When dragging the clip curve out, remember that it will clip off the side of the curve that is shaded. If you mess up, just *CTRL + Z* undo and try again.

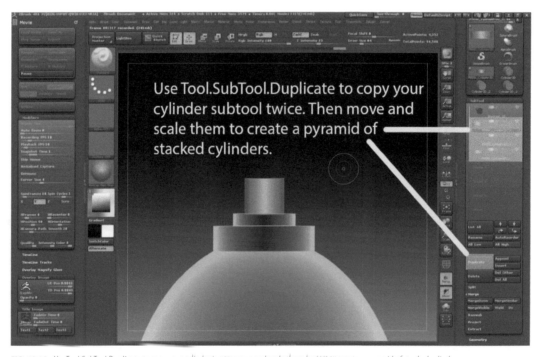

FIG 13.18 *Use* Tool.SubTool.Duplicate *to copy your cylinder twice; move and scale the cylinders to create a pyramid of stacked cylinders*

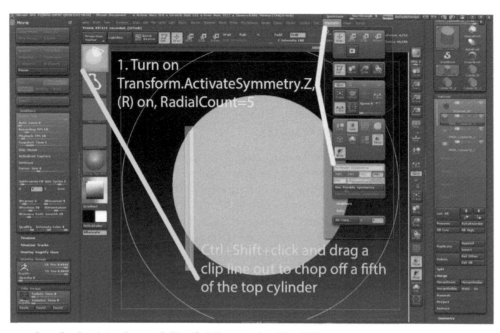

FIG 13.19 *Turn on* Transform.ActivateSymmetry.Z, (R) *and* RadialCount = 5; *then* CTRL + SHIFT + click and drag *out a* Clip Curve *to chop off one fifth of the top cylinder*

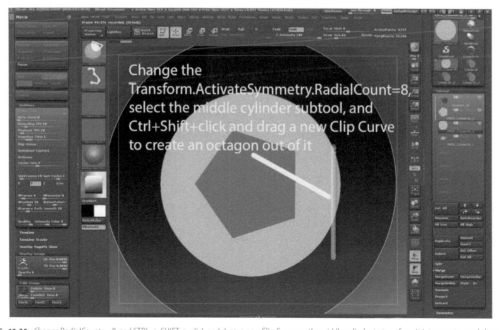

FIG 13.20 *Change* RadialCount = 8 *and* CTRL + SHIFT + click and drag *a new* Clip Curve *on the middle cylinder to transform it into an octagonal shape*

With the radial *(R)* button still on, change the *RadialCount* = *8* and select the middle cylinder from the subtool layer list. Now *CTRL* + *SHIFT* + *click and drag* a new *Clip Curve* on the middle cylinder to make it an octagonal shape.

Merge these subtools together using the *Tool.SubTool.MergeDown* command to complete the top bolt shape.

Water spouts

The hydrant has three large water spouts protruding from its main body. We will start off by adding another cylinder to our hydrant (you're starting to see a theme, perhaps, in how we approach modeling this object). In the *Tool* pop-up menu, select the *Cylinder3D*, draw it on canvas, go into *Edit* mode, and set the *Initialize.HDivide* slider to *256*. In the *Tool* pop-up menu select your hydrant tool and *Tool.SubTool.Append* this new *Cylinder3D*. Transpose, move, and scale the cylinder into position off one side of the cylinder to form one of the "arms" of the hydrant.

Tool.Geometry.Divide several times to round off the cap ends. Choose the *Inflate Brush*, set *Zintensity* = *10* and turn on *Transform.ActivateSymmetry*.

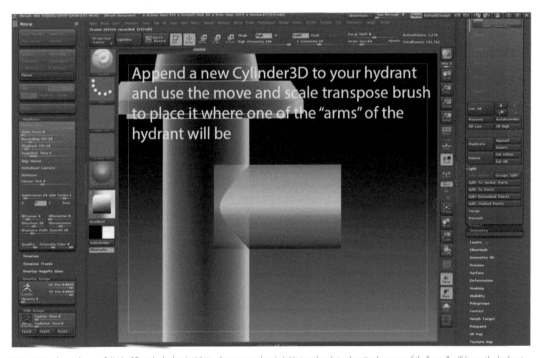

FIG 13.21 *Append a new Cylinder3D to the hydrant and use the move and scale transpose brush to place it where one of the "arms" will be on the hydrant*

Choose the *X* axis, turn on the *(R)* button, and set the *RadialCount* slider to *64*. Makes sure the *LSym* button is on so that the symmetry effect is centered on the new cylinder.

Increase the *Draw Size* of your brush to around 250. Now press *ALT* or turn on *Zsub* and shape your cylinder down subtly at the outer end. Hold down the *SHIFT* button to switch to the *Smooth* brush and smooth out any irregularities.

Now is a good time to remove any subdivision levels we have on this cylinder. Use the *Tool.Geometry.DelLower* button to do so otherwise the *SliceCurve* brush won't work. Press *CTRL* + *SHIFT* and select the *SliceCurve* brush from the brush menu. This brush is used to create new polygroups and edge loops. It actually creates new polygon edges wherever your drag the *SliceCurve* line through. Now draw in some new edge loops where the gap in the spout head occurs. If you press the *SHIFT* key while you draw the line, it will lock straight down. If you hold down the *Spacebar* key you can reposition the line wherever you like on the model. Turn on *PolyF* to see the new polygroups you've created.

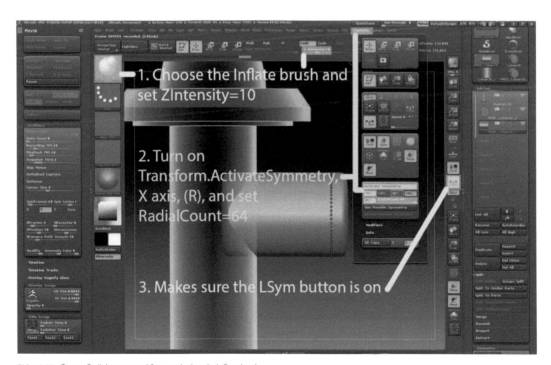

FIG 13.22 *Turn on Radial symmetry, LSym, and select the Inflate brush*

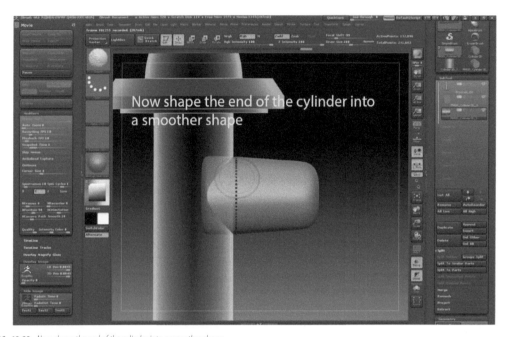

FIG 13.23 *Now shape the end of the cylinder into a smoother shape*

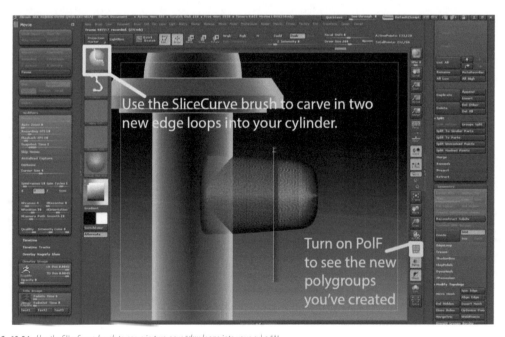

FIG 13.24 *Use the SliceCurve brush to carve in two new edge loops into your cylinder*

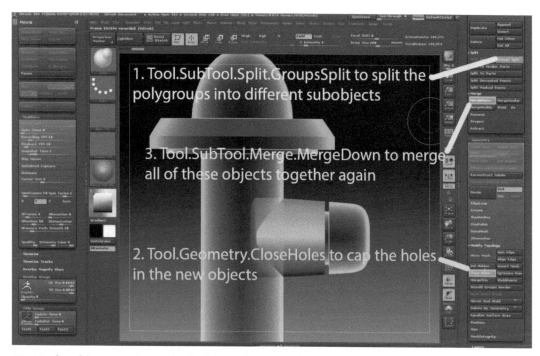

1. Tool.SubTool.Split.GroupsSplit to split the polygroups into different subobjects

3. Tool.SubTool.Merge.MergeDown to merge all of these objects together again

2. Tool.Geometry.CloseHoles to cap the holes in the new objects

FIG 13.25 GroupsSplit *to separate the pieces, then* CloseHoles *to seal the ends, and finally* MergeDown *to merge all of the subtools together again*

Use the *Tool.SubTool.Split.GroupsSplit* command to split the cylinder into three pieces. Select the centerpiece and scale it down to fit inside the other two pieces. Use the *Tool.Geometry.CloseHoles* command to cap the holes in these new objects. Then merge these subtools together using the *Tool.SubTool. Merge.MergeDown* command.

Creating the other spouts

Now that we have one of the spouts, it is an easy enough matter to make the other ones. Use the *Tool.SubTool.Duplicate* to duplicate the spout cylinder. Now use *Deformation.Mirror.X* to place it on the other side of the hydrant.

Use *Tool.SubTool.Duplicate* to create a third copy of the spout cylinder. Activate the *Transpose Rotate* brush and rotate this new spout 90 degrees. Hold down *SHIFT* while you rotate to snap the spout to a right angle.

Set the *Transpose Scale* tool to the center of the new spout by clicking once on the center tip of the spout. Now scale the spout using the middle circle to widen it.

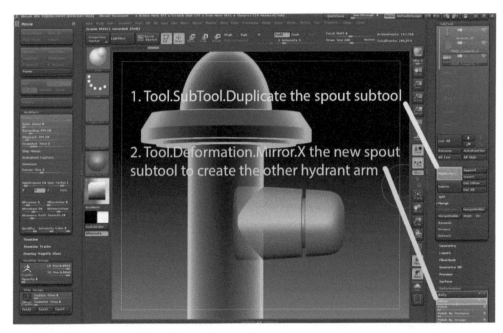

FIG 13.26 Duplicate *a new spout and* Mirror.X *it into position*

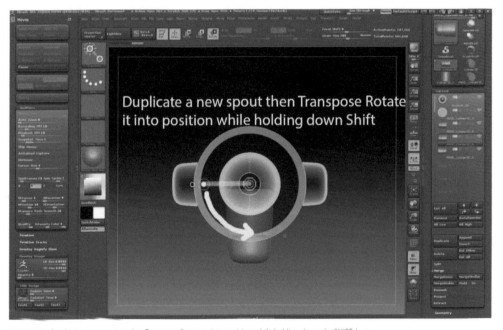

FIG 13.27 Duplicate *a new spout, then* Transpose Rotate *it into position while holding down the* SHIFT *key*

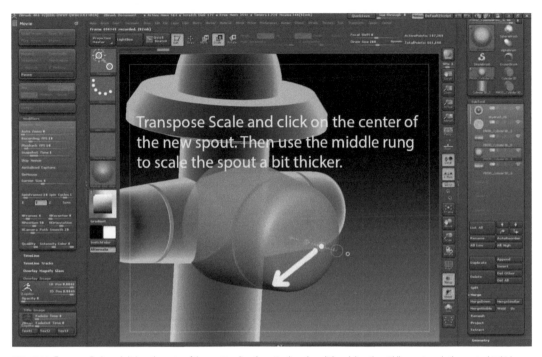

FIG 13.28 *Transpose Scale and click on the center of the spout to align the action line, then click and drag the middle rung to scale the spout a bit thicker*

Adding the spout tips

There are similar bolts at the tips of the other spouts. We can just copy and modify our existing bolt to create these shapes. First select the subtool for the bolt at the top of the hydrant. Now use *Subtool.Duplicate* to create a copy of the bolt and rotate and move it into place at the tip of a side spout. Use the *Tool.SubTool.SplitToParts* to break apart the new bolt into its cylindrical pieces.

Select the cylindrical lowest part and use the *Transpose Move* tool to make it thin. Now we need to add polygroups using the *Tool.Polygroups.GroupsBy-Normals* command. Just like we've done before, isolate the bottom by *CTRL + SHIFT + clicking* on it. Then *CTRL +* mask off the bottom cap. *CTRL + SHIFT +click* the background to reveal all and *CTRL + click* the background to inverse the selection so the bottom cap is unmasked. Now activate the *Transpose Scale* tool, click on the center of the visible bottom, and *CTRL + click and drag* the middle rung to inset a new polygon on the bottom.

Switch to the *Transpose Move* tool and *CTRL + click and drag* the middle rung while holding down *SHIFT* to extrude a new bottom out.

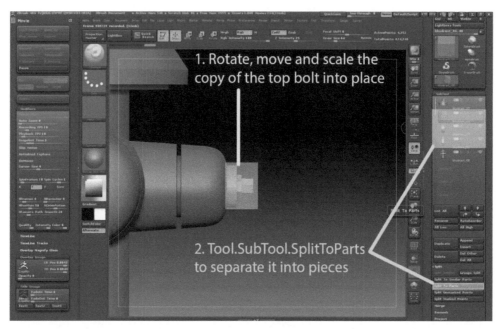

FIG 13.29 *Rotate, move, and scale the copy of the top bolt into place, then use* Tool.SubTool.SplitToParts *to separate it into pieces*

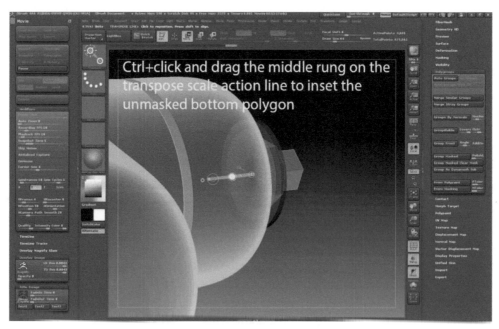

FIG 13.30 CTRL + click *and drag the middle rung on the transpose scale action line to inset the unmasked bottom polygon*

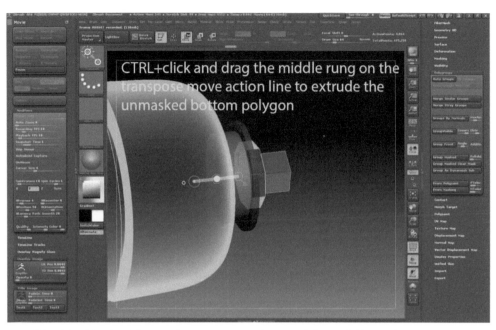

FIG 13.31 CTRL + click and drag *the middle rung on the transpose move action line to extrude the unmasked bottom polygon*

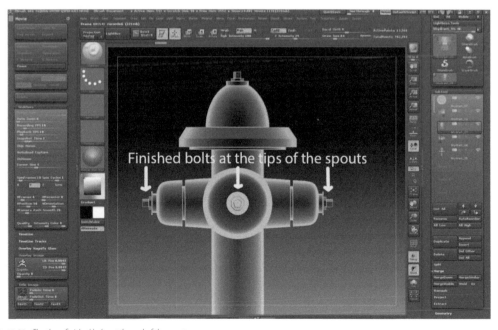

FIG 13.32 *The three finished bolts at the end of the spouts*

Use the *Tool.SubTool.MergeDown* command to merge the pieces of the end bolt for the water spout. With the newly merged bolt's subtool layer selected, use *Tool.SubTool.Duplicate* to copy it. Now use *Tool.Deformation.Mirror.X* to copy the end bolt to the tip of the other water spout. *Tool.SubTool.Duplicate* the bolt again and use *Transpose Rotate* and *Move* to fit it onto the remaining water spout.

Bottom detail section

There is an interesting piece of the hydrant's bottom that is slightly larger than the rest and has some shallow cutouts in it. We're going to have to build that as well. You know this part of the drill by now. Draw a new *Cylinder3D* on screen and go into *Edit* mode. Set the *Initialize.HDivide = 256*. Click on the *Tool. MakePolymesh3D* button. Now switch to our hydrant and append the new cylinder to it. Scale and move it into place. To create the upper lip of this piece, just *SubTool.Duplicate* this cylinder and move and scale this to form the upper rim piece. Subdivide the larger of the two cylinders a couple of times to round off its edges.

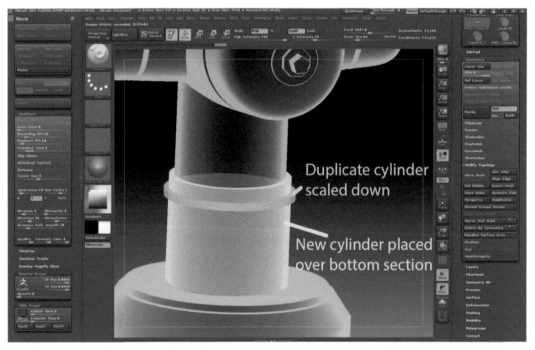

Duplicate cylinder scaled down

New cylinder placed over bottom section

FIG 13.33 *The bottom section is made of two separate cylinders*

Band cutouts

Most of the hydrant has involved the creative use of just a few functions and simply leveraging ZBrush's subtools. To create the shallow cutouts, however, we're going to move into some new territory. We are going to Boolean the cutouts into the hydrant. A Boolean is a type of mathematical function for adding, subtracting, or otherwise combining two or more objects. We are going to use a subtractive process and create shapes with which we are going to cut away parts of the hydrant.

Select the *Sphereinder3D* tool in the *Tool* icon menu, draw it on screen and go into *Edit* mode. Then use the *Initialize* command with the following settings: *TRadius* = 67, *TCurve* = 100, *HDivide* = 128. Now *MakePolymesh3D* this object.

Mask off the bottom of the shape and use the *Move Transpose* brush to lengthen the *Sphereinder3D* model.

Switch back to the hydrant and *Subtool.Append* the *Sphereinder3D* to it. Now use the *Transpose Move* and *Scale* brushes to place it so that it can form the cutout on the band around the bottom of the hydrant. Scale the *Sphereinder3D* piece a bit thinner so it doesn't create too deep a cutout later.

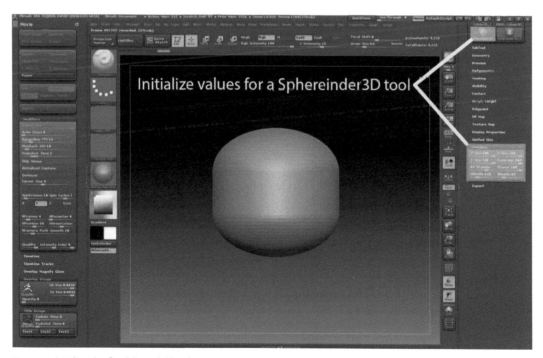

FIG 13.34 *Initialize values for a* Sphereinder3D *tool*

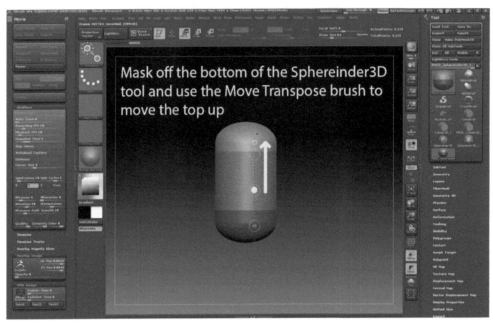

FIG 13.35 *Mask off the bottom of the* Sphereinder3D *tool and use the* Move Transpose *brush to move the top upwards*

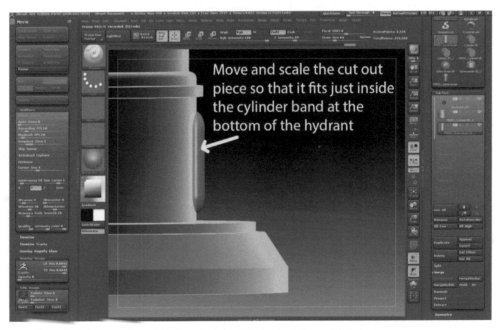

FIG 13.36 *Move and scale the cut-out piece so that it fits just inside the cylinder band at the bottom of the hydrant*

Save your work now using the *Tool.Save As* command. *Tool.SubTool.Duplicate* the cutout tool twice. This is just so we have a backup of it to use after we try out our Boolean operation.

Subtractive *DynaMesh*

The subtractive method we are going to use is a subtractive *DynaMesh* model. There is a very specific workflow you must follow to get this to work.

First, place the subtractive mesh immediately underneath the main model in your subtool layer list.

Next, turn on the *Difference Icon* on the subtractive mesh's subtool layer. Turning on the *Difference Icon* tells ZBrush that you want to subtract one model from the other. Without this icon being on, the process will not work correctly – you will just get a normal DynaMesh result.

After that you have to activate *Tool.Geometry.DynaMesh.DynaMesh* for the main object.

Select the upper subtool and use the *Tool.SubTool.MergeDown* to merge the two subtools together.

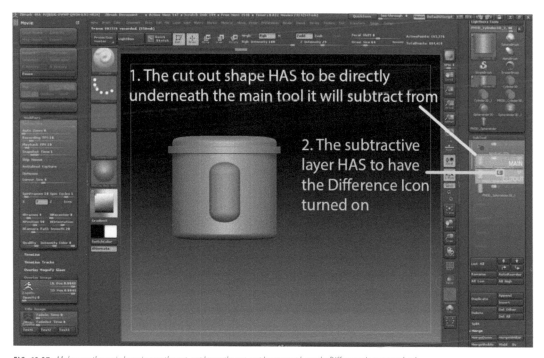

FIG 13.37 *Make sure the main layer is over the cut-out layer; the cut-out layer must have the* Difference Icon *turned on!*

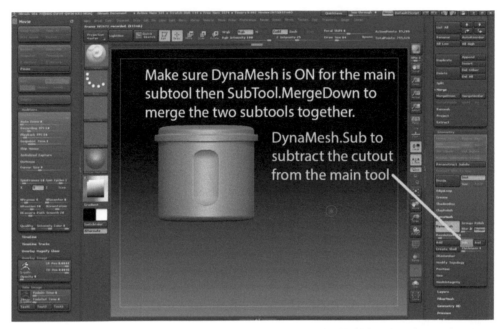

FIG 13.38 *Make sure* DynaMesh *is on for the main tool and* MergeDown *the layers together*, then *DynaMesh.Sub* to subtract the cutout from the main tool

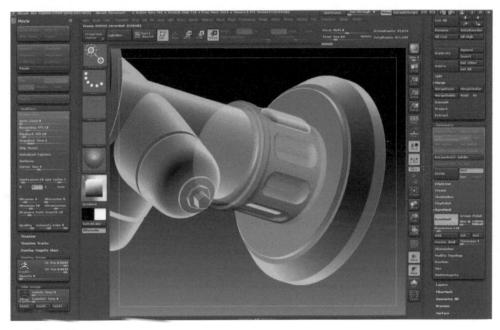

FIG 13.39 *The rest of the cutouts*

Click the *Tool.Geometry.DynaMesh.Sub* button to perform the Boolean operation.

Select the copy of the subtractive mesh you made earlier and duplicate seven copies of it. Rotate each one into position using the *Transpose Rotate* brush of the *Deformation.Rotate* command and repeat this process. It's a bit tedious, but doing it one by one prevents any complications from occurring. Don't forget to save frequently – preferably after each successful operation using a different name each time (i.e.., "boolean_01.ZTL", "boolean_02.ZTL", and so forth). Boolean operations are extremely finicky and error prone, so taking precaution here is wise.

Cap cutouts

Select your last copy of the *Sphereinder3D* tool that you built and position it so that it is just in front of the cap shape using the *Move* and *Scale Transpose* brush.

Now turn on *PolyF* and look at the *Sphereinder3D* object. If it doesn't have any edge loops in the middle of the object cutting across it horizontally,

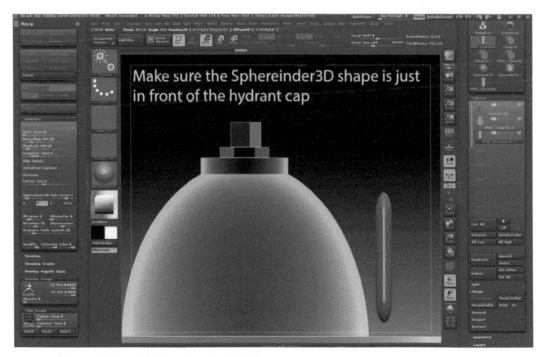

FIG 13.40 *Make sure the* Sphereinder3D *shape is just in front of the hydrant cap*

you will need to add some. Remember, a straight edge can't be bent so we have to do this or we won't be able to deform our *Sphereinder3D* to the cap successfully. The easiest way to do this is to simply *DynaMesh* the *Sphereinder3D* shape.

Use the *B–M–T* shortcut to switch to the *Move Topological* brush and turn on *Transform.ActivateSymmetry.Y* (you may need to use a different axis). Now, gently shape the *Sphereinder3D* shape to taper slightly at the top so it matches the reference pictures of the fire hydrant in this book.

Select the *MatchMaker* brush and set your *Z Intensity* to around *10*. Drag the brush over the Sphereinder shape to deform it to match the cap. You may have to move the Sphereinder shape into final position so that is sits just crossing the surface of the cap.

Now duplicate your Sphereinder shape and rotate it around the cap so that you end up with eight pieces in total, equally spaced around the cap model. Make sure you turn on the *Difference Icon* on each of the Sphereinder subtool layers.

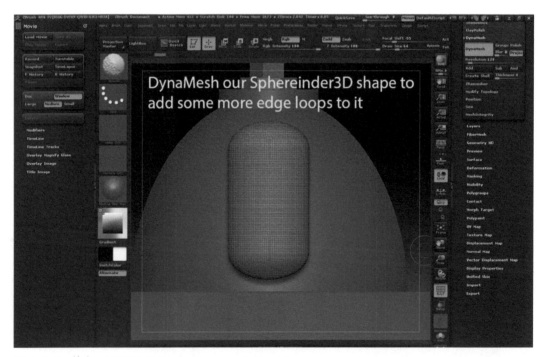

FIG 13.41 DynaMesh our Sphereinder3D shape to add some more edge loops to it

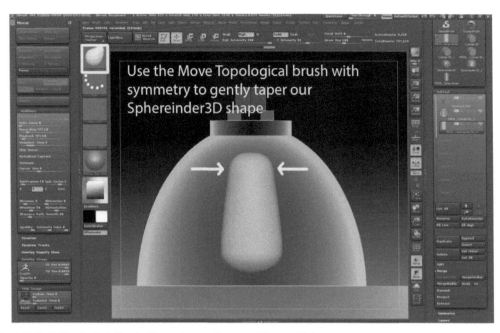

FIG 13.42 *Use the* MoveTopological *brush with symmetry to gently taper our* Sphereinder3D *shape*

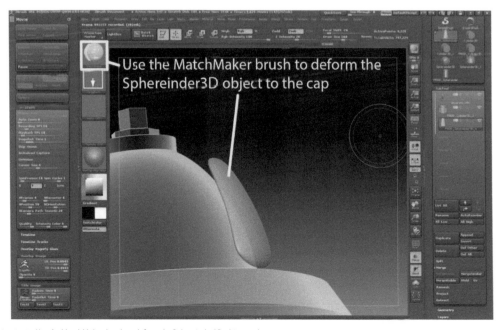

FIG 13.43 *Use the* MatchMaker *brush to deform the* Sphereinder3D *object to the cap*

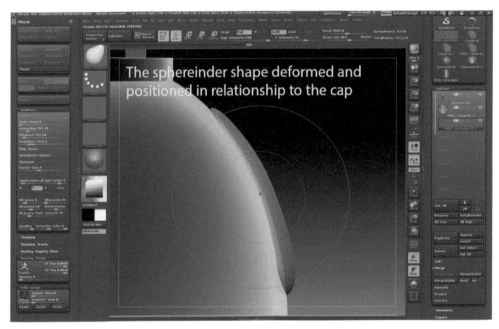

FIG 13.44 *The Sphereinder3D shape deformed and positioned in relationship to the cap*

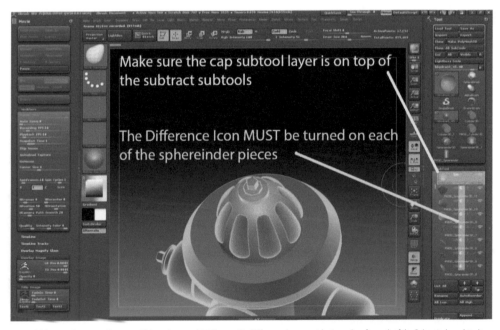

FIG 13.45 *Make sure the cap tool is on top of the subtract subtool layers; the Difference Icon must be turned on for each of the Sphereinder subtools*

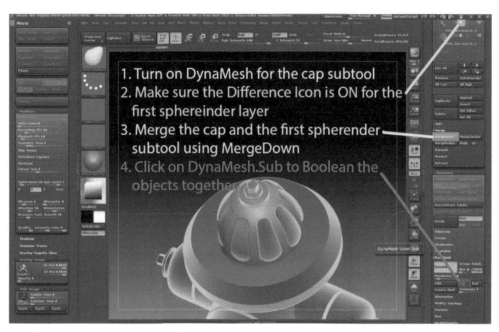

FIG 13.46 *The entire process for creating a subtractive Boolean*

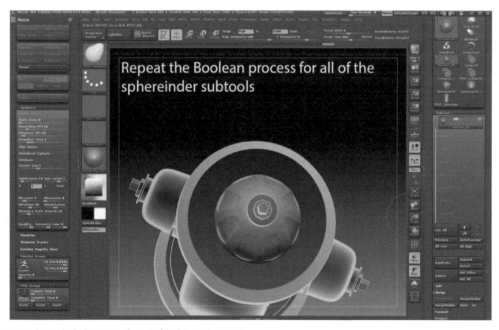

FIG 13.47 *Repeat the Boolean process for each of the Sphereinder subtools*

You will probably need to use the *SubTool.SplitToParts* command on the hydrant to separate out the cap piece. Make sure that the cap subtool layer is immediately over the mesh subtract pieces:

- Turn on *Tool.Geometry.DynaMesh* for the cap subtool.
- Make sure the *Difference Icon* on the first Sphereinder layer is active.
- Merge the cap and the first Sphereinder subtool using the *Tool.SubTool. MergeDown* command.
- Now click on *Tool.Geometry.DynaMesh.Sub* to Boolean the objects together.

Go around one by one repeating this operation for each of the Sphereinder pieces.

Adding bolts

The hydrant has some rather bulky bolts holding the top and bottom flanges together, so we need to create these as our last step in building our hydrant. Draw a *Cylinder3D* on screen, activate *Edit* mode, and initialize it to *HDivide = 6*, *XSize* and *Ysize = 30*. Now append it to the hydrant, then move and scale it into place.

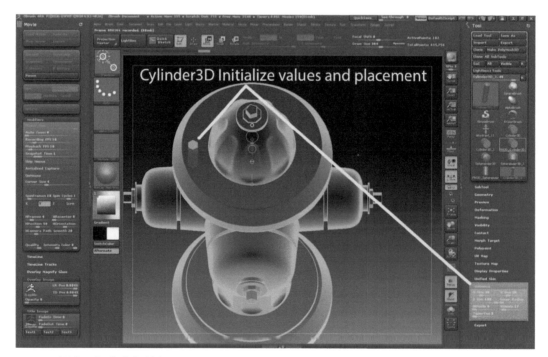

FIG 13.48 *Initialize values for the final bolts*

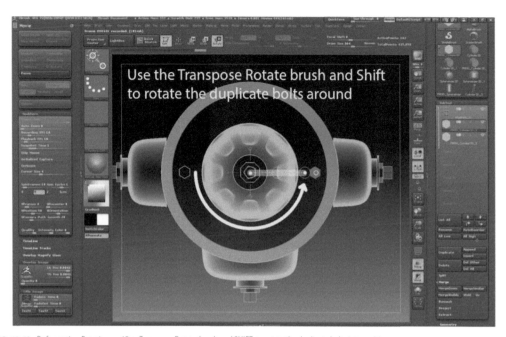

FIG 13.49 Deformation.Rotation = 45 *or* Transpose Rotate *brush and* SHIFT *to rotate the duplicate bolts into position*

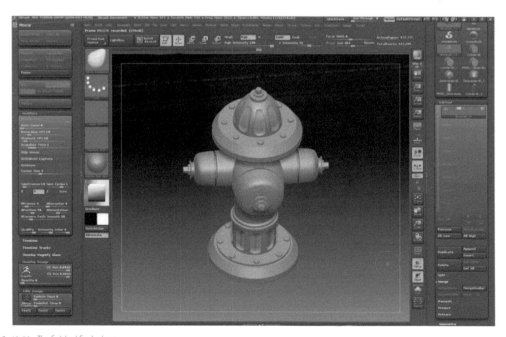

FIG 13.50 *The finished fire hydrant*

Duplicate this bolt, *Deformation.Rotation = 45*, or *Transpose Rotate* brush and *Shift*, and repeat until you get eight bolts spaced evenly around the cap piece. Merge the bolts together once you've created them all.

Duplicate the entire set of bolts and move the new set down to fit in the bottom flange.

Use the *Move Transpose* brush with radial symmetry set to 8 to fine-tune the bolts' placement.

The Base-Stand

It is quite common when displaying 3D models to place them on a virtual display stand. Take a look at some of the professional models at the Zbrush Central "Top Row Gallery" (www.zbrushcentral.com/zbc-top-row-gallery.php) to see a few examples of how this works. Basically, the idea mimics that of a real small figurine or sculpture and can be made out of wood, plastic, or metal. Since I think this has the potential to look quite nice (and it gives us a chance to play with a few more functions in ZBrush), let's do it!

Making the base

To start off, we will just make a very simple base and give it the appearance of polished wood. Go to the Tool menu and click on the largest tool icon. From the pop-up menu of all of the basic tools and 2.5D brushes, choose the *Cylinder3D* object. Now draw it on screen while holding down *SHIFT* so that the object aligns with one of the major axes. Immediately press the *Edit* button or the *T* key to treat the object as a 3D model. Look on the right hand side of the screen under the *Tool* menu and find the *Initialize* palette. Open it up and set the following values: *VDivide* = 3, *Hdivide* = 128, *ZSize* = 10, and *TaperTop* = 10.

Once you are finished with that, click on the *Tool.MakePolymesh3D* button to convert our primitive object into sculptable geometry. Turn on the *Floor* button to see our virtual ground plane in ZBrush. You will need to rotate the cylinder so that it sits flat on the ground and not on its side. Use the *Tool. Deformation.Rotate* slider with the *X* option turned on and set its value to *90* to rotate the cylinder 90 degrees.

We need to subdivide the model so we can paint the wood grain on it; but if we go to *Tool.Geometry.Divide* now and start subdividing it, the hard edges at the rim of our cylinder will soften too much. In order to avoid that we are going to leverage a feature in ZBrush known as *PolyGroups*. This feature allows us to place selected sets of polygons into specific groups, which we can then

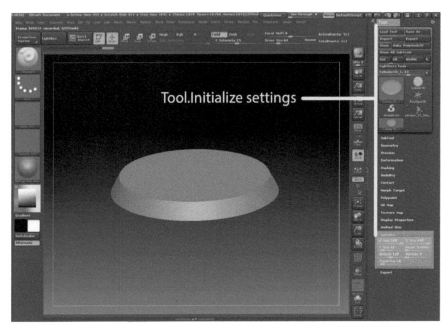

FIG 14.1 Tool.Initialize *values for our* Cylinder3D *object*

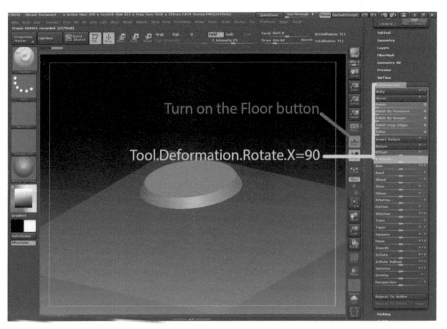

FIG 14.2 *Turn on the* Floor *button, then* Tool.Deformation.Rotate.X = 90

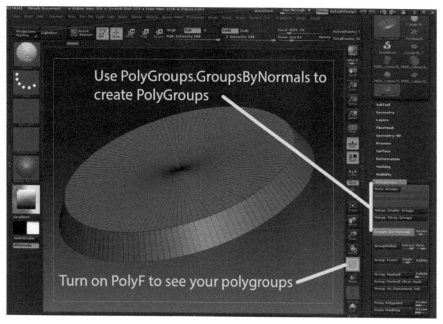

Use PolyGroups.GroupsByNormals to create PolyGroups

Turn on PolyF to see your polygroups

FIG 14.3 *Using* Tool.Polygroups.GroupsByNormals *with* PolyF *turned on*

isolate for particular purposes. Use the *Tool.Polygroups.GroupsByNormals* to group the top, bottom, and side of the cylinder into different groups. Turn on the *PolyF* button to see the polygroups on your 3D mesh.

Now we apply a crease command using *Tool.Geometry.Crease.CreasePG* so that the edges of our groups remain sharp during subdivision. You will see a fine dotted line appear on any edge that has been creased.

Go to *Tool.Geometry.Divide* and click on the *Divide* button three times until the SDiv slider reads 4.

Now use the *Tool.Geometry.Crease.UnCreasePG* button to get rid of the crease on the object.

Use *Tool.Geometry.Divide* twice more to create a nice subtle lip on our base-stand. Our cylinder may have developed a hole in the middle and we will have to even out our geometry anyway to paint on it, so make sure the *SDiv* number is 6 and use the *Tool.Geometry.DelLower* button to get rid of our lower subdivision levels.

Now go to our *Geometry.DynaMesh* palette and set the *Resolution* slider to *256*, then click on the *DynaMesh* button to resurface our object and fix the hole.

239

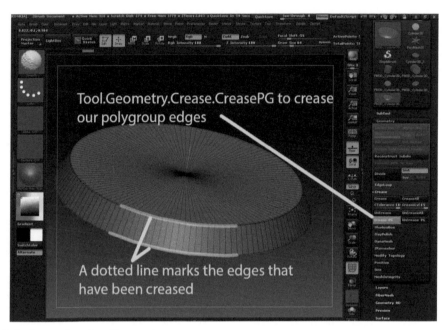

FIG 14.4 *The* Tool.Geometry.Crease.CreasePG *command*

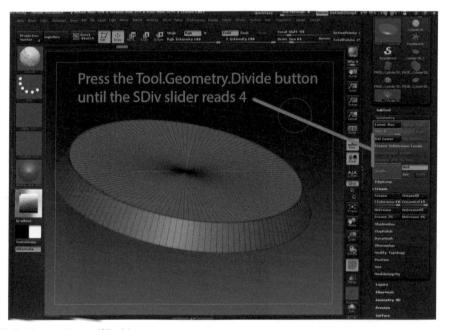

FIG 14.5 *The* Tool.Geometry.Divide *and* SDiv *slider*

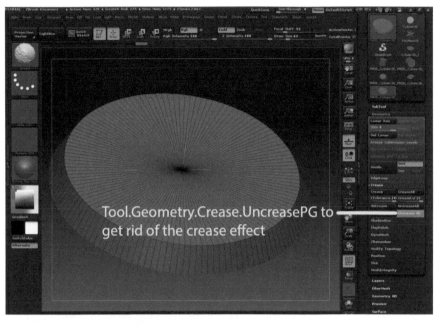

FIG 14.6 Tool.Geometry.Crease.UnCreasePG *to get rid of the crease function*

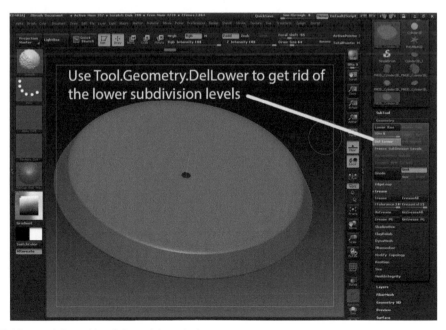

FIG 14.7 Tool.Geometry.DelLower *deletes the lower subdivision levels*

Creating the ground plane

I want dirt to be the surface on which the dragon will sit since using wood would look odd. We will just use a scaled-down copy of the base for this. Use *Subtool.Duplicate* to create a copy of our base-stand.

Turn on the *Transp* button so we can see our subtool as we scale it down. Activating the *Transp* button makes out inactive subtools transparent, letting us see the active one more clearly. Select the new subtool layer for the copy and use *Deformation.Size* to size it down a bit.

Use the transpose move brush to place it so just the top of the subtool sticks out. Now rename this subtool layer using *Tool.SubTool.Rename* "Ground", then name the our original subtool "Base_stand". You can turn off the *Transp* button now.

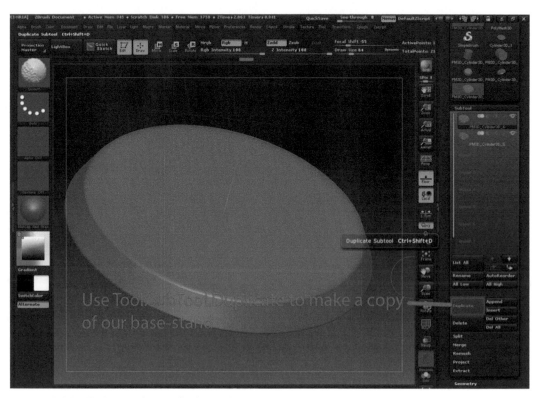

FIG 14.8 *Use Subtool.Duplicate to make a copy of our base-stand*

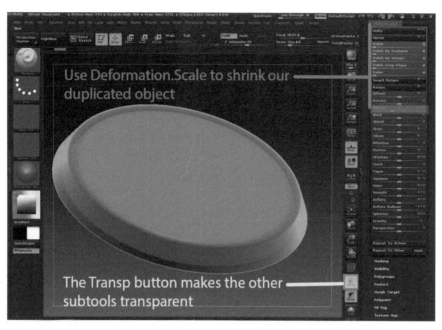

FIG 14.9 *Turn on* Transp *and use* Deformation.Scale *to shrink our duplicate object*

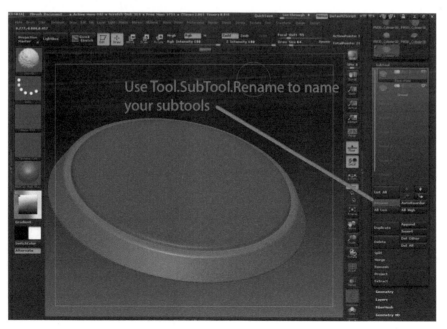

FIG 14.10 *Use the* Tool.SubTool.Rename *tool to name your* subtools

Adding a wood texture

To achieve the look we want we will use ZBrush's *NoiseMaker* function to add a wood grain to our base-stand model. First click *Tool.Geometry.Divide* once to add one more level of resolution to your object. Now select the "Base_stand" subtool, then click on the *Tool.Surface.Noise* button.

In the *NoiseMaker* interface that pops up, set the *Strength* to around *0.05* (higher than that and it starts showing errors), then find and click the *Noise-Plug* button at the top of the right-hand side of the window.

Another *NoiseMaker* interface pops into existence at this point (this one with a different colored frame, though). On the left-hand side choose the *Wood* checkbox. Now set the *Ring Scale* to around 60 and adjust the *Octaves*, *Frequency*, and *Amplitude* settings until you are happy with the results, then press *OK*.

Back in the first *NoiseMaker* interface that popped up, press *OK* at the bottom of the interface.

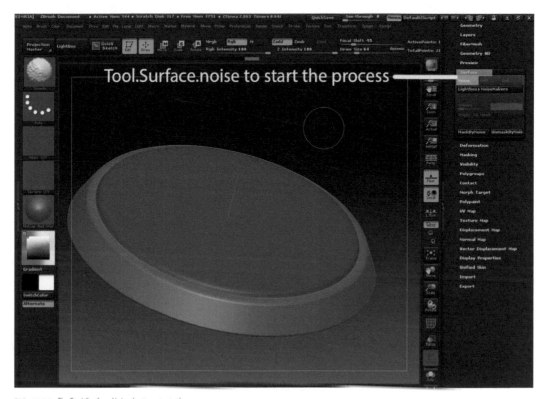

FIG 14.11 *The Tool.Surface.Noise button starts the process*

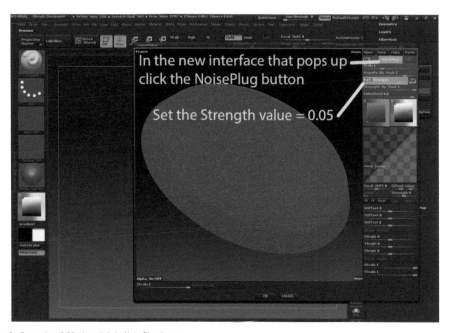

FIG 14.12 *Set* Strength = 0.05, *then click the* NoisePlug *button*

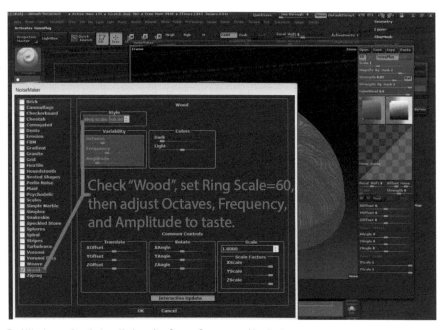

FIG 14.13 *Check* Wood *on, set* Ring Scale = 60, *then adjust* Octaves, Frequency, *and* Amplitude *to taste*

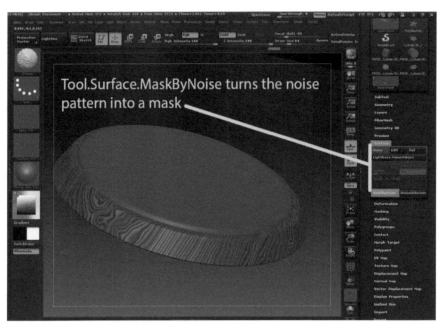

FIG 14.14 Tool.Surface.MaskByNoise *turns the noise pattern into a mask*

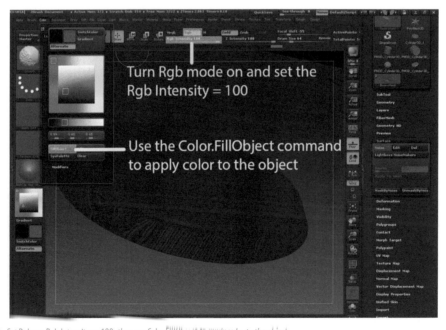

FIG 14.15 *Set Rgb on,* Rgb Intensity = 100, *then use* Color.FillObject *to apply color to the object*

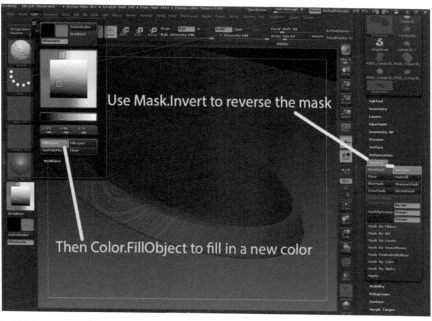

FIG 14.16 *Use Mask.Invert to reverse the mask, then Color.FillObject to fill in a new color*

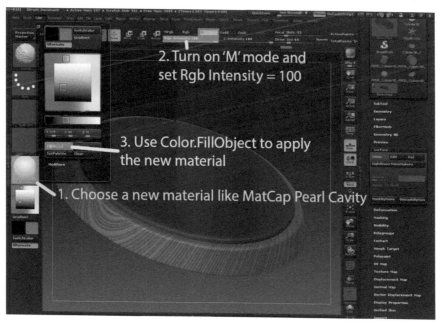

FIG 14.17 *Fill the base-stand with a new material*

In the main ZBrush interface under the *Surface* palette press the *MaskBy-Noise* button, which will generate an alpha mask of this pattern on your object.

Now you can select a warm brown color; turn on *Rgb* mode, set your *Rgb Intensity* to *100*, and use the *Color.FillObject* command to colorize your object.

Use the *Mask.Invert* command to flip the mask, choose another color, and use *Color.FillObject* again to finish making the wood pattern.

Now choose a pleasing material like *Matcap Pearl Cavity*, turn on *M* mode for applying materials, and use *Color.FillObject* to apply the material to the object. Make sure you turn off the *Tool.Surface.Noise* button at the end of the process otherwise the function can obscure your results.

Texturing the ground

Go back into the subtool menu and select the "Ground" layer. Repeat the entire process, but this time select the *Speckled Stone* noise option and set your *Detail* level to *0.1* in the *NoiseMaker* window. Repeat the rest of the process using different brown and tan colors to get a sandy surface look. Try applying the *MatCap_Skeleton* material to the ground for a sandy look.

15

Grass

Our base-stand looks pretty good, but it needs some grass growing on it. It would be way too boring just to have our dragon sitting in the dirt. Some grass will make it look like someone's yard and help ground our future illustration in a sense of reality. Fortunately, ZBrush has a very good tool for adding grass to our scene, the FiberMesh tool set.

Use *Tool.LoadTool* to load our base-stand model into ZBrush. Draw it on screen and go into *Edit* mode by pressing the *T* hot key. In the *Tool.SubTool* menu, select the ground subtool of the base-stand tool. Now hold down the *CTRL* key to activate the *MaskPen* brush and paint a mask on the ground model. This mask will control where and how many fibers are placed.

To generate the grass, go to the *Tool* menu and find the *FiberMesh* palette and open it. Simply turn the *Tool.FiberMesh.Preview* button *on* and ZBrush will automatically generate a patch of grass on the masked areas of the Ground subtool.

Use the settings in the *Tool.FiberMesh.Modifiers* palette to control how the grass looks:

- MaxFibers = 8 (MaxFibers counted in thousands);
- length = ~70;
- twist = 9;
- coverage = ~10 (controls width of the fibers);
- gravity = 0;
- width profile: set to a curve that is at the top on the left-hand side and curve off to the right;
- base: dark blue-green color;
- tip: green;
- BCVariations: 1;
- TCVariations: 1;
- segments = 5.

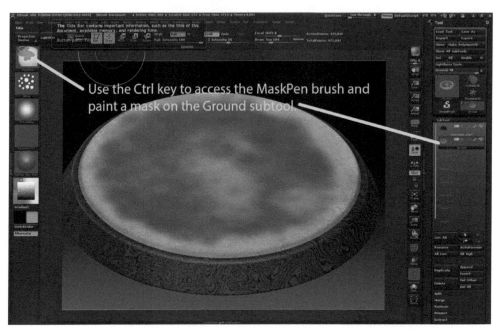

FIG 15.1 *Use the* CTRL *key to access the MaskPen brush and paint a mask on the "Ground" subtool*

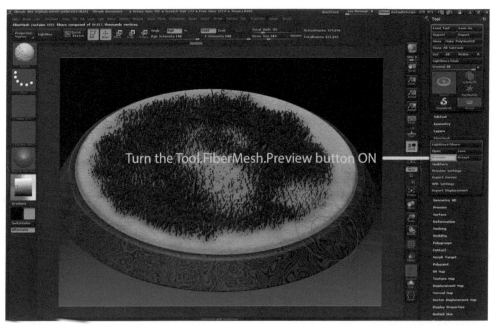

FIG 15.2 *Turn* Tool.FiberMesh.Preview *button* on

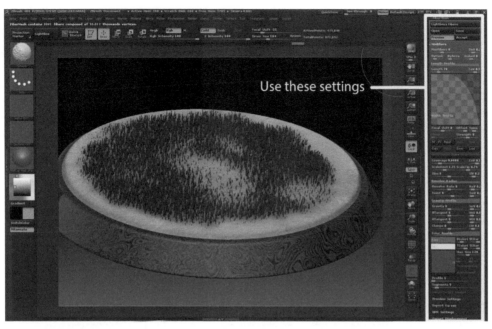

FIG 15.3 *Use these settings*

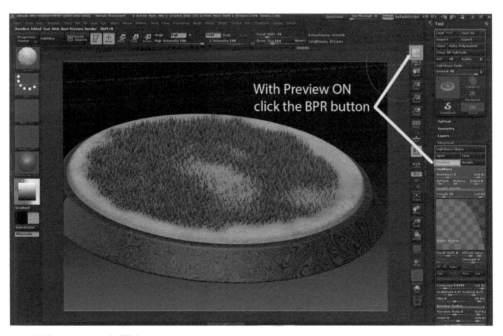

FIG 15.4 *With* Preview *on, press the* BPR *button*

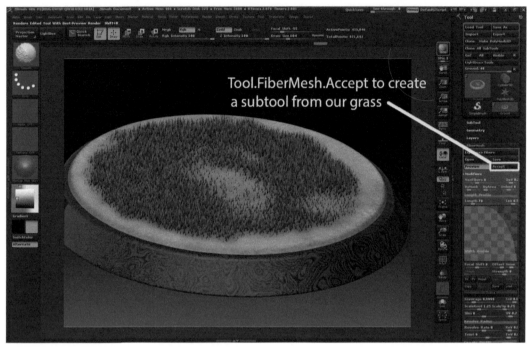

FIG 15.5 *Use* Tool.FiberMesh.Accept *to create a new subtool from the grass preview*

After a while, *Preview* automatically turns off and you will need to turn it on again. With *Preview* on, click on the *BPR* (*Best Preview Render)* button. This is a necessity. If you do not, then the fibers generated afterward will not have the proper width profile and will revert to simple strands.

After the FiberMesh renders on the canvas, click *Tool.FiberMesh.Accept* button to convert the preview into a new subtool. If a query window pops up, just say *NO*.

I then inverted the mask on the ground model and added in some dark gray coloration under the grass using the *Color.Fill* command in *Rgb* mode with an *Rgb Intensity* set to around 10.

Combining It All

Loading and merging

We've come far enough along now that we need to collect all of our models into one file so that we can begin creating our final illustration. Use *Tool. LoadTool* and load all of the various models we've built so far. This includes the dragon with his collar, the fire hydrant, and the base-stand.

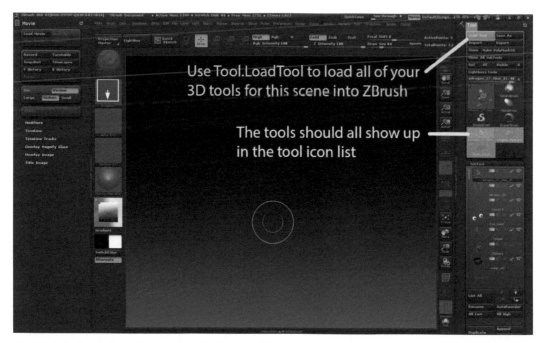

FIG 16.1 *Use Tool.LoadTool to load all of your 3D tools for this scene into ZBrush*

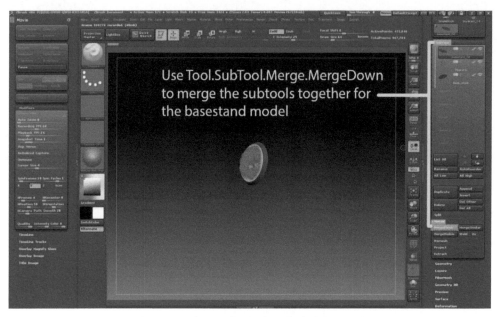

FIG 16.2 *Use the* Tool.SubTool.Merge.MergeDown *command to merge the subtools together for the base-stand*

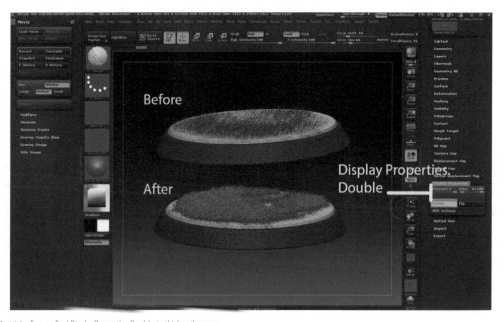

FIG 16.3 *Turn on* Tool.DisplayProperties.Double *to thicken the grass*

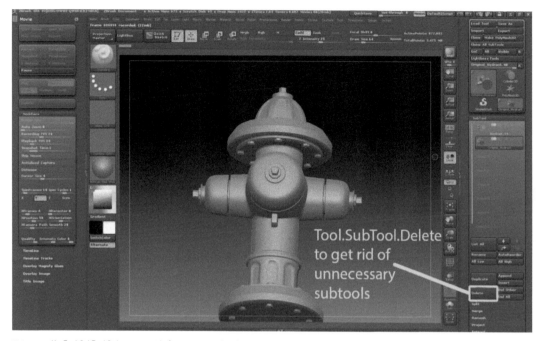

FIG 16.4 *Use* Tool.SubTool.Delete *to get rid of unnecessary subtools*

Select the base-stand tool and draw it on screen. Merge all of the subtools of the base-stand tool file into one tool using the *Tool.SubTool.Merge.MergeDown* command. Turn on the *Tool.DisplayProperties.Double* button. This changes how the grass renders so that it shows both sides of the blades of grass. It will have the effect of thickening the appearance of our grass.

Switch to the fire hydrant tool by clicking on it in the Tool menu icon list and merge the subtools so that the entire hydrant is one object. Use *Tool.SubTool. Delete* to get rid of any redundant subtools that you no longer need.

Decimating subtools

Load up the dragon. The subtools for the dragon have a lot of polygons in them – too many, in fact, to safely merge together without crashing ZBrush. We can use the Decimation Master plug-in to reduce the size of subtools though, and merge them together afterwards. First we should save a backup of our ZBrush tool (.ZTL) using *Tool.Save As* just in case ZBrush crashes during this operation. Now open *Zplugin.Decimation Master* and click on the *Pre-process Current* button. This performs the calculations for optimizing our polygon model. Next, still in the Decimation Master palette, set the *% of decimation* slider equal to around *15%*. You can always go back and redo

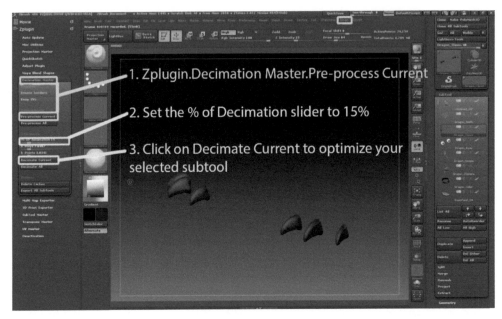

1. Zplugin.Decimation Master.Pre-process Current

2. Set the % of Decimation slider to 15%

3. Click on Decimate Current to optimize your selected subtool

with a slightly different value if you don't like the results, and 15% is usually a significant savings in polygon size while not being terribly different in appearance. Once you have checked all of your settings, click on the button to perform the operation. It may take a fair bit of time to perform, so remember to be patient.

Repeat the decimation process for the eyes, collar, teeth, and claws. While *Decimation Master* shouldn't destroy our color paint job, sometimes ZBrush can glitch or yield unpredictable results and it is just better to play it safe. With that in mind I'm going to create UVs for my tongue and create a color texture map just in case. If something happens, I can use the color texture map to restore the color paint to the tongue; but I will have to modify my *Decimation Master* settings a little bit to allow it.

First we need to create a set of UVs for the tongue. Select that subtool and go to *Tool.UV Map*. Set the *UV Map Size = 4096*, the *UV Map Border = 2*, and click on *Tool.UV Map.Create.PUV Tiles* to make the UVs for the tongue.

To create the color texture map now that we've generated our UVs, go to *Tool. Texture Map.Create* and click on *New From Polypaint*. The texture map will appear as an icon in the *Tool.Texture Map* palette. In the same *Texture Map* palette, push the *Clone Txtr* button.

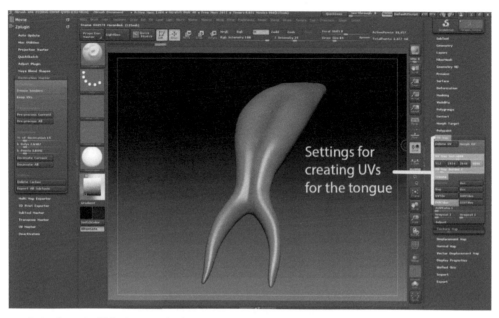

FIG 16.6 *Settings for creating UVs for the tongue subtool*

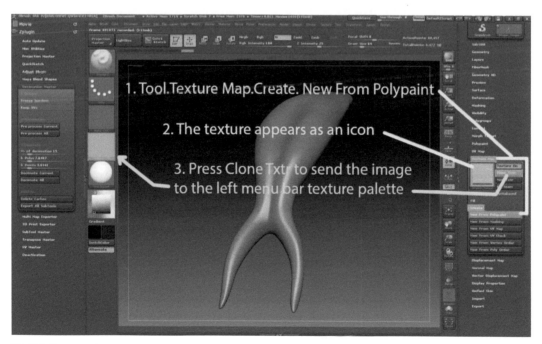

FIG 16.7 *Texture mapping process*

This sends the texture over to the left menu bar texture palette. Go to the left hand side of ZBrush and find the *Texture* icon and click it. At the bottom of the pop-up icon menu find the *Export* button and push it to save out the texture file as a PSD, TIF, or BMP image file (try to use these file formats since they won't compress your image).

Once you have finished creating the texture map you can decimate the tongue model. The process is the same as for the other subtools except this time you need to have the *Keep UVs* button selected at the very beginning before you use the *Pre-process Current* button to run the calculations.

If the decimation process destroys your paint job on the tongue, it is OK. Make sure that your texture map for the tongue is selected in the texture selector on the left-hand menu bar. Now select the *Tool.Polypaint.Polypaint From Texture* command. This will apply the selected texture to the model and restore your paint job.

Once you've finished this, merge the dragon subtools together. Next go to *Tool.SubTool* and append the dragon and the fire hydrant to the base-stand tool using the *Tool.SubTool.Append* command.

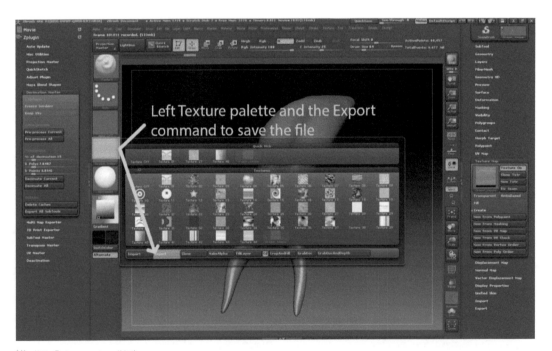

FIG 16.8 *Texture export command*

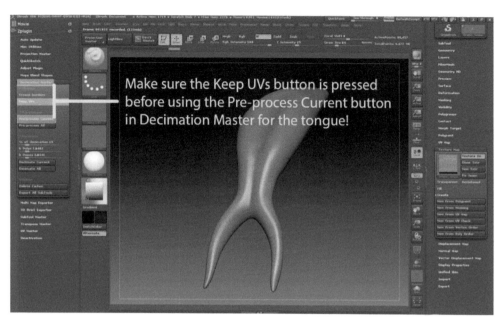

FIG 16.9 *Make sure you have* Keep UVs *pressed before using the* Pre-process Current *button*

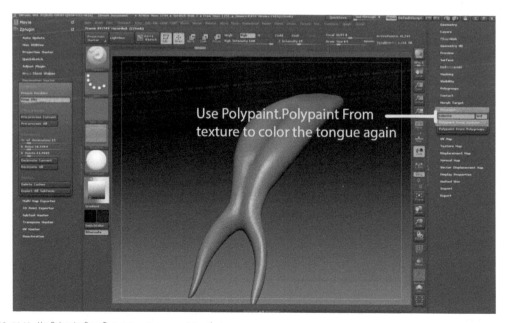

FIG 16.10 *Use* Polypaint From Texture *to restore your paint on the tongue*

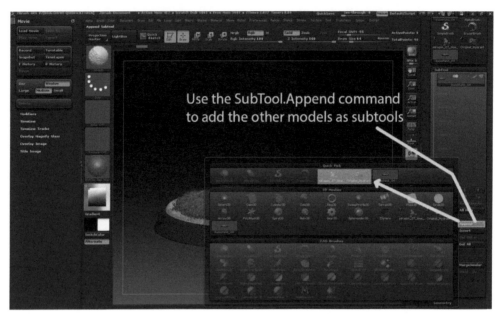

FIG 16.11 *Using the* Tool.SubTool.Append *command*

FIG 16.12 *The* Tool.SubTool.Rename *command*

Rename all the subtools in the file so they are descriptive using the *Tool.Sub Tool.Rename* command. Rename the base-stand to "base-stand", the dragon model as "dragon", and so forth.

Use the transpose move, scale, and rotate brushes to adjust our subtools to fit together properly and position them where you want them in relation to each other. Everything should fit together and it will take a bit of work to get everything in place. Just select the subtools one at a time and transform them into place. Take your time and be patient. Afterwards we can move on to the next chapter.

Posing the Dragon

Principles of posing

Our dragon looks pretty good, but he is way too stiff and doesn't yet look alive. To create the illusion of life we need to pose him asymmetrically. Living creatures are never in a perfectly symmetrical pose, partly because living things are never perfectly symmetrical themselves and partly because our movements are never that coordinated. An artist can spend weeks creating the perfect pose for his or her character! Take your time and do this part right. A good pose can make the difference between a stellar finished piece and a lackluster one. A creature is usually putting most of their weight on one foot or the other. This moves the feet, twists the hips, bends the spine, raises one shoulder, and changes the placement of the arms. This type of pose is called a "*contrapposto*" or counterpose. We will implement this type of pose for our dragon to give him the illusion of real weight.

There are several different approaches you can take in ZBrush for posing characters. The easiest way to move the dragon's limbs around is to use the transpose rotate brush combined with the mask tool. This way we can isolate the part we want to adjust and have the rotate tool affect only it. We could use the Transpose Master plug-in to create a virtual proxy of our character and then a ZSphere armature to pose it. Another approach would be to use the original ZSphere armature we created to make the dragon as a ZSphere rig on a unified dragon model. Since both of these latter approaches are more memory intensive and error prone than just simply using the masking tools and transpose action line, we will forgo them and just keep things simple. When you are working in a production environment and you have to get things done within a certain timeframe, you won't always have the luxury of exploring the software. You just have to get the job done and done quickly.

Posing techniques

Load the combined ZTool file into ZBrush using the *Tool.LoadTool* command. You can delete the original ZSphere model since we won't be using it again. If your machine starts slowing down, try changing the interactive render setting to *Render.Fast* to free up some RAM.

First turn off *Transform.Symmetry.X*, then press the *CTRL* key to access the *MaskLasso* tool and use it to mask off one of the arms. Now invert the mask by *CTRL* clicking on the empty canvas or using the *Tool* menu *Masking. Inverse* command. It is almost always easier to mask off the smallest piece possible and invert it than to try and mask off the majority of an object directly.

Blur the mask by *CTRL + clicking* on it a few times or just use the *Tool.Masking. BlurMask* command. Now select the transpose rotate brush. Starting at the shoulder joint, draw out a transpose line down the length of the arm.

Now click and drag the inside of the bottom circle of the transpose action line and rotate the limb into position.

FIG 17.1 *Turn Render.Fast on to speed up rendering times*

FIG 17.2 *Using CTRL + MaskLasso to mask off part of the dragon model*

FIG 17.3 *Transpose rotate*

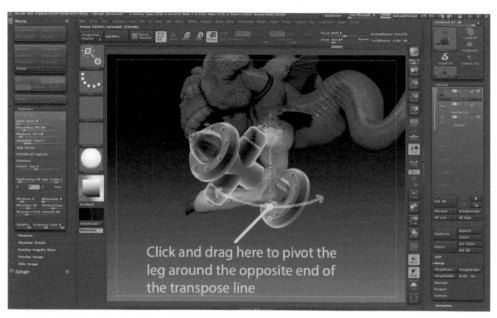

FIG 17.4 *Click here to rotate the leg around the opposite end of the transpose action line*

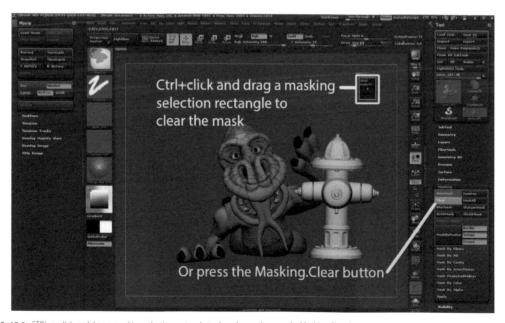

FIG 17.5 CTRL + click *and drag a masking selection rectangle to clear the mask or use the* Masking.Clear *button*

FIG 17.6 *Repeat the process*

Once you are done, clear the mask by clicking on the *Tool.Masking.Clear* button or you can *CTRL + click* and drag a small gray masking selection box on the background canvas which will also clear the mask.

Repeat this process to rotate the head, bend the torso, and adjust each of the feet. While this is a very straightforward and understandable technique, don't underestimate its efficiency. Combined with a bit of *Move* brush and smoothing, this technique can pose your character any way you want!

Another variation on this technique is to use the *Tool.Masking.MaskAll* command and then use the *CTRL + ALT + MaskLasso* tool to deselect an area of the model.

Painting the Fire Hydrant

Principles of texturing

Texturing an object is the process by which you paint your model in as realistic a manner as possible. It is a complex art form and takes lots of practice to master. Let's start with some general principles for texturing an object. Never leave objects in a pristine condition. This will make the object look fake and unbelievable. Always add levels of dirt, grime, and wear and tear to the object to make it look believable. Try to envision the object's history – how has it been used – and then communicate this to the viewer. An object will be more worn where people have been handling it. There will be sun fading on the areas repeatedly exposed to the sun, plus layers of dirt, grime, rust, sludge, slime, graffiti, chips, drips, and gouges. All of these things when added to an object will make that object more believable.

Beige makes a good color for sun-fading and should be applied thinly but broadly with a very soft-edged airbrush over any upper surface of a weathered object. Don't forget to add in details such as stains, fluid leaks, and places where the object's bare metal is revealed by the paint being abraded off. Add different layers of dirt where it has splashed up and stuck to the object. Keep in mind that different terrains have different colors and types of dirt! Add some shininess to places where the paint has been polished and worn smooth by contact or worn off entirely. Pay attention to details and constantly observe things around you.

Reference material

When acquiring reference images, always keep in mind your source. That clean 3D-view of your subject that you found on the internet may not be accurate! Go out and take or find some reference pictures of the actual object. The more images you can acquire, the more accurate your final product will be.

FIG 18.1 *Not how it used to look, but a great example of weathering!*

When taking your own reference pictures, try to go out on an overcast day to reduce the contrast of your images – this will make for better texture references later on. You don't want to have to paint out the strong lighting present in any pictures you've taken if you use them for textures. When building a model, keep in mind that silhouette is everything and communicates the object better that any other single aspect. Remember that objects found in museums are *not* in their original shape – fluids leak and the supports flatten, tires deflate, and parts may be missing, replaced, or welded solid, or you might get the exact opposite and the item may be in such pristine shape that it looks like no one has ever touched it!

Weathering

It isn't so much about creating a good model, it's about creating a good texture on the model. A good texture will make a poor model work; a bad texture or no texture will make a good model unusable. Black letters fade – gray them out by adding a little white. Add some gray to wash out the entire object a little. Apply a dark brown to the crevices of the object to represent dirt buildup. You can use an ambient occlusion baked image as a mask for applying dirt. The AO mask provides a good indicator of where the crevices of the object lay, plus you can render multiple AO maps at different strengths for different types of dirt. We can demonstrate this using a simple *Gear3D* model from the *Tool* menu. Select the *Gear3D* tool from the *Tool* menu and draw it on screen. Go

into *Edit* mode (*T* on the keyboard). Under the *Tool.Geometry* menu, first turn off the *Smt* button so our shape doesn't deform as we subdivide it, then press the *Divide* button three or four times to add some geometry resolution to our shape. Now try out some different AO masks on the object using the *Tool.Masking.MaskAmbientOcclusion* button to create the mask. Now change the *Occlusion Intensity* slider from 1 to 10 and click on the *MaskAmbientOcclusion* button to create a slightly larger AO mask on the object. You can use these various masks to paint different types of dirt and stains on your object.

Brown, red, tan, and black are all possible colors for dirt and road debris. Rainwater will make further weather patterns, and if it accumulates long enough

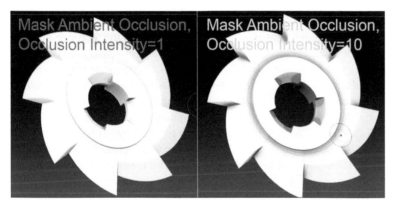

FIG 18.2 *Different* Occlusion Intensity *settings for the* Mask Ambient Occlusion *command*

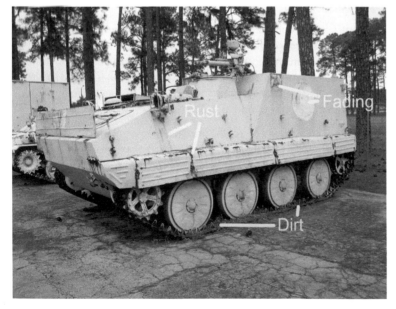

FIG 18.3 *A prime example of rust, paint fading, and dirt*

will create rust and even holes. Paint chips away and reveals previous colors, and then the bare metal underneath that. Leave the metal bare long enough and it will oxidize and change color, rust, and then streak. Use a dark rust color to create streaks where rust has dripped downwards across the surface. Don't forget to add things like fluid leaks, oil, and other stains, as well as anything else you can think of!

LightBox

The *LightBox* interface can be a useful way to access your models and other ZBrush files. You can launch the *Tool.Lightbox>Tools* or just use the *comma* key or *LightBox* button to open up the LightBox interface. Simply double click the tool or image you want to load. ZBrush will automatically load what you select into the right area: textures for images and the tools pop-up menu for, well, tools. It's a good idea to provide easy access from *LightBox* to any folders you use to store your ZBrush materials. Create a shortcut to your project folder(s) and paste into the *ZBrush Install Folder location\ZProjects* folder. Create another shortcut to your tool folder and paste that into the *ZBrush Install Folder location\ZTools*folder. On my computer the folder pathways are *C:\Program Files (x86)\Pixologic\ZBrush 4R6\ZProjects* and *C:\Program Files (x86)\Pixologic\ZBrush 4R6\ZTools*. Remember when looking at the tool icons in the folders that the top tool in the subtool list creates the icon for the *LightBox*.

SpotLight

The *SpotLight* function in ZBrush is used to copy the information from a texture image to your active 3D object. It is a very useful tool for painting an object quickly from photographic references, but it has a unique and somewhat confusing interface unlike anything else in ZBrush. It is a good idea to open the *Texture* menu and click on the circular tab icon and drag the Texture palette into the left tray to work with *SpotLight*.

To use the *SpotLight*, load one of the fire hydrant reference pictures provided in the supplemental materials for this book into the texture menu palette using the *Texture.Import* command. Next, click on the image you want to use in the *SpotLight* from the list of loaded image in the Texture palette to select it. You should see the image you selected become the largest image icon in that palette.

Press the *Add to SpotLight* button to load the image into *SpotLight* and turn it on. If the *LightBox* pops up, just press the comma key to get rid of it.

The *SpotLight Dial* will turn on. This gives you access to all of the different *SpotLight* commands. First, we are going to rotate our image so that it faces up.

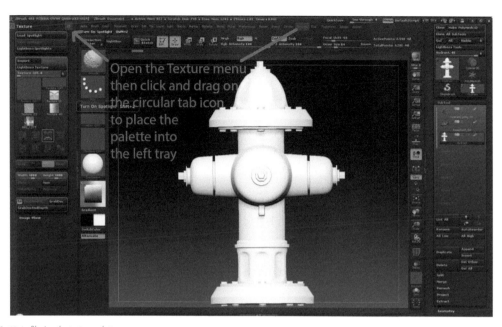

FIG 18.4 *Placing the texture palette*

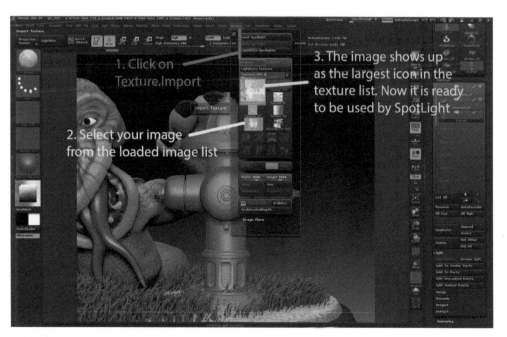

FIG 18.5 *Loading an image into* SpotLight

FIG 18.6 *Turn on* SpotLight

FIG 18.7 *Use* SpotLight Rotate *to orientate the image*

Click and drag on the *SpotLight Dial Rotate* icon to turn the *SpotLight* image around the center of the dial.

Now adjust the transparency of the *SpotLight* image by clicking and dragging the *Opacity* icon on the dial. This activates a circular slider within the *Dial* that indicates what the opacity value is. The opacity setting does not affect how paint is applied to the object; it just changes how opaque the *SpotLight* image is.

You can move the *Dial* around by clicking and dragging the red circle in the middle of the *Dial*, or place it directly by clicking somewhere outside of the *Dial* completely. Place the *SpotLight* image so the elements you want to transfer from the image to the object are directly lined up. In other words, if you want to copy the picture of a bolt from your image to the tip of the hydrant, for example, then make sure the bolt sits on top of the tip where you'd like it to go. Now press *Z* on your keyboard to turn off the *Dial* and start copying from the image to the object by clicking and dragging your brush over the object just like a regular paint brush.

Press *SHIFT + Z* to turn off the SpotLight and see your progress. You can even rotate and move your object around, then press *SHIFT + Z* to activate the *SpotLight* over another location on the object. Press the *Z* key to pull up the

FIG 18.8 *Adjust the* Opacity *of the image*

FIG 18.9 *Placing the SpotLight*

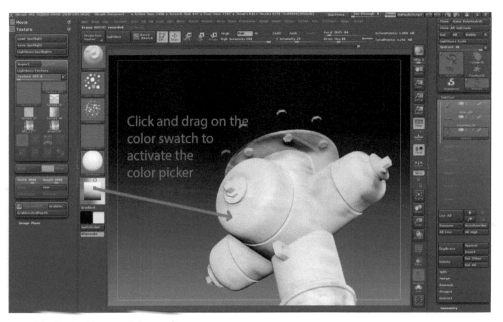

FIG 18.10 *Using the color picker to sample from our object*

SpotLight Dial again to adjust the placement of the image you are painting from. Now simply keep repeating this process of rotating your object around and placing the *SpotLight* over different locations, then painting elements from it onto your object. You can load up more textures into the texture palette, select them, then add them to the *SpotLight* to paint with other images too. I find it especially useful to use *SpotLight* along with masking, the subtool palette, and using *CTRL + SHIFT* to isolate the element of the object that I am working on so I don't accidentally paint on something I don't want to.

Once I've added my major details and established my colors using *SpotLight*, I can turn off *SpotLight* and switch to the *Standard Brush*, choose the *Color Spray* stroke, and *Alpha 07* for my brush alpha. Make sure you are in *RGB* mode and have *Zadd* turned off on your top menu bar. Now click on the color selector swatch and drag onto the ZBrush canvas to activate the color picker function and choose a color that you've painted onto your object from *SpotLight*. Continue by just brushing in any remaining spots that need the extra paint.

ZAppLink

You can also use the ZAppLink plug-in to paint your model. However, if you want to paint both sides using the *Double Sided* check-box you will have to turn on *Tool.DisplayProperties.Double* before you activate the ZappLink plug-in.

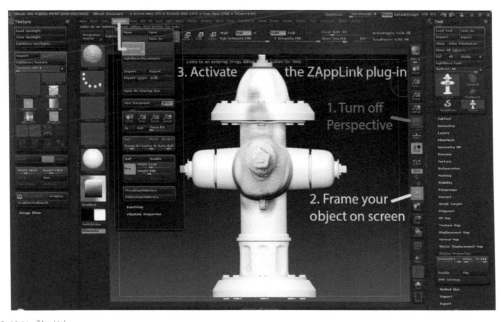

FIG 18.11 *ZAppLink*

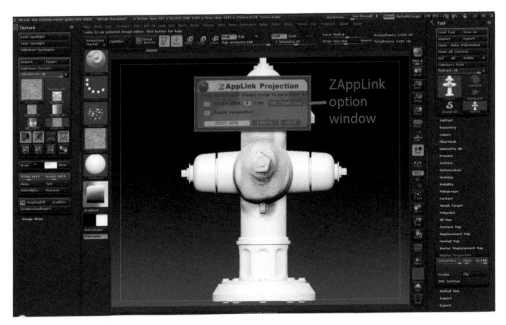

FIG 18.12 ZAppLink *option window*

Using *ZappLink* is very simple. Frame your object on the canvas using the *Frame* button or *F* key on the keyboard. Make sure that you have *Perspective* turned off. Go to the Document menu and click on the large *ZappLink* button there.

A large light gray option window will appear. You can pick *Double Sided* if you want the work you do in your image editor to appear on both sides of your object. The *Double Sided* option in ZAppLink is buggy though, and you have to enable or disable that option using the *Tool.Display Properties.Double* button, in addition to selecting *Double Sided* in the ZAppLink option window. Fade is a useful option if you are going to be working close to the edge of your object.

ZAppLink can link to most image editors, but Adobe Photoshop is a very popular choice to work with. Now let's go into Photoshop and see what *ZAppLink* has done there.

Open up the reference image of the fire hydrant in Photoshop (*CTRL + O*). Select all (*CTRL + A*) and copy the image to the clipboard (*CTRL + C*). Now go to your ZAppLink image and paste (*CTRL + V*) the fire hydrant reference image into your ZAppLink picture. Now use the transform function (*CTRL + T*) to scale it to fit over the top of our object.

Once in Photoshop, remember that you should not edit the top- and bottom-most layers at all. To send everything back into ZBrush, you will have to merge all of your color information layers together first. Select your paint layer and

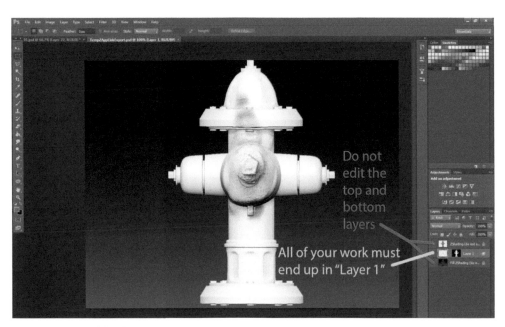

FIG 18.13 *ZAppLink inside of Photoshop*

FIG 18.14 *Merging layers in Photoshop*

FIG 18.15 *Re-enter ZBrush*

FIG 18.16 *Pickup Now*

press *CTRL + E* to merge this layer down into "Layer 1". A query window will pop up asking you if you want to *Apply*, *Preserve*, or *Cancel* the layer mask. Choose *Preserve*.

Then save the file (*CTRL + S*) and switch back to ZBrush. Choose *Re-enter ZBrush* from the pop-up window.

In the final pop-up window, select *Pickup Now*. Your work from Photoshop will almost magically transfer into ZBrush and paint your object.

Keep working with your paint brush, *SpotLight*, and *ZAppLink* functions to finish painting your fire hydrant.

Polishing the Model

All of our models are now combined into one file. Everything looks pretty good, but now is the time to step back, take a look at our overall composition, and see if there's anything we need to improve before we move on to lighting and rendering our scene.

Saving the file

First off, let's save out our scene file as "Dragon_Final_01.ZPR" using the *File. Save As* command so we can keep track of it a bit better. Saving a ZBrush project file like this has the benefit of saving all of our camera positions, associated tools, lights, documents, and so forth in one file for easy access. I will also save out a copy of my ZBrush tool, as well as a backup just in case a file gets corrupted.

I can already see one problem – the fire hydrant model doesn't yet have a material assigned to it. Select the fire hydrant model from the *Tool.Sub-Tool* list and use *Color.FillObject* to apply the *MatcapWhite* material to the hydrant.

Now we need to finish posing the dragon alongside the fire hydrant. Just use the rotate and move transpose brushes to turn and adjust the position of the hydrant and the dragon in relation to each other. Use the *CTRL + MaskLasso* brush to mask off each toe on the foot near the hydrant. Then blur the mask a bit using the *Tool.Masking.BlurMask* command. Now use the transpose rotate action line to curls the toes around the hydrant a bit so that it looks like the dragon is holding onto it. Take your time and be careful when drawing the mask so you don't accidentally leave anything unmasked that you shouldn't and thus distort your model.

FIG 19.1 *Using the transpose rotate action line to turn the fire hydrant*

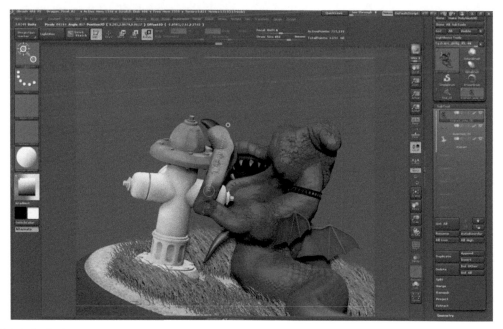

FIG 19.2 *Bending the toes*

Changing the eyes

Studying my composition a bit, I've decided that the eyes of our dragon are too small. After all, most cartoon characters have rather large eyes – it helps to create empathy with the character. Our dragon has ended up looking a bit too sleepy for my taste. In order to fix this we will have to split the eyes from the rest of the model and scale them up a bit.

Let's isolate the eyes. Makes sure that you have the dragon subtool selected in the SubTool palette. *CTRL + click* on an eye. This should hide the dragon and leave the eyes. Click on the *SubTool.Split.SplitHidden* button to separate the eyes from the rest of the model onto a new subtool.

Go to the *Tool.SubTool* palette and select the eyes. Use the *Split.SplitToParts* command in the *SubTool* palette to split the eyes into individual subtools. Go ahead and delete one of them using the *SubTool.Delete* button.

Now use the transpose scale and move brush to increase the size and adjust the position of the remaining eye. Draw out transpose line from the center of the eyeball and go into rotate mode. Use the center circle to

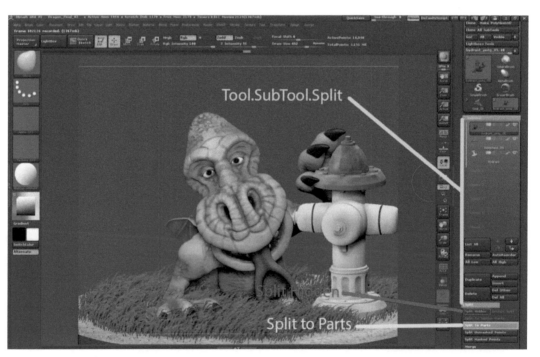

FIG 19.3 *Split commands*

rotate the eyeball around its axis. Tweak its position with the transpose move brush.

To rebuild the eyelids, choose the *ClayTubes* brush and select a round, soft alpha like *Alpha 01*, along with a *FreeHand* stroke. Now just gently stroke along the upper rim of the eyeball and build up the eyelids. Once you have the eyelids established, you can switch to the *MoveTopological* brush and pull the eyelid down over the upper part of the eyeball. Switch back and forth between the *ClayTubes* and *MoveTopological* brushes to continue to shape the eyelids and occasionally swap to the *Smooth* brush to smooth away any irregularities you happen to create. Make a point not to be in *Transform.Symmetry* mode – the model isn't symmetrical anymore and you would get weird results if you try to use symmetry now.

Once you've finished with one eye, duplicate that subtool using the *Tool.SubTool.Duplicate* command. Move the new eye to the other side of the head and repeat the process of recreating the eyelids. One nice side effect of this will be to create a degree of asymmetry in our model. This is actually quite an important element to achieve; since no living creature is perfectly symmetrical, introducing little asymmetries will help the creature appear more believable.

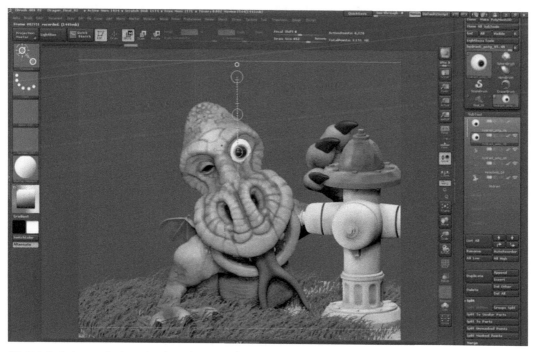

FIG 19.4 *Use the transpose brush to scale and move the eye around*

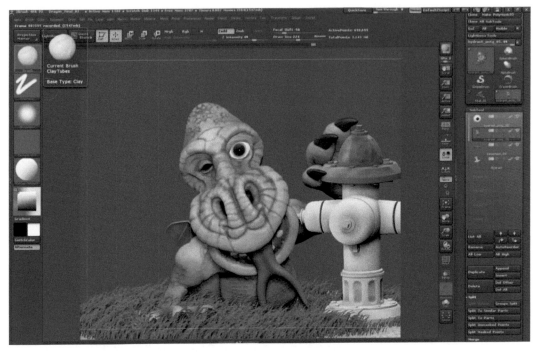

FIG 19.5 *Use the* ClayTubes *and* MoveTopological *brushes to create a new eyelid*

Posing the tongue

We also need to adjust the tongue a bit since it is currently sticking into the ground. *CTRL* + click on the tongue to isolate it and use the same *SubTool. SplitHidden* command we used to split off the eyes on the tongue. Now mask off and transpose rotate the tip of the tongue to bend it into a nice forward curl. You can use the *MoveTopological* brush to tweak the shape of the tongue and touch up anything else still needing a little tweaking.

Once you are done you need to set your view up. Unfortunately, ZBrush doesn't come equipped with a full set of camera controls for things such as shutter speed like most 3D packages do. ZBrush has a much more limited set of controls and these are broken up into several different areas. The basic camera controls are found in the *Draw* menu. Here you can use the *Angle Of View* slider to control the amount of perspective on screen. The *Persp* button must be active to see the effect. Find a good, aesthetically pleasing place that shows off your models to their best advantage. Adjust the *Draw.Angle_Of_View* slider to play with the cameras field of view and perhaps get an interesting camera angle.

FIG 19.6 *Curling the tongue using masking and the transpose rotate*

FIG 19.7 *Using the Angle_Of_View slider to control camera perspective*

Creating an interesting composition for your render can be a very challenging proposition and there have been many books written on the subject of image composition. While I won't go into all of the aspects of design this entails, there are a few things to always bear in mind.

First off, we have the "Rule of Thirds". Basically, this means dividing the composition into evenly spaced thirds both horizontally and vertically. The invisible division lines are then used to place items of interest. This helps to ensure that items are not placed in the dead center of the image and creates a dynamic, yet balanced, composition. You can see that a lot of the elements of our dragon picture line up quite nicely on the "thirds".

Another key compositional element is that of contrast. In our dragon picture you can notice this in the play of light on dark, and especially in contrasting areas of color such as the red tongue set against the blue of the dragon, or the yellow of the fire hydrant against the blue of the dragon and the green of the grass.

When someone looks at a painting, their eyes travel around the image, absorbing each part in turn but lingering especially on areas known as focal points. Any area that attracts the eye serves as a focal point and there are several in

FIG 19.8 *The "Rule of Thirds" drawn in cyan on our finished dragon image*

our image. The dragon's eyes, the hydrant, and the tongue are the main ones. The most important of these are the eyes, especially the dragon's left eye, which I placed almost at the center of the image for enhanced effect. The contrast of the eye with the rest of the dragon only enhances the effect. The last note on design I will discuss here is that it is OK to break the rules. This creates tension in the viewer and if overdone can ruin a composition; but when done "just right" it can make for the most brilliant compositions of all.

Keeping all of this in mind, play with your camera placement and try to get an energetic and pleasing composition for your own dragon. Once you are done, save the ZBrush project using *File.Save As* so that you can capture the camera position and your composition.

Lighting

Lighting is incredibly important to setting a mood and creating drama in your work. The right lighting can make or break an image. Chiaroscuro, Film Noir, or just sunlight can define the emotional tone of your work. So, how do we do it in ZBrush?

Adding lights

Open the *Light* menu at the top of the window and drag the palette to the left tray. Now activate the first light by pressing on the first light-bulb icon (called a light switch in ZBrush) and turning it orange. Grab the dot on the sample sphere and move it ever so slightly to the left to change the position of the light. Set the following values in the sliders immediately underneath the light-bulb icons:

- Intensity = 0.85, Ambient = 0;
- Light.Properties.Shadow: on.

To check the look that this has created, first turn *SPix = 0* on the upper right-hand corner of the canvas. This drops the quality of our renders but speeds things up significantly. Since we're just doing previews and tests at the moment, there's no need for a high-quality render; but we do want our results fast. We will turn it back up when it is time to render out our final images. The key light is often the only one in the scene that will have shadows cast from it. This is to avoid any complicated patterns showing up unexpectedly on our model and gives us a large degree of control over where the shadows fall in our picture. Shadows can, in and of themselves, be an important compositional element in the picture and a person can make an entire career out of being a professional 3D lighter.

Activate the second light by pressing on the next light switch and turning it orange. The light whose settings you are currently able to adjust is the one which is outlined by the thin gray border and has nothing to do with whether

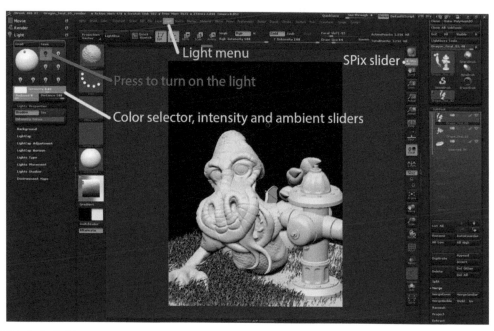

FIG 20.1 *Turning the lights on*

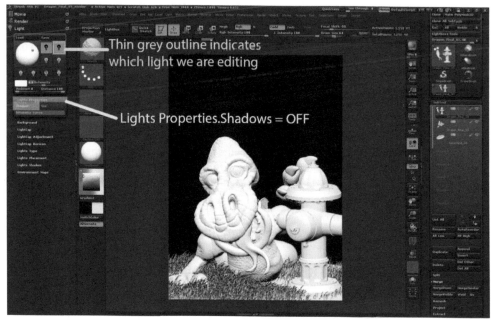

FIG 20.2 *The second light and its properties*

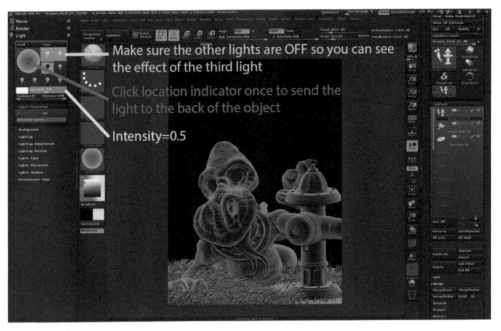

FIG 20.3 *The third light*

or not the light is on (orange) or not. It can be a little difficult to keep track of, so always pay close attention to which light you are currently tweaking.

Set the second light to *Intensity = 0.3* and make sure *Light.LightsProperties. Shadows* is off. This is our Fill light which we are including to brighten up our shadows a bit, so we don't want it creating more shadows.

Turn on the third light and push it to the back of the object by clicking once on it. You should see a dramatic change in the lighting on your object. Set the *Intensity = 0.5* on our third light. This light is our back light whose job is to provide a rim of light around the edge of the character and objects in our scene so that they separate from the background. Without it there's a tendency for the shadows on our object to merge with the shadows of the background and the edges of our subject to become lost and ill defined. It is very useful to turn the various other lights off and to isolate the effect of the light you are currently working on so that you can see the changes take place. The third light shouldn't have shadows either, so make sure they are turned off.

High-key and low-key lighting

Because this is a cute cartoon character, we've set up what is called a "High-key lighting" configuration. This is a very bright lighting scenario where there are very few strong shadows and the lighting ratio, which is the

amount of difference between the key or main light source, is quite small compared to the fill light that brightens the shadows. High-key lighting is great for creating a cheerful and upbeat look and mood. You can find examples of it in most movies made for children. If we wanted something more dramatic, we could go with a "Low-key" setup where the fill light is minimal or even absent. A low-key lighting setup is great for high contrast and dramatic shots. Great examples of low-key and dramatic lighting can be found in the Film Noir genre of movies.

Three-point lighting

We're using what is known as a three-point lighting for our setup. This consists of a main light, a fill light, and a back light. The main light is normally set up in front of the character and slightly to one side. The fill light is set in the front on the opposite side of the main light and the back light is placed in the back, of course. It is a very simple yet effective way of lighting a character or scene and has been used for decades in photography and film. You should begin to

Back Light - helps separate the subject from the background

FIG 20.4 *Diagram of a typical three-point lighting setup*

Camera

Key Light - the primary light

Fill Light - this light fills in the shadows created by the key light

study and analyze the lighting used in movies and photography. For example, it is quite instructive to simply observe the lighting used on the cover of glamor magazines when standing in the checkout line of the grocery store. You will probably be surprised at how standardized the lighting setups are for the majority of magazine covers.

A useful trick is to add a hint of color to our lights. A very light touch of a warm color like orange to the main light and a cool color such as blue to the fill light can create a very nice effect. Warm lighting will add a cool color to the shadow. Whatever the complementary color to the light, it will appear in the shadow. So an orange light will have blue shadows. Try playing with the colors in your lighting setup, although keep the colors subtle. It is all too easy to overdo it and create an unpleasant look. To change the color of the light, click on the color swatch found immediately underneath the light-bulbs in the *Light* menu. This will bring up the color selector and allow you to choose a color.

Take some time and play with the values and settings for your lights so you can achieve exactly the look you are going for. I thought the lighting was looking a little too bright, so I dropped the first light's *Intensity* to *0.5* to dim

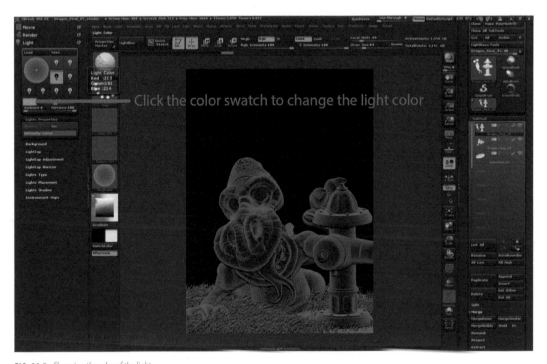

FIG 20.5 *Changing the color of the light*

FIG 20.6 *Saving our lights*

things down a bit. Lights are notoriously finicky in ZBrush and it can be hard to achieve the same exact effect twice, so once you've gotten things to look the way you want make sure you save them for later use. Use the *Light.Save* button to save out a ZBrush Lighting file (or ZLI). Now that we're happy with our lights and have saved them, it's time to set up our final render.

Rendering

Rendering our image is the final step that we can take in ZBrush. It simply means creating as high-quality a picture of our model as possible. This can be a lot more involved than simply pressing the *BPR* (Best Preview Render) button in the upper right-hand corner or using the *SHIFT + R* shortcut. Let's explore our rendering options in ZBrush!

Setup

Let's use *Document.NewDocument* to create a new document. Since I want to be able to print this image, we are going to have to make our new document quite large. There's a huge difference in resolution between a computer monitor and the printed page. Monitors and televisions operate at 72 DPI, or dots per inch. A standard HD display has an image ratio of 16 × 9 – that is to say, it is 16 units wide for every 9 units tall, and has a typical pixel resolution of 1920 × 1080 pixels. Printed material has a DPI of 300. So, to create an 11 inch × 8 inch picture, you would need an image size of 3300 × 2400 pixels. Turn off *Document.Pro*, which constrains the size proportions, and use the *Document. Width* and *Height* sliders to input the size of our document in pixels, then click on *Document.Resize* to update the picture. A fast and easy way to increase the size of our doc is to use the *Document.Double* command, which simply multiplies the current image size by two.

Now load up your model and place it in the scene. From now on we're going to be using *File.Save As* to save out ZBrush Project, or ZPR files. This will save all of our lighting, canvas, model, and other settings so that we don't have to go back in and fix the camera every time we need to render.

We also need to load in our lighting setup that we saved earlier. Click on the *Load* command in the *Light* menu and load the ZLI file you saved out in the previous chapter.

FIG 21.1 Document.NewDocument, *proportion, width, height, double, and resize*

FIG 21.2 *File.Save As*

FIG 21.3 *Light.Load*

Rendering process

Open up the Render menu and click on the circular icon in the top right corner of the menu and drag it to the left tray. This way the render menu will stay open while we tweak it. Activate the *Preview* toggle button and click on the *Render Properties* header to open it. Turn on the *Shadows*, *AOcclusion*, and *Sss* buttons. These buttons tell ZBrush to create shadows, an ambient occlusion pass, and the subsurface scattering effect. An ambient occlusion pass shows where the shadows fall on the object when there is a very general all-over (ambient) light source. It is useful for figuring out where dirt would accumulate on an object and provides a good foundation for shading our model. Subsurface scattering, on the other hand, describes how light refracts just inside the surface of a semi-translucent object like marble or skin. Both features can add a great degree of realism to a computer-generated image. Now set *Details = 3*. This setting increases the size of the environment maps that ZBrush generates for use with the render. What does that mean?

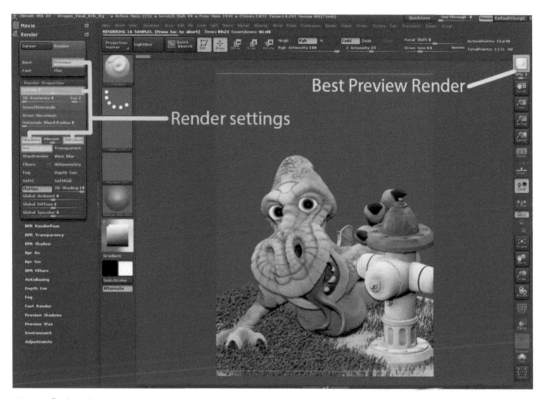

FIG 21.4 *Render settings*

Basically, ZBrush generates a number of internal image files to store the light-ing and shading data while it renders. The *Details* slider affects the size and therefore the accuracy of those internal files. Lower *Details* to 1 when creating your test renders to see how everything looks. Once you are ready for your final render, then crank the *Details* number up and sit back because the render time has increased dramatically. Once you have your settings, complete use *SHIFT + R* or press the *BPR* button to generate the render.

Document.Export and the *BPR RenderPass*

Save out your render using the *Document.Export* command. It may seem a little odd that we aren't using the *Document.Save As* command instead. How-ever, the *Save As* command creates an image file that only ZBrush can read, whereas the *Export* command saves out trustworthy Adobe PSD, Targa TGA, TIFs, and JPGs that hundreds of programs recognize, including ZBrush itself; so we should use it instead for the flexibility it provides us.

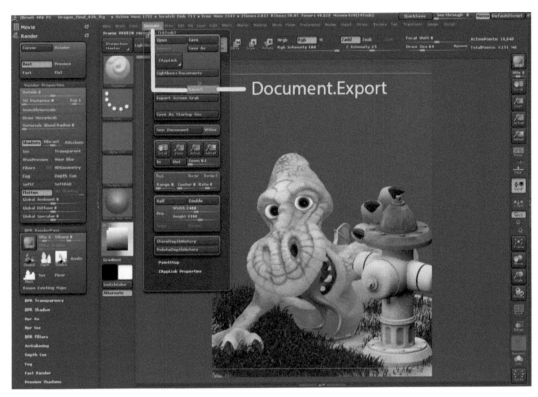

FIG 21.5 *Document.Export*

This render is good enough to serve as a final stage; but if you are a perfectionist like I am then there's still another few steps you can take to give you that final level of control over your finished product. The core idea is that you can take the rendered image and dissect it into its component parts. Separate out the main body of color from the shadows and highlights and any other elements such as depth, masks, and even shininess and save each of these elements individually. This lets you take the different pieces into a photo editor and composite them together. In the process you gain control over how much of each element you want to add. This is exactly how movie companies work with visual effects elements and this technique allows you a great level of artistic control over the final product. I think if you explore this option you will be able to improve the quality of your work tenfold, plus it has the added benefit of saving time. It may seem like it takes longer rendering out each different element and is a big hassle; but if you want to tweak the amount of shadows in the final image, you won't have to go back in and re-render the project. All you have to do is adjust the blend amount of the shadow layer in

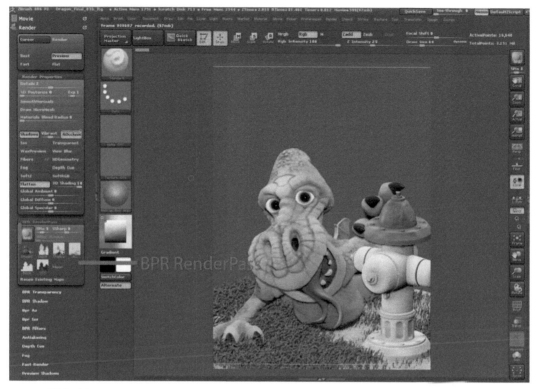

FIG 21.6 *BPR RenderPass*

your photo editor and *voila!* You're done. A little extra effort on the front end creating render passes will save you an immense amount of time in the long run. With that in mind, after you save out your basic render go to the *Render. RenderPass* and click on each of the icons to save out that type of render pass. Now you can just composite them together in Photoshop.

Now that you have both types of images, compare the BPR render with the standard render from the *Document.Export* command. See the difference?

Creating a variety of looks

For a slightly more complicated render process that gives you even more control over your final image, fill all of the objects with the *Flat Color* material and render this out. This will be your color pass.

Repeat this process using the *MatCap White* material and save out the render for a shadow pass.

FIG 21.7 Flat Color *render*

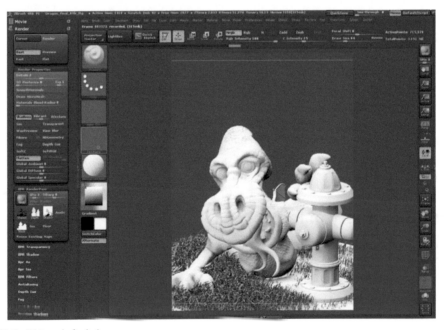

FIG 21.8 MatCap White *render for shadows*

FIG 21.9 *Various materials rendered out*

Now try filling all of the objects with black or white color and putting various materials on them, rendering these out. This is a useful way to isolate highlights and to create different looks for compositing the final image. For our render I tried out *MatCap Gorilla, Chrome A, MatCap Pearl Cavity, MatCap WedClay, ToyPlastic, SkinShade4, Metal 01*, and others.

MatCap White was especially useful for recreating our shadow pass since the *RenderPass* for Shadows had some severe errors (splotches!) in it, probably due to our large image size and ZBrush running out of memory since the small test renders using our lighting setup and a small document size worked OK. It is very important to learn to problem solve 3D programs and to develop "work-arounds" or fixes to the issues that crop up – because they will crop up, usually at the most inopportune times when you are up against a tight deadline. Unfortunately, that sort of thing has to be learned directly from experience and from resolving the problems that occur during your own productions. ZBrush is a strange and complicated program with lots of quirks and unusual workflows to learn, but that is to be expected of any cutting-edge program capable of doing what it does. When it works, it is amazing! When it doesn't, it can be very stressful; but it is all part of working on high-end 3D programs!

Generating masks for illustration

A really good trick when doing this process is to isolate each different object and material in the scene. So, what in our scene would have a different look from everything else? The dragon, the hydrant, the grass, the dragon's tongue, and eyeballs would all have different specularities and levels of shininess, so these are the things we need to render a mask for. To isolate an element for later, simply fill it with a white flat material and everything else with

FIG 21.10 *Object masks*

flat black color. When you render this it will create a mask for that element in the final picture.

That should be all of the render layers we need. I hope you've enjoyed our sojourn through ZBrush. We've gone through all of the basics of the program, but there is still a lot of stuff for you to discover. It would take another ten volumes the size of this one to talk about everything in the program and all of the workflows associated with it. It is, however, the basic workflow that is the most important thing to learn. Once you have mastered it you can figure the rest out on your own, or buy the next excellent Focal Press book on advanced ZBrush techniques if you need a little help. Make sure you visit the wonderful resources available at ZBrush Central (www.zbrushcentral.com) and take the time to study what professional artists are doing with ZBrush and examine their techniques. I hope you enjoy the program and give your creativity free reign! Next up: the final chapter on compositing our renders together using Adobe Photoshop (though the lessons apply to any photo editing software, too).

Compositing

Now we've come to the final stage of putting our image together. Compositing an image from rendered layers is an extremely powerful technique that gives the artist a lot of control over the finished product.

Adding layers

Open all the image files that you rendered out in the last chapter in Photoshop (or another image editor such as GIMP – GNU Image Manipulation Program, *www.gimp.org*). You should have one render that is just the color image created by using the *Flat Color* material on your objects. This is one we want on the bottom of our compositing stack, so select this image now. Save this image as a new name, "Final_Composite_v01.PSD".

Now find the render titled "BPR_AO". This is the ambient occlusion render we separated out in ZBrush using the *BPR RenderPass* feature in the *Render* menu. Select the entire image (*CTRL + A* in Photoshop) and cut this image off its background (*CTRL + X*). Paste it onto your base color "Final_Composite_v01. PSD" image (*CTRL + V*). In your Photoshop *Layers* panel you should see the icon for this new layer on top of the color layer. Double click on the name of this new layer you just pasted into the image and rename it "shadows". This will be one of our shadow layers that add shading to our flat color rendering. It is a good idea to rename all of the layers you add to the picture so that their name matches their function (i.e., "base color", "shadows", and so forth). This just makes the function of each layer a bit easier to keep track of. Now change the layer *Blend* mode of the shadows layer to *Multiply*.

This will take the dark parts of the shadow layer and composite them into the color layer. You can adjust the *Opacity* of the shadow layer to adjust the level of effect it gives the overall image, but 100% should be OK for this layer. Now repeat this process and cut and paste the other renders into our final composite.

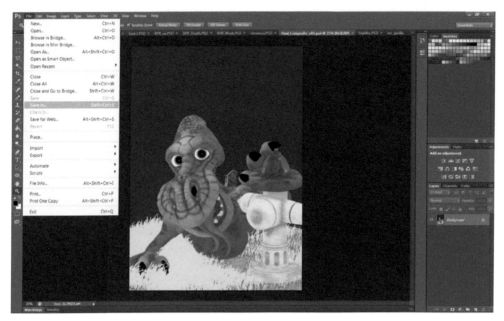

FIG 22.1 *The flat color layer goes at the bottom of the layer stack*

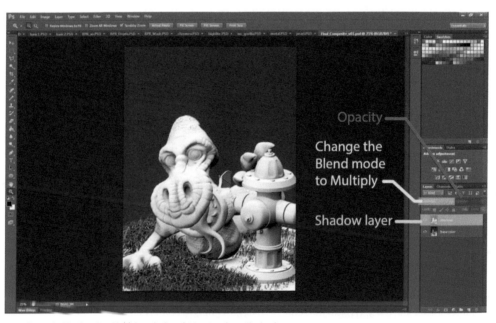

FIG 22.2 *Change the Blend mode to Multiply and adjust the Opacity of your Shadow layer*

FIG 22.3 *Named and organized layers*

Don't forget to name the layers as you go so you don't lose track of which layer is which. The order in which the layers appear in the layer stack is also important. The effects accumulate going down the stack so you want your base color on the bottom, your shadows on top of it, then highlights, and finally other effects on top of that. You can always change the placement of a layer just by clicking and dragging it to a new position in the layer stack. Changing the layer order is an easy way of getting new effects quickly and you will have to play around with your layers a bit to get a feel for what is going on.

The images we don't want to add as layers are the BPR_Mask, BPR_Depth, and black-and-white item mask renders (dragon, ground, hydrant, eyes, and tongue). These renders are for creating selection areas and they need to go someplace different. In the *Layers* panel, switch to *Channels* mode. Click the tiny little down arrow icon at the top of the *Channels* panel and select *New Channel*. In the list of available channels below you should see *RGB*, *Red*, *Green*, *Blue* and now an empty *Alpha 1* channel. Select the *Alpha 1* channel and paste the BPR_Mask render into it. Now do the same process for the BPR_Depth render and the item masks. You should end up with two new alpha channels: one for the BPR_Mask and another for your BPR_Depth information.

305

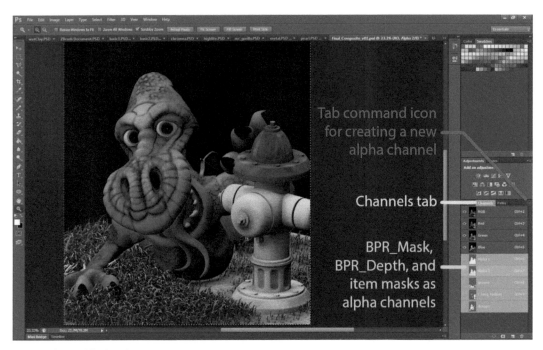

FIG 22.4 *Creating alpha channels*

Editing the layers

Now that we have all of our layers pasted into the same picture we can really start editing our image. Simply select a layer, choose a blending mode for it, and adjust the opacity to control the amount of effect you want to add. Try out different combinations of various blending modes and differing opacity. Keep in mind that the effect can change dramatically depending upon how the layers stack. When you find something you like you can isolate it to one element of the image by loading up one of the alpha masks and deleting everything else you don't want from that composite layer. For example, after selecting the Chrome layer, I then loaded up the dragon mask using the *Select. LoadSelection* command, inverted it (*CTRL + SHIFT + I*) to select everything else in the scene, and deleted the selection using the *delete* key. This leaves the chrome effect just on the dragon itself. I dropped the *Opacity* of the chrome layer to 50% to diminish the effect a bit.

For the Pearl layer I used *Image.Adjustments.Levels* (*CTRL + L*) to turn the layer into a strong but narrow highlight. Activating the levels command will display a histogram with a set of three triangular sliders along the bottom. The histogram graphs the amount of pixels in the image at each level of intensity in the image, working from dark on the left to light on the right. Basically, the

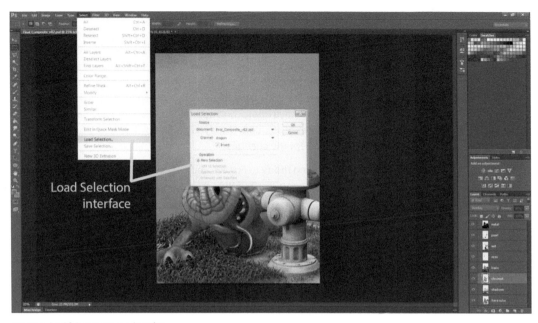

FIG 22.5 Load Selection *command interface*

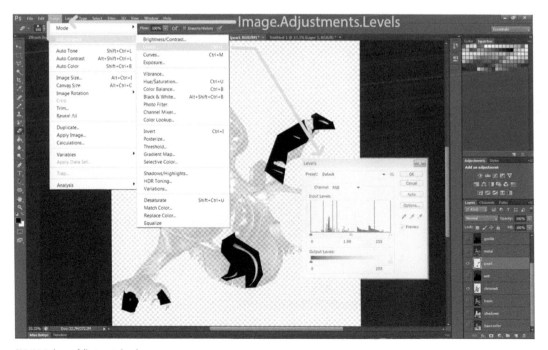

FIG 22.6 Image.Adjustments.Levels

height at any point on the graph tells you how many pixels of that intensity are in the picture. Moving the right light triangle slider sets the point at which pixels become white. Moving the left dark triangle slider sets the point at which pixels become black. Moving the middle gray triangle slider adjusts the brightness of the image. Play around with the sliders and watch the effect on the image. If you are still a bit confused you can always just click on the *Auto* button, which will have Photoshop automatically adjust the image to what it thinks is an optimum solution. Once you are happy with the effect, click the *OK* button to accept the changes.

I then set the blend mode to lighten and deleted everything except the shine on the claws and tongue using the eraser.

For the metal layer, I used *Image.Adjustment.Levels* to strengthen the contrast on the layer, then set the blend mode to *Lighten* and the *Opacity* to 20% to add just a hint of highlight to the hydrant. The MatCap_Gorilla and WedClay layers weren't useful so I just deleted them. Remember that you don't have to use all of these layers if you don't want to. Just get rid of anything that isn't useful. On the other hand, feel free to duplicate layers that are useful, move them around the layer stack, and use different blend modes and opacity amounts to achieve the effect you want. Some general rules are that you should use the darken and multiply blend modes on layers that add shadows or darken the image. Use lighten, screen, and the

FIG 22.7 *Photoshop Levels command interface*

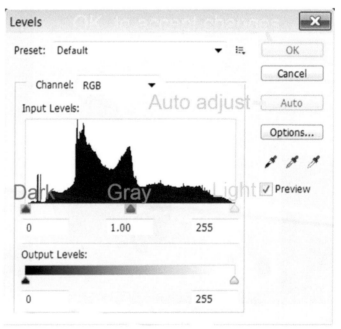

FIG 22.8 *Adding more color saturation*

dodge blend modes to add highlights and brighten the image. The color and saturation blend modes are useful with your color layer(s) to add more color to the picture.

I duplicated the base color layer using the Layers panel control tab command list *Duplicate Layer* command, then placed the duplicate on top of the layer stack and changed its blend mode to saturation to restore some intensity to the image since it seemed to be getting a bit washed out. To add some interest, I loaded up the depth mask, inverted it, and deleted that selection from this saturation layer. This adds just a hint of depth to the image since the saturation of the objects in the picture now fades with distance from the viewer.

To make the eyes of this cartoon character "pop", I duplicated my basic layer (a copy of the full render I did just by using ZBrush), then used the eye mask to isolate and delete everything but the eyes. An *Image.Adjustments. Levels* command (*CTRL + L*) to brighten the eyes came next. This made the eyes look much more intense and created a more powerful focal point for my image.

Adding a backdrop

The last thing to do is to add a backdrop. Gray does nothing for the image, so let's composite in a nice sky. Load the BPR_Mask channel as a selection using the *Select.LoadSelection* command. Load in the Alpha from the Channel pull-down menu, click the *Invert* checkbox on, and select OK. Now just go through the layer palette and select every layer and delete the background from it. It wouldn't hurt to group all of these layers together, so select all of these layers while pressing the *SHIFT* key and in the Layers menu command tab select *New Group from Layers*. Name this group something informative like "ZB renders". Now we are ready to bring in the sky image behind this group. Don't forget to save your image.

Open "pink_sky.jpg" and cut and paste it into our final image behind the "ZB renders" groups. Use the transform command (*CTRL + T*) to scale it up and the *Move Tool* (*V*) to place it. As a final touch you can create a new layer on top of everything else and add a few paint strokes with colors selected from the sky backdrop. Change the blend mode to *Hue* and drop the opacity to about 20%. This adds just a hint of reflected sky color to the scales and will help tie

FIG 22.9 *Image with the background deleted*

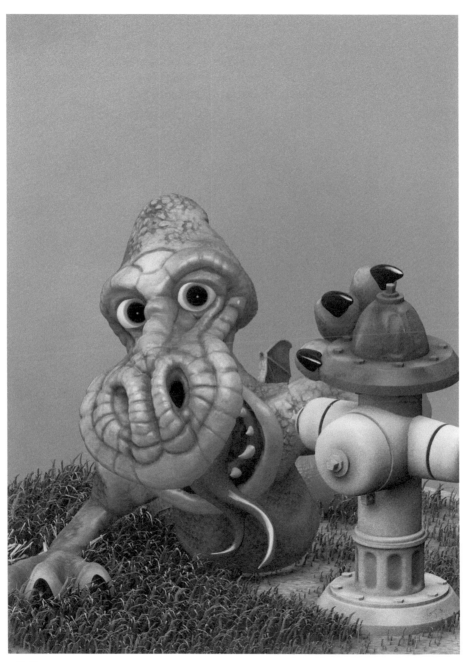

FIG 22.10 *Final image*

the dragon with the background. At this point it is simply a matter of tweaking your results and adding any other layers and elements that you desire.

All that remains now is to add a new layer, select a dark color, choose a small brush, and sign your picture. Now save your work. Congratulations! You've finished. I hope you have enjoyed going through all of these learning exercises and materials as much as I did preparing them for you.

Index

T - #0501 - 071024 - C330 - 235/191/15 - PB - 9780415705141 - Matt Lamination